ARDMORE

We are because of others

ARDMORE

We are because of others

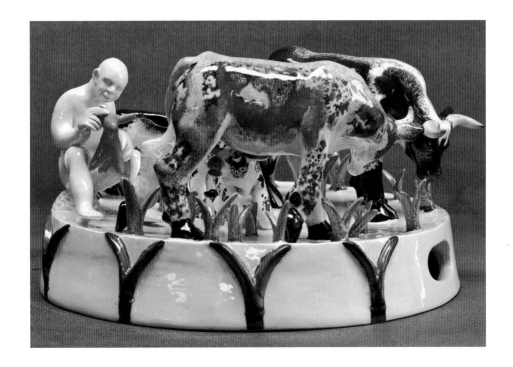

The Story of Fée Halsted and Ardmore Ceramic Art

Photography

Roger de la Harpe

FERNWOOD
PRESS

a

Ardmore
Ceramic Art

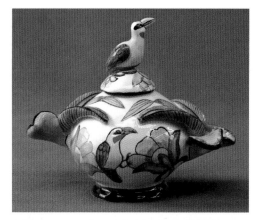

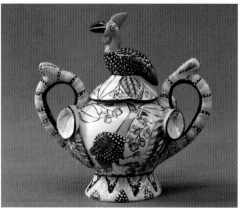

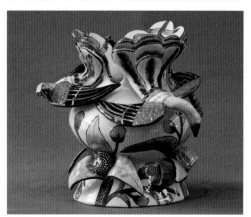

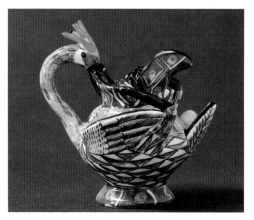

Published by Fernwood Press
(an imprint of Penguin Random House South Africa (Pty) Ltd)
Company Reg No. 1953/000441/07
The Estuaries No 4, Oxbow Crescent, Century Avenue, Century City, 7441
PO Box 1144, Cape Town 8000, South Africa

First published in 2012, Reprinted 2015, Reprinted 2017

Visit www.penguinrandomhouse.co.za and subscribe to our monthly newsletter.

Ardmore Ceramic Art
PO Box 273, Nottingham Road 3280, South Africa
Tel: +27 (0) 33 2344869 Mobile: 0823754486 / 0724952248 Fax: +27 (0) 86 5209398
Email: info@ardmoreceramics.co.za
www.ardmoreceramics.co.za

Publisher: Claudia Dos Santos
Managing editor: Roelien Theron
Designer: Johan Hoekstra, Catherine Coetzer
Cover designer: Catherine Coetzer, Diana Chavarro
Indexer: Michel Cozien
Proofreader: Lesley Hay-Whitton

Reproduction by The Scan Shop, Cape Town
Printed and bound in Malaysia by TWP Sdn Bhd, Malaysia

ISBN (Standard edition) 978 1 43170 1117
ISBN (ePub) 978 1 92054 5376
ISBN (PDF) 978 1 92054 5383
ISBN (Collector's edition) 978 1 43170 1131
ISBN (Special edition) 978 1 43170 1124

Cover: Leopard and elephant tureen thrown by Sabelo Khoza, sculpted by Thabo Mbhele
and painted by Jabu Nene, 2009.
Endpaper: Detail of a leopard tray sculpted by Somandla Ntshalintshali and painted by
Jabu Nene, 2010.
Half-title page: Giraffe egg cup thrown by Lovemore Sithole, sculpted by Thabo Mbhele
and painted by Nonhlanhla Khanyeza, 2008.
Title pages: Tureen depicting traditional Zulu scenes sculpted by Nkosinathi Mabaso and
painted by Roux Gwala, 2008 (left). Sculpture of a young herdsman modelling a clay toy
while watching over his cattle by Nhlanhla Nsundwane and painted by Alex Shabalala,
2009 (right).
This page (from top to bottom): Bird tureen sculpted by Bhekithemba Shangase and
painted by Charity Mazibuko, 2009; guineafowl tureen sculpted by Octavia Mazibuko and
painted by Qiniso Nene, 2009; bird vase sculpted by Mthobi Ntshalintshali and painted
by Matrinah Xaba, 2008; miniature crane vase sculpted by Victor Shabalala and painted
by Matrinah Xaba, 2008.
Opposite: Detail of a giraffe bowl sculpted by Somandla Ntshalintshali and painted by
Punch Shabalala, 2010.

'Yes, we can!'
Barack Obama, 2008

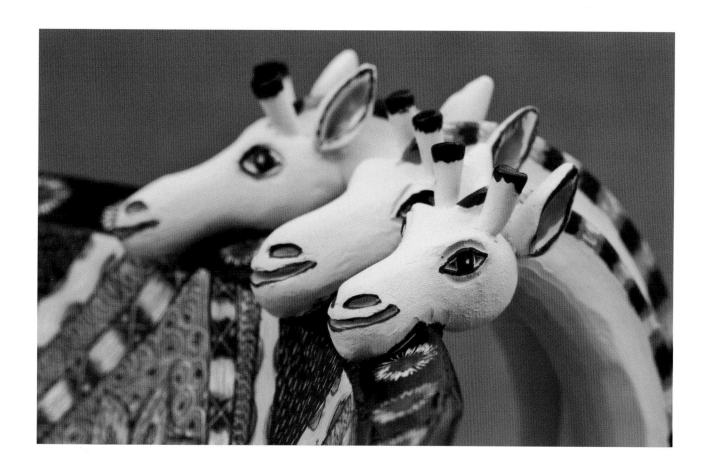

To my family, my friends and the artists who have shared my journey.
And in memory of Eleanor Kasrils who put Ardmore on the world stage.

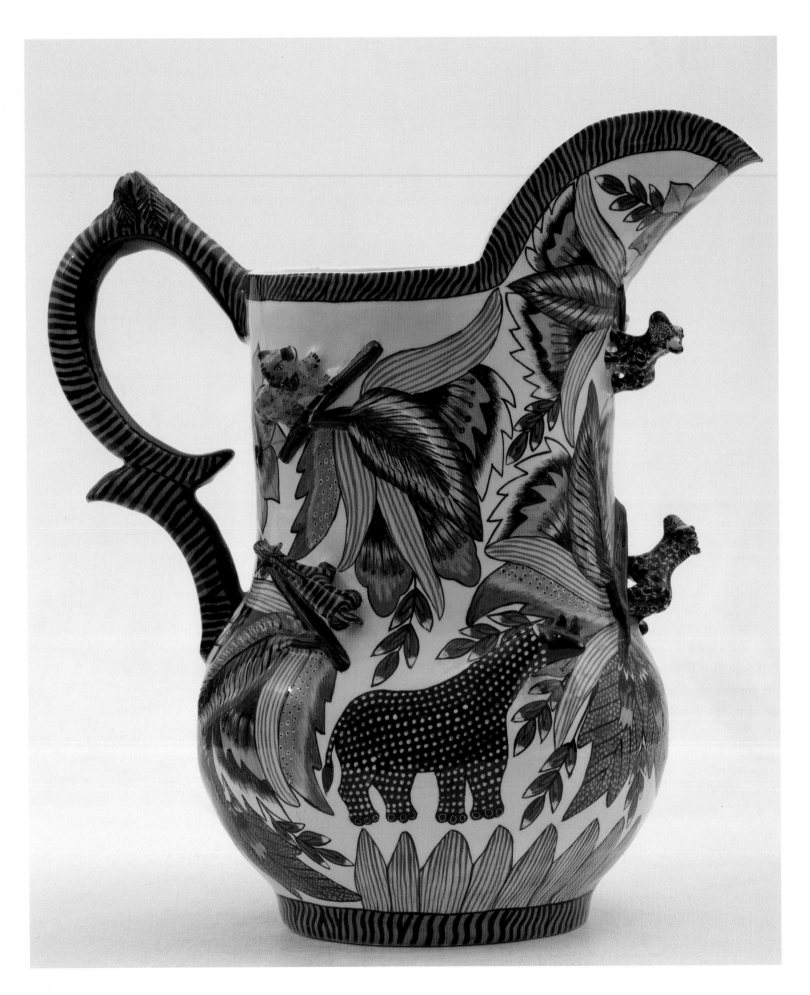

o describe what Ardmore is should be simple. Yet it is not, for the truth is as complex as the intricate, striking and colourful patterns and fantastically lifelike creatures that characterise Ardmore's creations.

What is immediately apparent, however, is that Ardmore has triumphed because of the dedication, will and passion of its founder, Fée Halsted.

Ardmore is a South African sensation. Its ceramics feature in some of the world's finest art galleries and foremost collections. Choice pieces are proudly presented as state gifts to world leaders and considered shining examples of *ubuntu* – 'We are because of others'.

Ardmore is an artistic tour-de-force. The imagination, creativity and considerable skill of its throwers, sculptors and painters have blossomed under Fée's dynamic creative direction. The result, over and over again, has been artworks of astounding vibrancy.

Ardmore is a family concern. The hands-on involvement of Fée, her children and close family in the day-to-day running and development of the studio has been pivotal in its achievements of international acclaim.

Most important, perhaps, Ardmore is also a successful community project that has enriched the lives of and provided secure livelihoods for impoverished families in rural KwaZulu-Natal. It was Fée who handed men and women back their dignity by giving them an outlet for their talents and enabling them to support themselves. Moreover, it was Fée who recognised the harsh reality of families ravaged by the HIV/AIDS pandemic and was bold enough to tackle the issues of treatment and prevention – even at a time when the South African government would not.

What moves me most deeply about Fée's account of her life, and of Ardmore, is her insistence on her own personal and artistic needs and the creative application of her unique talents. Fée's calling to improve the lot of others is not borne out of a sense of guilt for her own privileged past. Ardmore exists because Fée is the born mentor and teacher – part humanitarian, part disciplinarian – who knows how to cajole and badger in equal measure to get the best out of herself and others.

This book is a tribute to that indomitable spirit and to the wonder that is Ardmore. Fée, you and Ardmore Ceramic Art truly are proof that 'We are because of others'.

Brendan Bell

Brendan Bell
Director, Tatham Art Gallery

Opposite: Zebra and rhino jug sculpted by Beauty Ntshalintshali and painted by Jabu Nene, 2002.

Above: Reptile vase sculpted and painted by Zeblon Msele, 2007.

Overleaf: Hoopoe urn thrown by Elias Lulanga, sculpted by Sabelo Khoza and painted by Punch Shabalala, 2005.

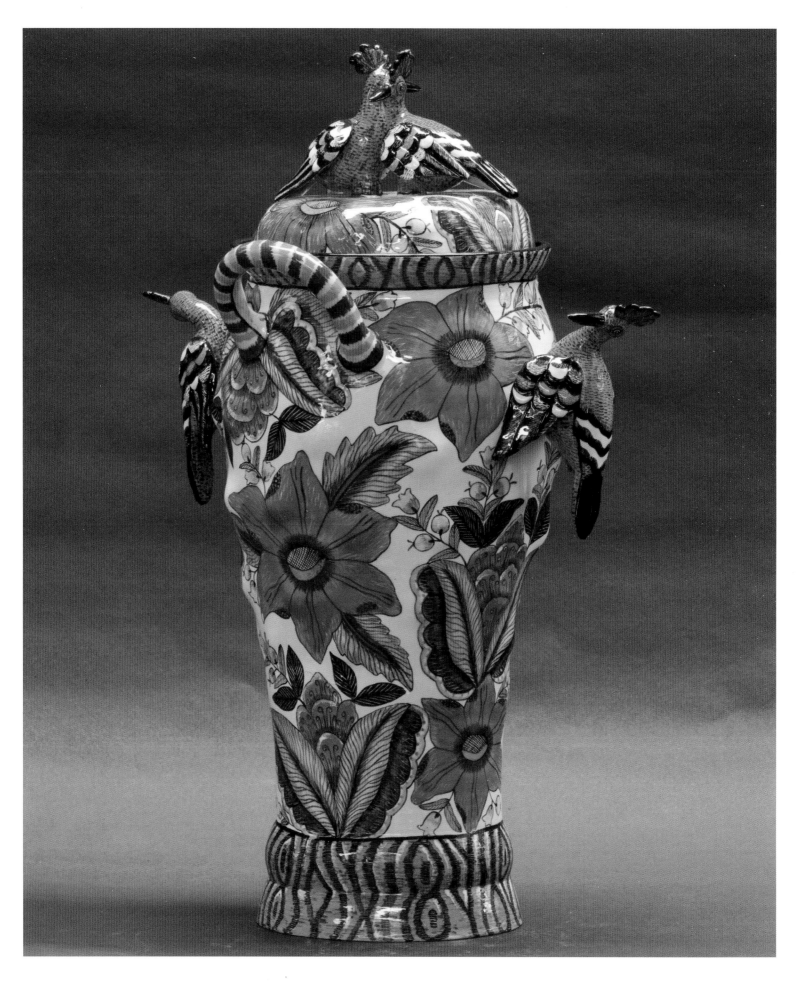

Punch Shabalala: I have lived a better life since I met Fée Halsted. She taught me to sculpt and to paint. I left school early, but Ardmore has given me many opportunities. Today, even though I am a single parent, I am able to provide for my children's education. There was a time when I was very, very sick; I nearly did not make it. When I found out that I was HIV-positive, the people at Ardmore gave me support, medicine and food, and took me to doctors. Today I am a happy woman because I'm always next to Fée at Ardmore. I also do not have any stress because I always concentrate on my work, which helps me forget all my problems. I say thank you.

P. F. Shabalala

Christopher Ntshalintshali: I was born in the Winterton area and grew up on Ardmore farm. I joined Ardmore in 1998 as an artist, learning sculpture under the watchful eye of Fée Halsted. Ardmore has improved my life. I have travelled all over the world, which has expanded my horizons and given me a love of learning, especially learning how to run a business. Fée gave me a huge opportunity when she made me responsible for running the Ardmore studio in the Champagne Valley. I really enjoyed and loved my work as a manager and production manager there. It was a dream come true.

Lovemore Sithole: The opportunities that I have been given by Ardmore in furthering my artistic education have helped me turn my life around. With the help of my wife, Sharon Tlou, who is one of Ardmore's painters and works in the gallery, I am able to support my family, something I would not have had the means to do in the country of my birth, Zimbabwe. There Sharon and I had almost no chance of improving our lifestyle or uplifting ourselves. Working at Ardmore has enabled us to educate our children and has given us new hope for the future.

Petros Gumbi: I was born in 1973 and grew up in the small village of KwaBhekuzulu near Estcourt. I am a sculptor and am so grateful for the talent that God has given me. Ardmore has helped me develop that talent. My work has been shown all over the world, and many people buy my sculptures because they love them. I continue to learn and do my best. At Ardmore I also teach young artists to make exceptional pieces. I feel so proud of my art and am thankful for the opportunity Ardmore has given me.

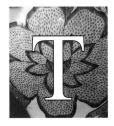

This book is a tribute to the artists of Ardmore who collectively have created a legend. Bonnie Ntshalintshali set the benchmark for originality, quality and artistry. She died more than a decade ago, and the artists who followed have raised the standards even higher, exploring the frontier of what can be done with clay. I love their creativity, the uninhibited imagination that is evident in their work and the joy their art brings to my life. The artists deserve a huge thank you from me – we have grown together and learnt from each other. In addition to their creative skills, many of the artists have demonstrated leadership and administrative abilities and have become indispensible in helping me run the studio – initially at Ardmore farm in the Drakensberg's Champagne Valley, then at Springvale farm near Rosetta and now at Caversham in the KwaZulu-Natal Midlands.

My mother, Catja, my brothers, Paul and Charles, and my sister, Catja, have given me every ounce of love and support, and I thank them for their encouragement. I have many members of James Berning's family to thank for their kindness, especially in the early years when we did not have the recognition we enjoy today: Louise and John Glenton, Jane and Gavin Relly, Rilda and Basil Hone, and Min and John Berning. Not least of all, I want to thank my son and two daughters, Jonathan, Catherine and Megan, who have grown up with Ardmore and have learnt so much, not only of artistry but also of Zulu culture and *ubuntu* – 'We are because of others'.

Some of my early friends remain treasured for many reasons, not least because they played such a big role in my initial years as an artist. Juliet Armstrong encouraged me to learn about ceramics. David Middlebrook taught me to break the rules. David Walters showed me how to run a ceramics business, and Andries Botha persuaded me to teach.

Many people came to Ardmore, bought a few pieces and then became supportive in many different ways. I call them my fairy godmothers and godfathers. Without them Ardmore would not be the enterprise it is today. Eleanor Kasrils, Dr Lindiwe Mabuza, Christopher Greig, Anthony Record MBE, Ted Adlard, Malcolm Christian, Deirdre Simpson, Fleur Heyns and Annie Halsted have given me and Ardmore so much; in return I give them my love and gratitude for inspiring me with their generosity and kindness. Their friendship has kept me going through tough times.

I would also like to thank my office staff, especially Cathrin Ogram, who was by my side from 2001 until she left South Africa for New Zealand in 2008. Those were the growing years and no one could have been a more loyal and hardworking colleague. Alan McGregor also came into my life at that time. He made a significant difference when the AIDS pandemic hit Ardmore. Alan worked hard to have us accepted into the United States

Opposite: With a leopard tureen sculpted by Sondelani Ntshalintshali and painted by Roux Gwala, 2007.

Above: Zebra and flower jug sculpted by Fundi Mathebula and painted by Nonhlanhla Nxumalo, 2004.

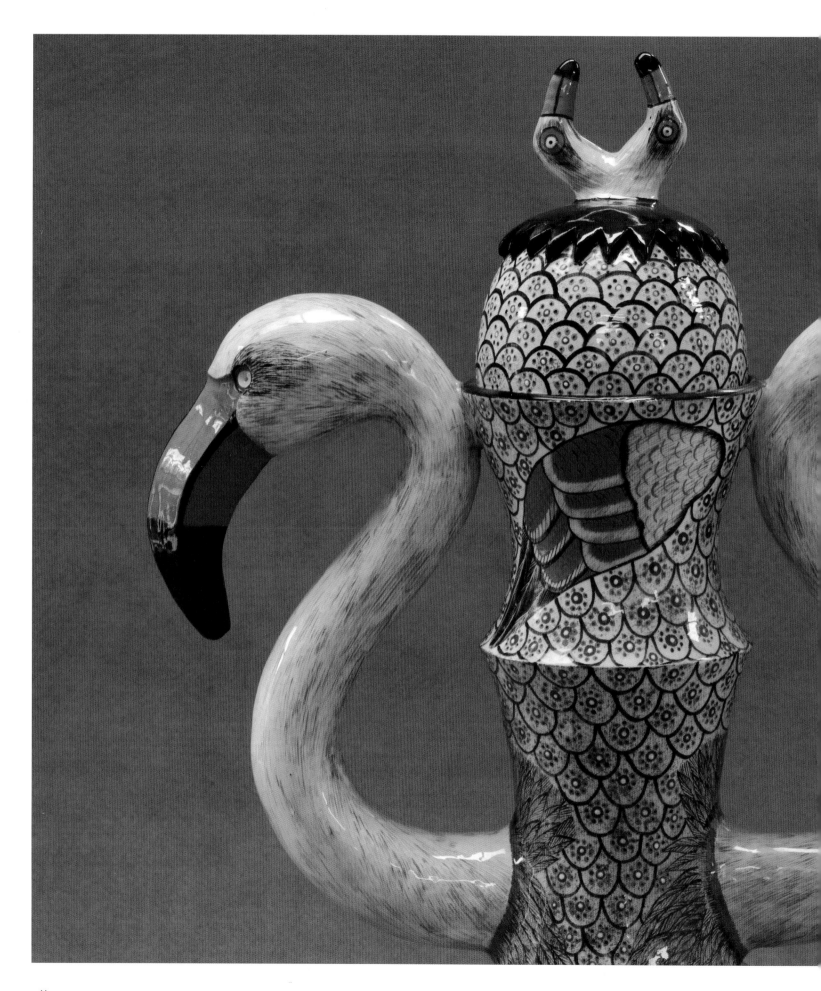

President's Emergency Plan for AIDS Relief (PEPFAR) programme at a time when antiretroviral (ARV) drugs were not readily available. He made a difference to the lives of many people, including my own. Alan also took Ardmore into the computer age.

I am grateful to the many people who have made this book possible, particularly our subscribers, listed on page 197, without whose generosity the project would have taken much longer to get off the ground.

More than 300 photographs have been included in the book, most of which were taken by Roger de la Harpe. He has done a magnificent job. I would like to thank Anthony Bannister and Doreen Hemp for letting us use photographs they took at Ardmore many years ago. Hetty Zantman and Franco Esposito also allowed us to reproduce some of their images.

I owe a debt of gratitude to Annie Halsted, the wife of my second cousin Craig, who moved to Australia more than a decade ago. Annie came to stay with me in Caversham for a month in the winter of 2011 and helped me put the finishing touches to this volume.

Working on the book has been a huge learning curve for me, and I had to grapple with questions to which I had no answers. My one stipulation was that it had to be a true account of my life with Ardmore. And here you have it, warts and all!

Left: Detail of a flamingo urn sculpted by Matthew Stitzlein, a visiting ceramicist from America, and painted by Mirriam Ngubeni, 1999.

Above: Crane and flower tureen sculpted by Beatrice Nyembe and painted by Bonnie Ntshalintshali, 1998.

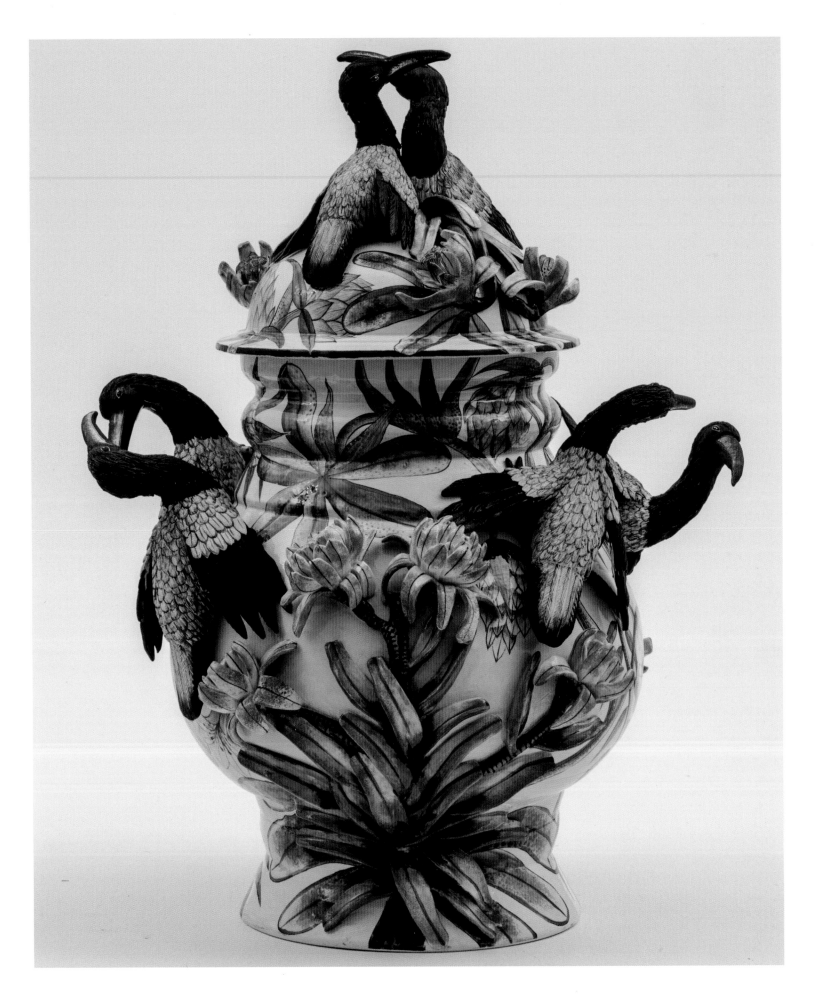

Opposite: Bird tureen thrown by Lovemore Sithole, sculpted by Sabelo Khoza and Thabo Mbhele and painted by Siyabonga Mabaso, 2012.

Above: Giraffe jug sculpted by Mondli Manatha and painted by Angeline Mathebula, 2006.

Overleaf: Giraffe riders sculpted by Alex Sibanda and painted by Wiseman Ndlovu, Roux Gwala and Siyabonga Mabaso for the *Travellers of Africa* exhibition held in conjunction with Charles Greig Jewellers and The Collection by Liz McGrath in Johannesburg in 2010.

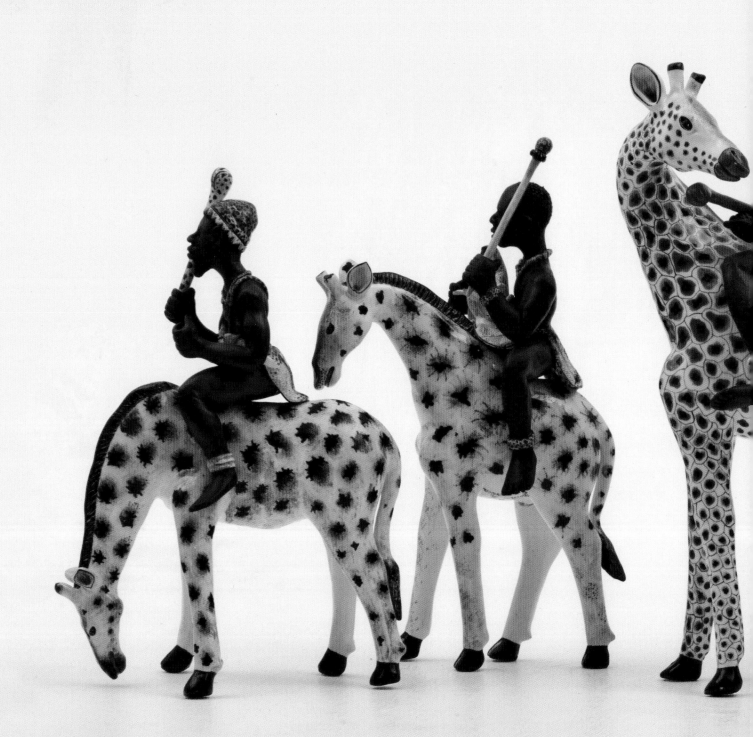

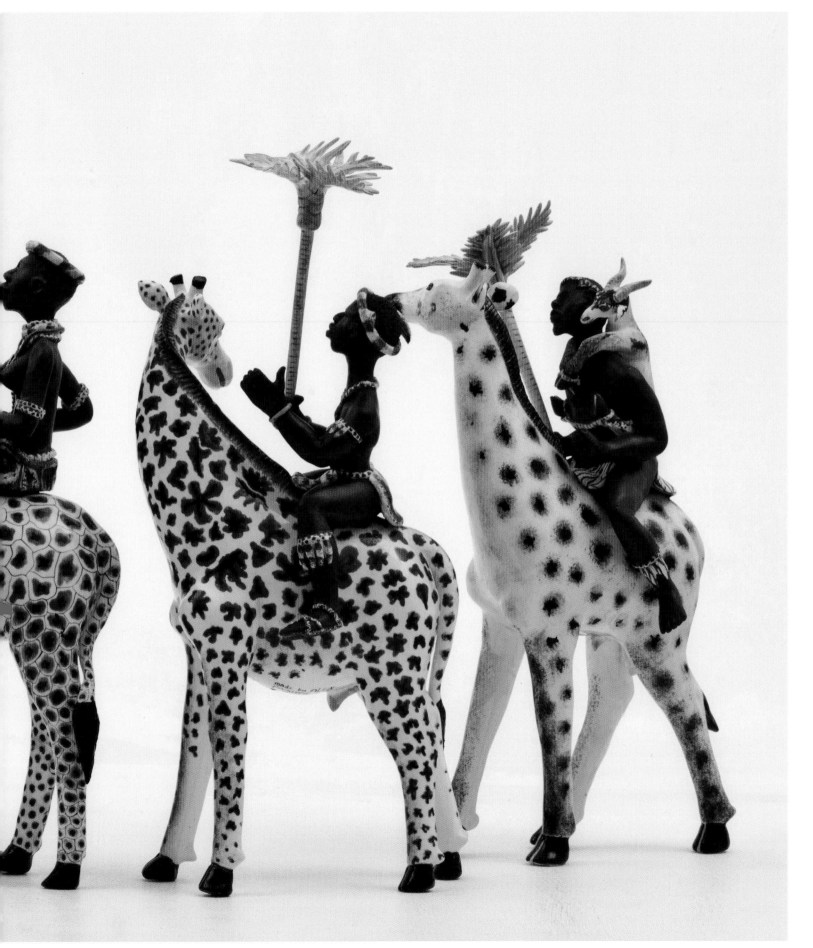

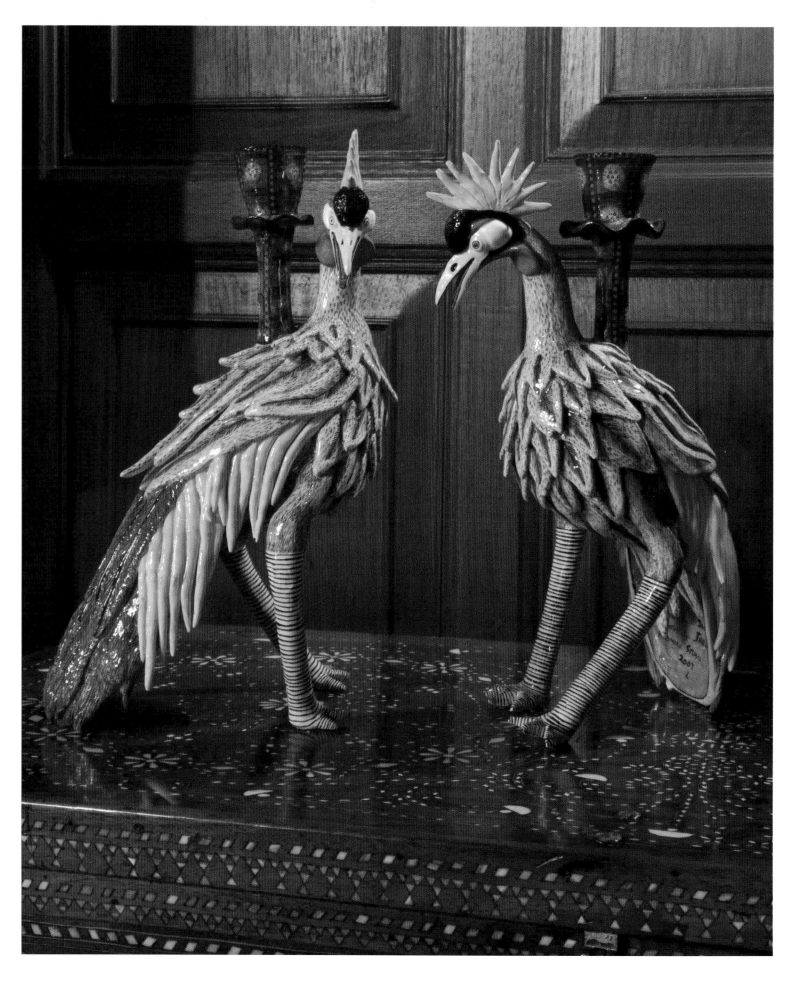

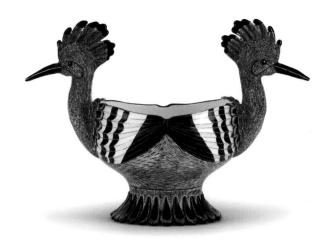

he story of Ardmore began almost thirty years ago when I started on a journey teaching ceramics to a talented group of rural people in a remote corner of KwaZulu-Natal, where the opportunities for employment – particularly for women – were few and far between. All we had were raw talent, clay and simple tools, primarily our hands. The combination of my teaching and the young artists' discovery of their creative talents enabled us to develop a unique style and range of ceramics, as well as achieve our first goal – that of putting food on the table. Years later I discovered that, as their skills matured and they gained confidence, the artists also nurtured their own ambitions. Of course they wanted cars and homes. But they wanted something even more important than that. They wanted recognition as true artists. Today, Josephine Ghesa, Wonderboy Nxumalo, Petros Gumbi, Nhlanhla Nsundwane, Punch Shabalala, Virginia Xaba, Mickey Chonco, Wiseman Ndlovu, Sondelani Ntshalintshali, Sabelo Khoza, Bennet Zondo, Alex Sibanda and Victor Shabalala are acclaimed artists in their own right.

I was fortunate that, from the time I lived in Zimbabwe, where I was raised, to the years I have spent in KwaZulu-Natal, I have trusted and loved the African people around me. As a child, my family taught me to appreciate the same values as those inherent in Zulu culture: inclusiveness, listening, sharing and *ubuntu* (meaning 'We are because of others'), which in one word describes how a person should behave – with respect, kindness and generosity. I believe that this sharing of a common culture has enabled me to vault the barrier that so often divides white and black and, together with a wonderful group of artists, to create an ethos of *ubuntu* at Ardmore. There are no politics, gender or race in creativity. Rather, the artists and I are connected by an unshakeable love of nature, and our day-to-day lives are filled with beauty and caring people. This is the foundation on which Ardmore has been built.

I have always followed my intuition, sometimes even doing things without understanding why. I have never been afraid to take on a challenge; if it failed, I would try again. I have always listened to advice, from friends, mentors and advisors, and have never hesitated to adopt new ideas or adapt to change. Like many people who live close to the land, I find peace and comfort in the beauty of nature. I have also learnt to embrace life and give thanks for every peaceful day.

As Ardmore developed, I came to share the helplessness of the artists when, at times, we collided with a world so different from rural Africa. I believe that, as our natural world shrinks, those who live close to nature will inhabit a far better world than those deluded by the belief that life in the twenty-first century is easier, with its modern technology, fast cars

Opposite: Crested crane candlesticks sculpted by Slulamile Mlambo and painted by Jabu Nene, 2008. The candlesticks were displayed at the Ardmore exhibition held at Groote Schuur Estate in 2008, and are in the collection of Lindiwe Mabuza.

Above: Hoopoe bowl sculpted by Matthew Stitzlein and painted by Bonnie Ntshalintshali, 1998.

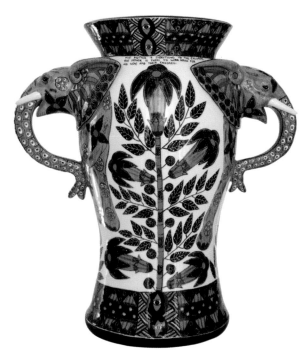

Top: Slulamile Mlambo's imaginative sculpture shows me 'giving birth' to an Ardmore espresso cup painted by Zinhle Nene, 2008.

Above: Elephant vase thrown by Lovemore Sithole, sculpted by Nkosinathi Mabaso and painted by Wonderboy Nxumalo, 2008.

Opposite: Blue crane candlestick thrown by Elias Lulanga, sculpted by Nkosinathi Mabaso and painted by Nelly Ntshalintshali, Bonnie's younger sister, 1998.

fuelled by an unsustainable resource, concrete jungles that do nothing for the soul, and the continual demand for more goods.

African creativity is filled with passion and celebrates nature. It has brought new meaning and relevance to westerners who all too often do not have the time to pause and wonder at the world around them. Whether it is music, song, dance or art, African creativity is an expression of a specific time and place, and a reminder of just how precious our planet is. It is also without any falsity, without pretension, without lies and without self.

Developing Ardmore has not been an easy ride, but an ethos of hard work, trust and belief in people has sustained me. I was always sure that we would fly above the clouds of doubt and failure. 'Yes, we can!' are words that have echoed down the years since that eventful day in 1985 when I started teaching Bonnie Ntshalintshali. There has been delight, excitement and heartache, and every step of the way has brought fresh challenges and creative responses.

For me Ardmore is colour and life and joy. It opens a door into an imaginary world filled with beauty, humour and the unexpected. Magical little elephants wear vibrant cloaks of flowers, spots and stripes. Others give birth to baby elephants in the shade of a ceramic palm tree. Giraffes stretch out their necks and elephants curl their trunks to make handles for jugs and vases. Inquisitive little monkeys peer over the edge of planters in fear and trepidation of the leopards below them. The variety is never-ending and each piece is unique.

Ardmore is not just about ceramics. It is about the artists who create them. As I have taught, I have also learnt. It has been a joy to watch as, one after another, the artists have developed skills and have grown in stature. They have been inspired by the creativity of those who went before and, in turn, have passed on their knowledge and experience to new throwers, sculptors and painters. They have learnt all I can teach them and have gone much further, encouraged and exhilarated by the critical acclaim they have received for their work.

Twenty years ago Ardmore had one outstanding artist. Today I would not know which artist to single out from the many names that immediately come to mind. There are the decorative artists whose work is beautiful, with fine brush strokes and delicate bead- and basket-like designs; the realists who observe nature closely; and the exotic artists whose work, while based on nature, is elegantly stylised. Then there are the storytellers whose sculptures and paintings incorporate the human figure and represent Zulu history and culture, or everyday events at Ardmore. They also comment on important issues in their society such as AIDS, alcohol abuse and promiscuity. There are the free spirits whose work is an expression of their own imagination and is without inhibition or apology. Lastly, there are

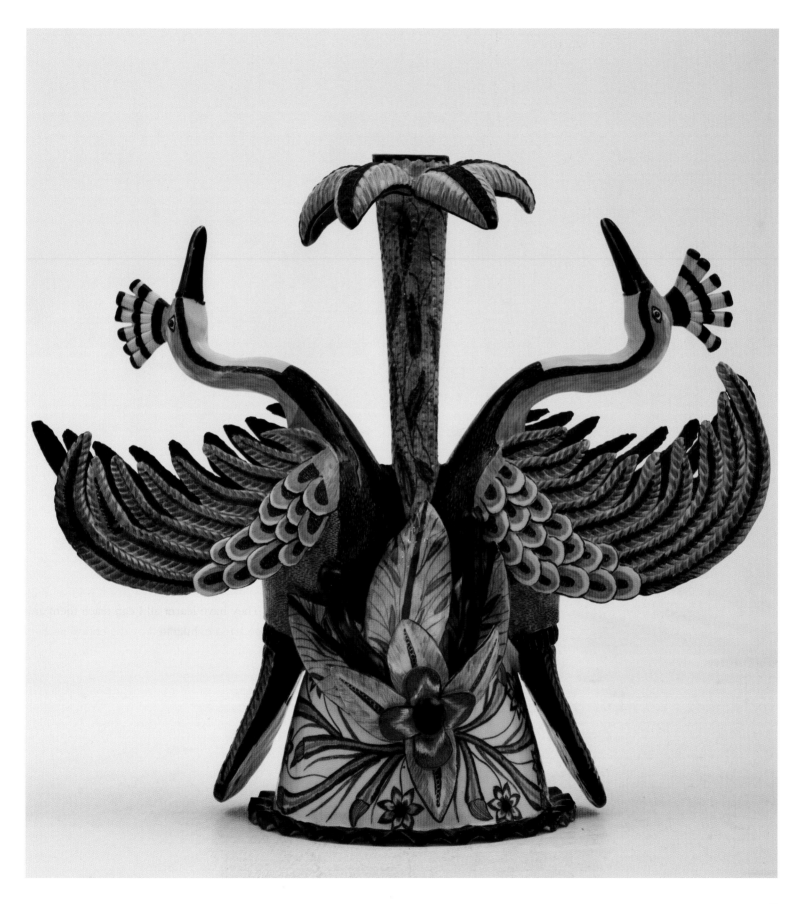

those whose work radiates a primeval power, a style that comes from deep within and cannot be taught.

Visitors to Ardmore's studio at Caversham in the KwaZulu-Natal Midlands are able to see for themselves the talent and dedication of the throwers, sculptors and painters who work there. These men and women have become known in the district as the *isigiwili*, or 'those of good fortune'. I will never forget that I, too, am of good fortune, having had the opportunity to teach so many wonderfully talented people.

In 1879, when the British invaded Zululand under King Cetshwayo, it was not bullets that destroyed the Zulu nation. It was a loss of pride. In a small way, Ardmore has helped rekindle that pride. I have been overwhelmed by the affirmation and praise the artists have received at the many exhibitions they have participated in all over the world. I remain awed by their craftsmanship and skill, their imagination and daring as they raise their standards to ever-higher levels. But, in all the years since the establishment of Ardmore, my greatest reward has come from a comment made by Lovemore Sithole, a Matabele (a tribe founded by Mzilikazi, leader of the Ndebele, who fled from Shaka in the 1820s), who brought his throwing skills to Ardmore after he left Zimbabwe. When asked what he thought of working at Ardmore, he replied, 'Fée has given me freedom.'

Above: Leopard and rhino candlestick sculpted by Obed Mkhize and painted by Zinhle Nene, 2008.

Right: Giraffe dish sculpted by Victor Shabalala and painted by Octavia Buthelezi, 2009. It was taken to America by Pascoe & Company.

Opposite: Crocodile hunt tureen sculpted by Sfiso Mvelase and painted by Rosemary Mazibuko, 2010.

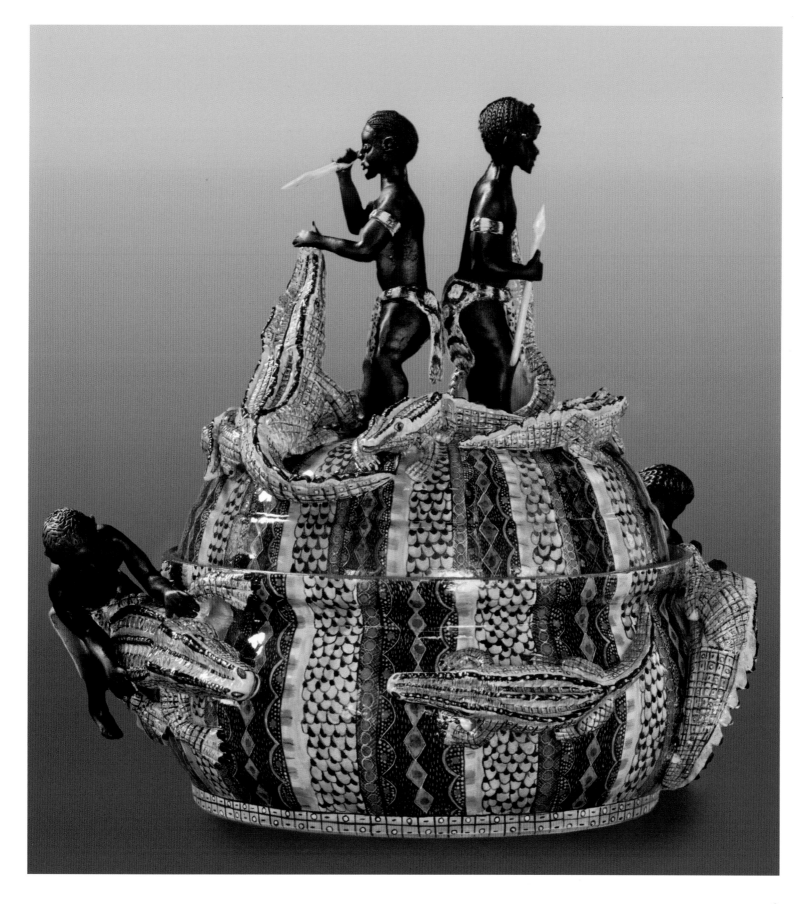

I could not have been born into a more fun-loving and caring family. For the first seven years of my life – before Charles, my baby brother, arrived – I was the youngest in the family, with two elder brothers and a sister. We had a big house in Bulawayo, Zimbabwe (then Rhodesia), and spent our weekends on cattle ranches an hour out of town. My first riding lesson was at the age of three; later on I also learnt to shoot, fish and survive in the bush. My memories are of the huge herds of sable antelope on the vleis at Matetsi, the zebras, the butterfly leaves of the mopani trees, and the fat impala, which we called God's goats because they survived the toughest of droughts.

I was always the 'victim' in the games we played. I was Joan of Arc who was burnt at the stake, the impala that was attacked and drowned by a crocodile, the Indian who was shot by the cowboys. There was no limit to my imagination and, while I often had fun playing these games, my instinct for survival was being fine-tuned at the same time. When we had gang fights, I really only felt confident that we would win when I had Robert, my big, elder brother, on my side. Later he played prop for the national rugby team and I am sure he intimidated many an opponent.

Vivid in my memories is my nanny, Sarah Thaka, who carried me on her back in traditional African style. Sarah showed me every little bug and beetle, the *toktokkies* (tapping beetles), *songololos* (millipedes) and chameleons, as well as spiders, snakes and butterflies. We were often out in the dense bush, where I learnt about all the wild fruits I could eat: sour plums, snot-apples and duiker berries. At an early age I was fascinated with the endless detail and intricacies of nature that Sarah showed me. She was infinitely wise and from her I learnt that 'There's no sorry after death'. It is a maxim I have adhered to all my life.

I had little understanding of the politics of the day beyond remembering coming home from school one afternoon and telling my parents that my friend Jackie Swambela had a boyfriend who was a terrorist. Dad did not dwell on politics although, in retrospect, I think he was very aware of the world around us. He was not a well man, though, and had to wait a long time before having a family. Even so, he was generous, full of humour and a great tease. He also had a great love of horses and encouraged us to ride. He recognised the vitality and excitement of the sport and understood that, while falling off a horse may be a painful experience, it teaches you how to cope with the ups and downs of life. Most importantly, he cherished us and loved life in Zimbabwe.

My dad, Paul Halsted, was born in 1902, shortly after the South African War had ended. His father, Major Charles Halsted, loved to tell the story of reading his own obituary in a Johannesburg newspaper shortly after

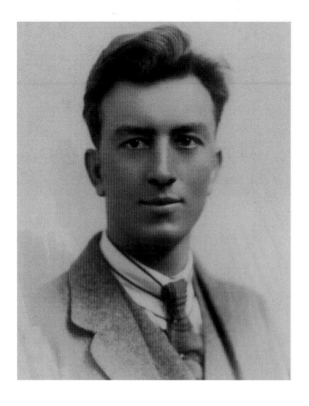

Above: My dad, Paul Halsted.

Below: Dad with me on his lap.

Previous spread: Sculpture of the horse ridden by Prince Dabulamanzi, commander of the Zulu forces that attacked the British at Rorke's Drift in 1879, by Josephine Ghesa, 1990.

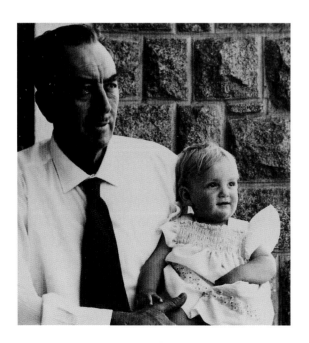

the Jameson Raid in 1896 – despite not having participated in the abortive raid. Charles Halsted was well known to Cecil John Rhodes, who referred to him as 'The Sportsman', because he was a great shot, loved horses and rode well. Rhodes spent six years in the then Southern Rhodesia; in that time he asked my grandfather to design the Bulawayo racecourse, which he did before returning to South Africa. The family of my grandmother Pauline deserves a little space of its own in my narrative. Her mother, Kate Sulley, fell in love with and married the daring and talented James Frederick Cooke, who was the owner of a British travelling equestrian circus.

Founded in the 1700s, the Cooke family circus delighted audiences around the world for almost two centuries. In 1889 the company travelled to Russia and then via Buenos Aires to South Africa, where they entertained audiences for two years before moving on to Sri Lanka (then Ceylon) and India. On their return to South Africa in 1894, my grandfather went to watch one of the company's circus performances in Johannesburg. He was smitten with the beautiful Pauline, who rode horses in her father's circus. When, much later, a family tree was put together, grandmother Pauline's occupation before marriage was stated as equestrienne. If she had been born a century later, I guess she would have taken all the honours open to her in competitive riding.

With his brother, Robert, and his nephew, Eugene, Dad started a company in Bulawayo, Halsted Brothers, which specialised in mining and building supplies. In those days, Zimbabwe was a country with so much potential. It was a net exporter of food and had thriving tobacco, mining and tourism industries. People came from all over the world to see the Victoria Falls and enjoy the beauty and magnificence of the country. Dad was quick to pick up opportunities and he bought a number of farms. He also built a cottage on our farm, Happy Valley, in Harare (then Salisbury), where we stayed when we went to horse shows in the city, as Dad did not like asking his friends to accommodate his large, spirited family.

Dad was a constant presence in my life, taking pleasure in my riding and my early attempts at drawing and painting. He believed that there were many lessons to be learnt outside of school. He would often take me with him when he went to work and I would entertain myself, sometimes shooting house sparrows with a pellet gun in the factory warehouse. Or we would go to Glen Gray, our cattle ranch outside Bulawayo, and I would help him dip cattle. Afterwards I would swim in the reservoir – slime, frogs, water scorpions and all – and dry off while sitting in my white knickers on the spare tyre on the bonnet of our green Landy.

My first art lessons were highly unconventional. My dad's younger sister, aunty Pat, took me with her to her art classes. There I would paint with all the grannies, who showered me with encouragement. When I was a bit

older, a friend of my parents', Terry Donnelly, who worked at the Bulawayo Museum, took me under her wing. She showed me how to look closely at nature, studying the fine veins of a leaf or feather. When I went to school at St Peter's, I found that I loved the art classes. However, the best thing about those years was coming home and riding my ponies. As a child I preferred my own company. The one exception was my school friend Sue Hawthorne who, like me, was a tomboy. She loved riding and we played cowboys, riding bareback whenever we could. Christmas holidays were often spent at my uncle Robert's beach house, which he named 'Kontiki', in Plettenberg Bay. I loved fishing for musselcracker off the Robberg Peninsula with my uncle; it was far preferable to joining the bikini parade on the beach.

My mother, Catja, was level-headed, wise, caring and a wonderful homemaker. She was always immaculately dressed and made sure the entire family was well behaved, neat and tidy. She grew up in the Netherlands during the war years and her life there was difficult. After the war, she worked as a stewardess. It was while on a flight between Amsterdam and New York that she met and fell in love with my father. Under his tutelage she learnt to speak English in a far more masculine way than she would have if she had gone to a school for young ladies. The results sometimes shocked dinner guests. Once, when a bulldog lifted his leg on her skirt at a formal dinner party, Mum, in Eliza Doolittle style, told the dog to 'Bugger off!'

I also remember going to our farm in Matabeleland, Battlefields, where Dad hosted an annual driven francolin and guineafowl shoot. Known as the Governor's Shoot, this event was launched in 1947 and was reputed to be one of the premier bird shoots in the world at the time. Dad used these occasions to entertain his business friends and, from an early age, I was able to identify some very special people among them – those who enrich the lives of others with their generosity, humour, enthusiasm and great spirit of adventure. As my siblings and I grew older, we would also join family and friends for hunting parties on our Matetsi estates. The smells of cartridge shells, gun oil, panting pointers and wet Labradors bring back great memories of those happy days.

During those shoots, Dad sometimes lent me to his friends because my Labrador, Purdie, was such a wonderful retriever. Purdie was probably my first venture into teaching and I loved her to bits. She was so talented and responsive. What a dog! I also remember my determination to teach my younger brother to read. I even resorted to locking him in a cupboard with a book. Needless to say, that was not the way to teach. It was a great life. Then, in 1975, when I was sixteen years old, Dad died.

Dad was a huge part of my life. I still miss the special bond that we shared. He had the ability to make me feel cherished and I would have done anything not to disappoint him. After he died, my eldest brother,

Above: My mum, Catja, soon after she was married. My mother and her mother, Pauline, lived through difficult times and, of necessity, became thrifty. I remember my grandmother making a quilted jacket from scraps of cloth and decorating her hat with ribbons. I, too, avoid waste, always looking for ways to save an artwork by sticking flowers and little animals over the cracks.

Below: Horse bowl sculpted by Bhekithemba Shangase and painted by Angeline Mathebula, 2008.

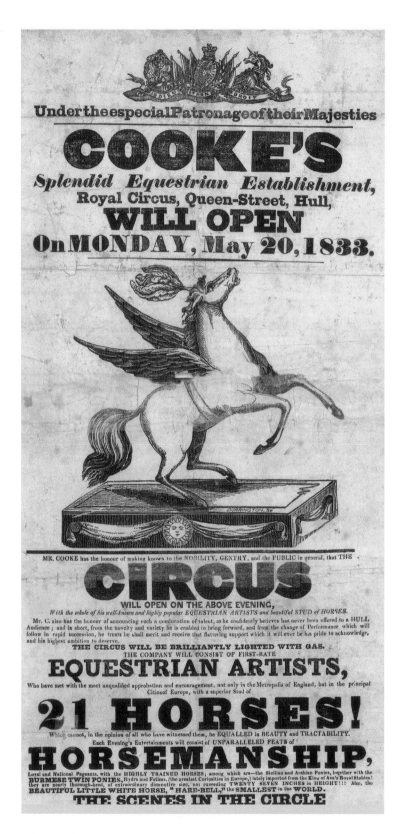

Above: This circus announcement has survived in the family for 179 years. The star performers in 1833 were John Henry Cooke and his nephew, Alfred Cooke.

According to a book by Harry Lumsden, first published in 1936, the Cooke family were 'among the circus aristocracy', a description that may have stemmed from their good looks, grace and talent, as well as a general belief, supported by a renowned genealogist of the time, that the family were descended from the Earls of Leicester. They also enjoyed the patronage of royalty, hence the name 'Cooke's Royal Circus'.

The most famous members of the family in the nineteenth century were Alfred Eugene, my great-great-grandfather, and his brother, John Henry. At that time, the circus was all about horses. The family and their entourage were always on the go, crisscrossing Europe and travelling to other continents around the world. In 1836 the entire circus of 130 performers, including forty members of the Cooke family and a full complement of musicians, grooms and others, sailed to Canada. With them were forty-two horses and fourteen ponies.

Alfred was a versatile performer, brilliant with horses and a successful trapeze artist and clown. He became widely known through a popular song of the day: 'He floats through the air with the greatest of ease, / That daring young man on the flying trapeze.'

Alfred's second son was James Frederick, described as one of the finest bareback riders in Europe. He married my great-grandmother, Kate Sulley, in Ipswich in 1870. He was also an excellent manager and under his guidance, in 1889, the Cooke circus left England for Russia and then Buenos Aires before setting sail for Cape Town. By this time their daughter, Pauline, had her own act riding in the circus ring. After two years in South Africa, the circus sailed to Sri Lanka (then Ceylon) and then India. On their return, they again toured South Africa.

In June 1894, my grandfather, Major Charles Halsted, went to a Cooke's circus performance in Johannesburg and was captivated by the lovely Pauline. Soon after they met, Charles and Pauline left for Zimbabwe (then Rhodesia). They spent only six years there before returning to South Africa. Their son, Paul, born in South Africa in 1902, was my father.

I am quite sure I have inherited the family genes: their daring and love of horses, travel and colour.

MARRIAGES.

COOKE—SULLEY—21st inst., at St. Stephen's Church, Ipswich, by the Rev. G. Stokes, James Frederick Cooke, Equestrian Director, the second son of the late Mr. Alfred Cooke, to Kate, only daughter of Mr. Charles Sulley.

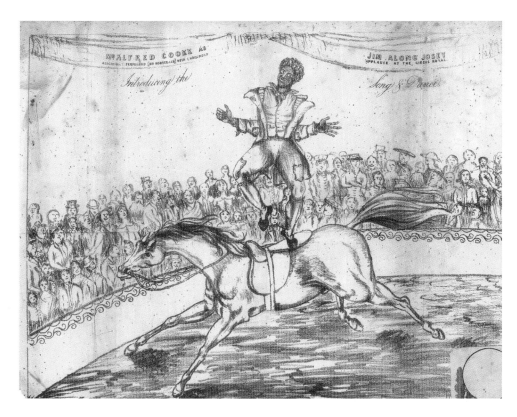

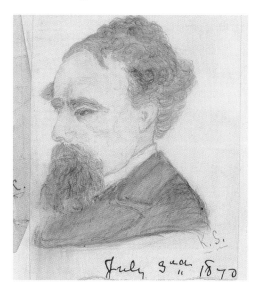

Left: In his younger days, Alfred Cooke, my great-great-grandfather, performed as Jim Along Josey in Cooke's Equestrian Circus. Below: James Frederick Cooke, sketched by Kate Sulley shortly before their marriage.

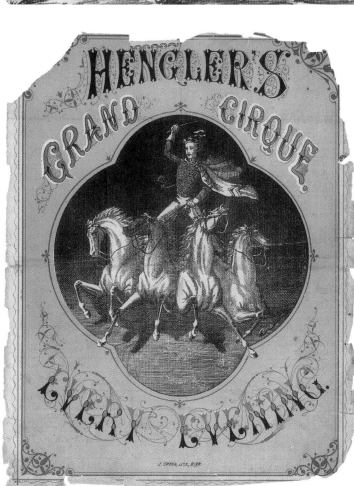

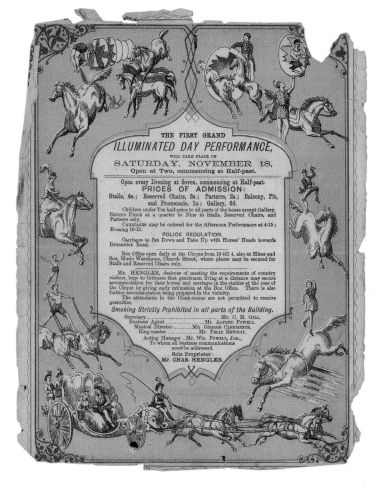

Above left and right: In the nineteenth century the Cooke family performed in America, Europe, Russia, Africa and Asia. This 1876 leaflet, promoting the circus in Plymouth, featured many of the Cooke family, including 'two great riders', John Henry and his son, Leicester Alfred. John Henry Cooke was born in Edinburgh, where he later set up a permanent circus.

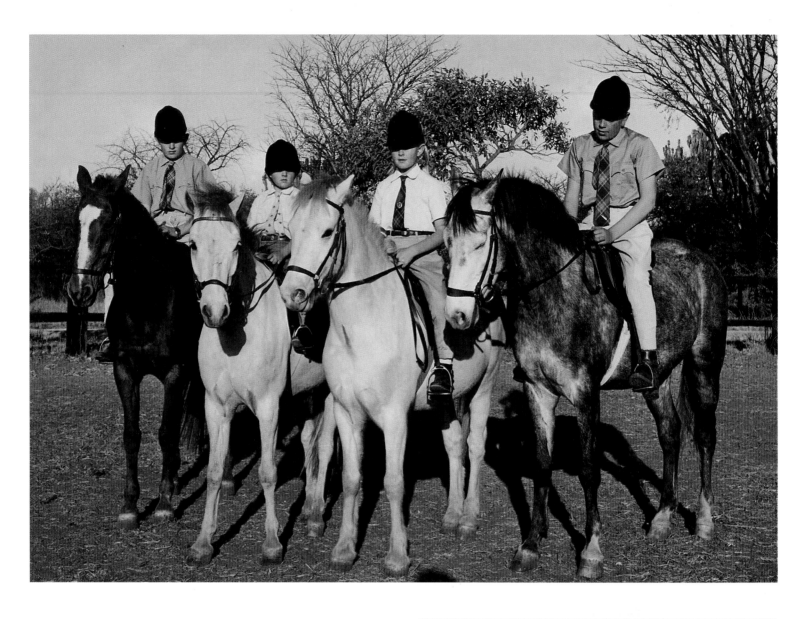

Above: The family on horseback, about 1964, before the arrival of my youngest brother, Charles. From left to right are Paul on Honey Pot, me on Atom, Catja on Prince and Robert on Falcon.

Right: Dad dressed the younger members of the family and the ponies as a circus troupe for a fancy dress at the Bulawayo Ascot Race Course. Here I am riding Atom with my cousin, Craig Halsted.

Robert, inherited the house in Bulawayo and he and his wife chose to make it their home. Mum decided that we would move to the cottage Dad had built on our farm in Harare.

Although it was quite a change for us, we had all spent a lot of time in Harare over the years and had made good friends there. One such friend was Ronnie Lawrence, whom I had met at a horse show after offering him the use of my pony when his went lame. Ronnie gave me a gift in return: after he rode Chiminey that day, my pony lost all fear of water. I subsequently went on to win several cross-country events with him. Ronnie was a talented and daring horseman and it was always fun and exciting to compete against him. He was both a rival and a goal setter. I wanted so much to beat him. I did not want to be ordinary. He became a positive stimulus, not only in my riding career, but throughout my life, always goading me on to aim higher and to stand up for myself in a man's world.

I wrote my matric exams before we set off for Harare. The results, which were released after we had relocated, showed that I had gained a university pass despite the turmoil that preceded the move. Not yet ready to go to university, I persuaded my mother to let me go to Ireland. For six months I worked in Iris Kellett's stables in County Kildare. Iris was a wonderful role model for a young girl like me. Unpretentious, charming, dynamic, successful and wealthy, she had broken into the male-dominated world of show jumping and became the first woman European champion at a time when, because of her gender, she was not eligible to ride in her own country's nationals. Iris owned a superb training establishment, teaching show jumping and dressage. I loved the country, the charm, the whimsy of the people, and their folk tales of fairies and leprechauns. Most of all, I loved the horses. I lived on the outskirts of Naas, in a tack room on the property of my landlady, Mrs Mead. Every day, in the late afternoon, I would walk home from the stables, crossing the property of the Walsh family, now famous for their training school for steeplechasers. Sometimes I would stop over and chat to the lads; they would listen to my stories of lions and elephants in Africa for hours. One of the young men I met there was Ted Walsh, whose son, Ruby, would later become the only jockey in history to win the English, Irish, Scottish and Welsh grand nationals.

At the end of 1976 I came home. Mum had booked me into the University of Natal (now the University of KwaZulu-Natal) in Pietermaritzburg, South Africa, to study fine art. It was quite a shock for me – from mucking about with horses to knuckling down to university life. The first-year students spent their time preparing for Rag and performing as drum majorettes. I hated it all and missed my horses, but the art classes were great. When I went home for the long Christmas vacation, I told my mother I did not want to go back. By this time my friendship with Ronnie had become very special.

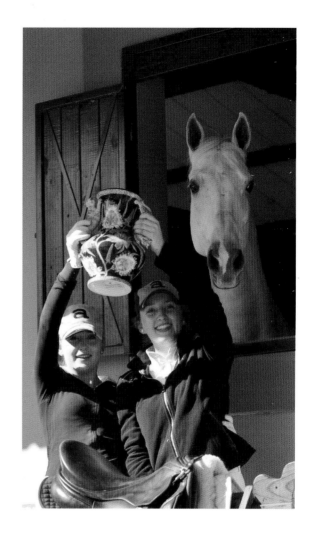

Above: My daughters, Catherine (left) and Megan (right), with Livius, on which Catherine won the South African Junior Individual Dressage Championship three years in a row and Megan the same title in 2011. In 2009 Catherine also won the South African Young Rider Championship on Livius. We acquired Livius in exchange for some Ardmore ceramics. Pots for ponies! He is a real circus horse, always showing off and enjoying performing for a crowd.

We were still teenagers, but we had so much in common. We were both risk takers and passionate about horses. Ronnie had an infectious charisma and together we dreamt of a future without fear of failure. I was given no room for doubt when Ronnie presented me with a diamond ring and told me we were getting married. That was Ronnie: positive and confident and not even asking for my 'yes'. While he correctly guessed what my answer would be, he had not given any thought to how my family would react. Nor had he thought about our age – I was eighteen and he was nineteen – or where and how we were going to live.

Ronnie picked me up and we drove all the way from Harare to Pietermaritzburg to collect my kit. When we got there we did not know where to go next. In the end we drove home. My mother was furious. She gave me no alternative: I would go to commercial college and learn shorthand and typing. At least I would have something to fall back on in the future. I sat with earphones and practised. I hated it but I hated failing more. So I competed with Ronnie and got a certificate that states that I can do shorthand and typing!

I loved Ronnie, but we came to realise that, despite being soul mates, getting married was not an option. We were simply too young. Instead, we became friends for life and he convinced me to go back to university. I told my mum and my brother Robert, who was on the 'committee' deciding my future, that I would go back only if I could take my horses with me. I got my way and returned to Pietermaritzburg with my two horses. I rode every morning before lectures and, because I was happy, I flourished. When I completed my Bachelor of Fine Arts (Honours) degree, majoring in painting, Professor Juliet Armstrong, head of the ceramics department, persuaded me to take a two-year advanced diploma course in ceramics to expand my repertoire of artistic skills.

Studio ceramics was only just beginning to take off in South Africa. Most university art schools followed the English studio pottery style of Michael Cardew and Bernard Leach, who were making simple but elegant functional ware in porcelain and stoneware. Glazing was far more technical than painting and required knowledge of the complex chemistry of highfire glazing. Juliet had only recently taken over the ceramics department and was trying to break free from the more conservative English tradition. The year before, in 1981, she had met American ceramicist David Middlebrook during his six-week lecture tour organised by the Association of Potters in South Africa and invited him to the university. I sat through his lectures and liked his ideas, most notably the concept of taking ceramics from craft into the realm of fine art. I too wanted to defy conventions and be creative. Yes, I wanted to use clay. But as a painter I wanted a shortcut to the complexities of glazing. I was also clear that I wanted Africa to be my inspiration.

Opposite: Artworks in the collection of Ronnie Lawrence include a horse and rider sculpture created by Nkosinathi Mabaso, 2006 (left), and a leopard urn sculpted by Sondelani Ntshalintshali and painted by Roux Gwala, 2007 (middle). *Natal Derby 2001*, **a sculpture of Ronnie with his horse and groom, was created by Petros Gumbi and painted by Wonderboy Nxumalo, 2006.**

Above: Sculpture by Josephine Ghesa, 2001, depicting the Lesotho warrior queen, Nthatisi, who led her army in the early nineteenth century during the wars known as the Difaqane. When her husband died at the age of 27, Nthatisi assumed the role of regent of the baTlokwa tribe on behalf of her young son. Her reputation as a great warrior grew with her success and she became the idol of her people, while neighbouring tribesmen trembled at the mention of her name.

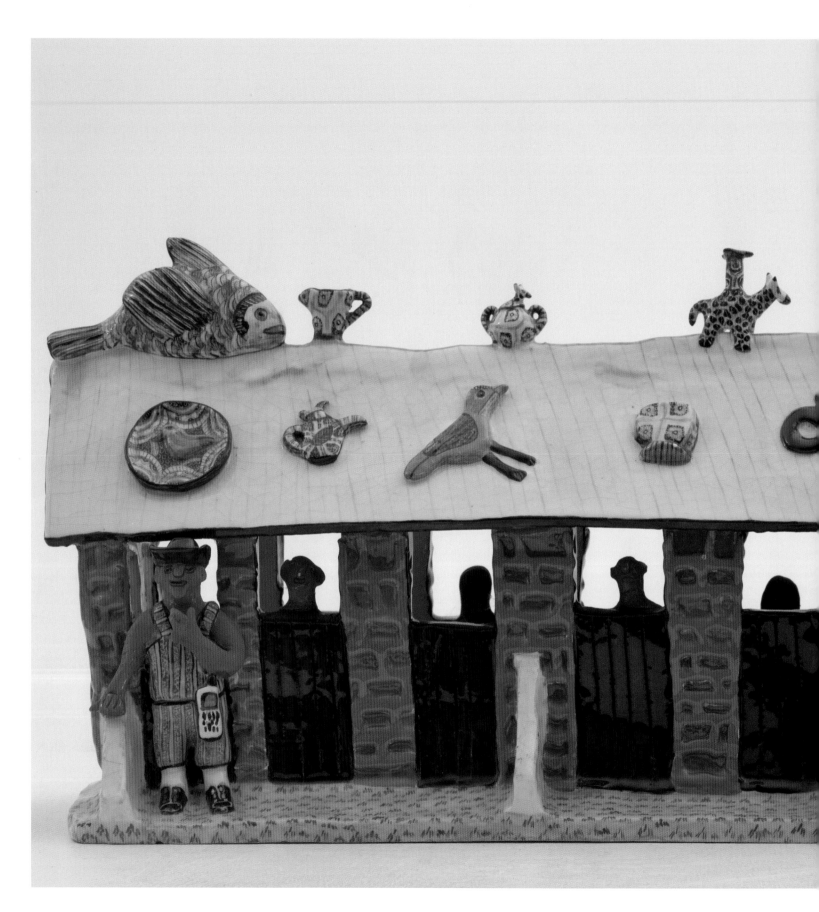

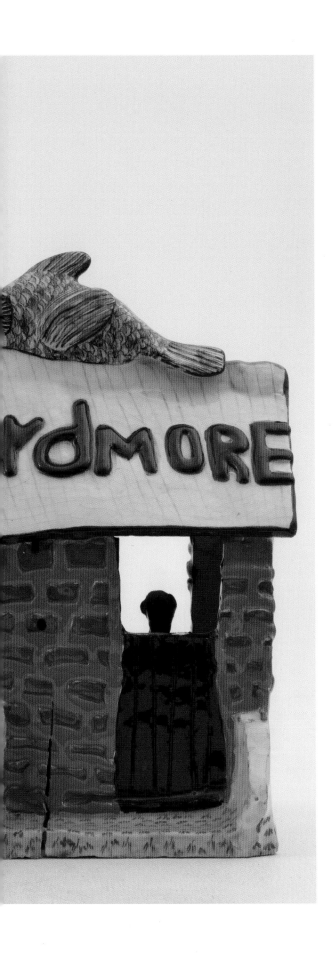

I started a two-year postgraduate course in ceramics at the former University of Natal in 1982 and was looking forward to a new and exciting creative phase in my life. I had little to distract me: my boyfriend, James Berning, had completed his agricultural degree and had taken a year off to visit the United States and Australia before deciding where and what he wanted to farm.

Then, in the course of a morning, my world changed dramatically. It was a summer's day and as hot as it can be in Pietermaritzburg before a storm. Even though I had a nasty cold, I started the day with my usual early morning ride. When I arrived at the ceramics department, I was met by a giant of a man sitting in my chair. American sculptor David Middlebrook, who had visited the faculty the year before, had taken up a year-long teaching position in the department. A former basketball player, he was also an exceptionally talented sculptor. He had a tornado-like energy, and his words that morning made a deep impression on me. 'I've been looking at your work,' he said. 'I want to know more about you. You're the only person here who shows originality, and you're the only one turning to Africa for inspiration. I'm coming home with you and we can talk.'

David showed me how to transfer a painterly style to ceramics. He introduced me to Amaco underglaze paints, which were readily available in the United States but not in South Africa. 'Don't bother with all those confounding glazes,' he told me. 'You don't need to do all this measuring and testing to get a perfect celadon glaze. Use the Amaco paints and stick a transparent glaze over the top. It brings the paint to life.' Rather than spend hours, or even days, creating a single colour by applying glaze science, I now had hundreds of different colours instantly available, all from tubes. His simple solution appealed to my painter's needs and my impatience to see results. He then showed me how to mix a white earthenware clay body that could be fired at a lower temperature than porcelain or stoneware – 1080 degrees celsius as opposed to 1300 degrees. This gave me a white clay 'canvas' on which to work and was essential in order to retain the colour of the Amaco paints.

David turned the ceramics department on its head. Until then, everything had been tightly controlled. Students were not allowed to fire the kilns, or choose their own clay or even the amount they wanted to use. Those were the responsibilities of an assistant, Eric Mtshatsha. Eric would routinely roll clay into tennis-sized balls and present them to the students, but David swept them away and told us that we were not to be spoon-fed. He was adamant that we should mix the clay ourselves and fully explore the material we were handling. Unlike a canvas, he said, clay has three-dimensional capabilities that should be exploited to the full.

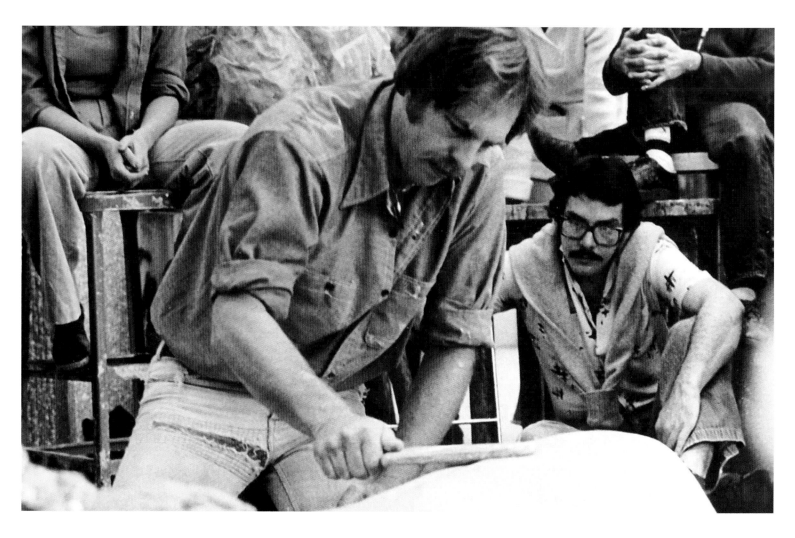

From David Middlebrook:

In 1981 I was invited to do a six-week lecture tour of South African universities. It was an incredible opportunity to see Africa and my whole family loved the experience. The following year I accepted an assignment to spend a year at the then University of Natal in Pietermaritzburg. My son Aron, who was eleven years old at the time, came with me and, once again, we had a fabulous time – largely because of Fée who I met almost as soon as I arrived.

Many times in history all that has been needed to start a revolution is one or two people. I recognised that Fée was the most talented person in my class. She had the potential to lead if not a revolution then a great change of direction in South African ceramics. I saw that Fée was trying to integrate her painting with a new material, clay. What she did was very expressive and I knew immediately that she would go her own way regardless of other influences during her career. I also knew that she would be more than happy to break the rules. She would use clay as a doorway to her soul and try and find a voice within that would help describe her feelings. Hers was the only work I saw that showed a sense of reckless abandon. She did not care if it did not work. She was prepared to fail and try again. She wanted to do things she had never seen. She would not be another follower; she would be original.

I put on three exhibitions that year and decided to take Fée under my wing and make her my assistant. At the same time I would teach her everything I knew. She was a raw power just waiting to have someone push her forwards and I knew that she would not in any way be resentful of me challenging her. She would be welcoming and very open to direction. In fact, I saw her as a woman of the earth who was hungry for guidance.

It was a great year in our lives. We were partners in crime – two souls who found each other at the very right moment in both of our lives. I loved teaching her and we had great fun together.

I am so proud of Fée. She has far exceeded anything I imagined. She is of her moment in time.

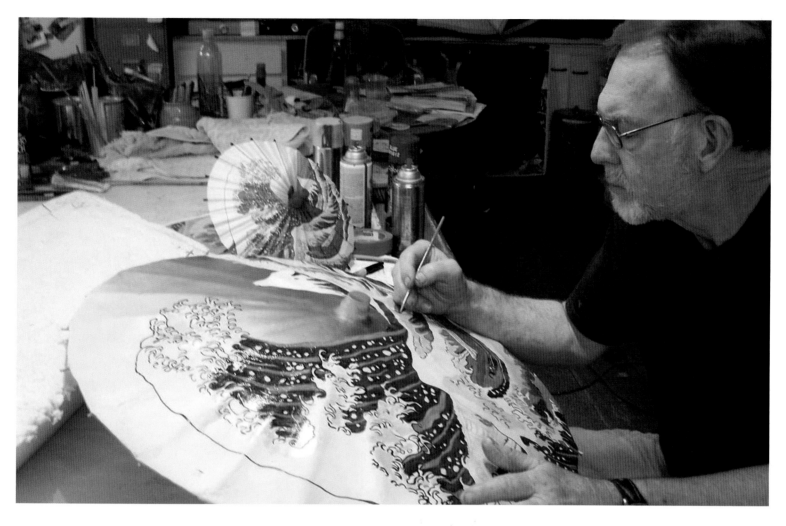

A 'lifetime liberal', David was not prepared to toe the line set by the apartheid government. When filling in a form to register his son at school, next to race he wrote 'human' and next to colour, 'pink'. He was opposed to any form of discrimination and, true to his principles, he sought to have Eric officially recognised as a university department technician. David opened my eyes to barriers – whether colour, race or religion – and enabled me to see the greatness and richness of difference. He made me question what had been accepted in South Africa as the norm.

Even though the most notable feature of clay is its ability to break, in the ceramics department any attempt to repair our creations was considered a sin. The catch phrase was always 'You can't!' We had to throw the broken pieces away and start all over again. David gave me the green light to use glue, putty and fillers. I felt there was no limit to where I could go with my creativity. Watching me one day trying to copy a snakeskin pattern on a tile in a painterly way, he said, 'Just roll the damned skin into the clay; it will give you an immediate skin texture and save you so much work.' Working with David was fun and enlightening. All the clays,

Opposite: David Middlebrook with a group of students on his return to the United States after having spent a year in South Africa in 1982.

Above: In 2010 the Triton Museum of Art in Santa Clara, California, featured twenty-five of David Middlebrook's works, including this parasol made of aluminium and bronze.

Previous spread: As Ardmore grew in popularity, so it grew in size. In 1990 the old grey stone stables on the farm in the scenic Champagne Valley were turned into a ceramic studio to house the artists. It consisted of a small gallery, beyond which were work spaces for the sculptors and painters. This sculpture by Sondelani Ntshalintshali and painted by Mavis Shabalala in 2001 captures both the humble beginnings of the studio and the vibrancy and diversity of the work created there.

Above left: Snakeskin watercolour by Fée Halsted, 1983.

Above right: Detail of a wall plaque, *All Things Bright and Beautiful*, by Fée Halsted, 1985. The work was inspired by Byzantine art, late mediaeval Ethiopian miniatures and Indian miniature paintings.

Right: Snakeskin tile by Fée Halsted, 1983. As an alternative to painting the scales, the actual skin was rolled into the clay and the colours brushed onto the surface. Excess clay and paint were then sanded away.

paints and transparent glazes he introduced me to then are today staples of Ardmore's production process. Without them, it would have been so much harder for me to teach the artists the complexities of glazing. More than anything, David freed me from the creative restrictions placed on students in the ceramics department.

David had broken away from the classic ceramic style and worked with clay as a sculptor would, creating fantastic surreal forms and illusionistic textures that looked like marble, wood and even fur! He loved illusions, and made works that resembled draped fabrics or puddles of water.

He was a passionate collector of African artefacts. We would go to curio shops, looking at headrests, masks and carvings. He opened my eyes to the rich variety of African arts and crafts, which was hugely exciting. These art forms have influenced my ideas ever since. Instead of concentrating on European artists and art traditions, which was the dominant focus at art school at the time, David encouraged an appreciation of all things African.

Before he left South Africa, David was asked to exhibit his ceramics in Cape Town. He offered me a rare opportunity to work as his apprentice on the show. Not only did he teach me his techniques of salt-firing, he also taught me what we never learnt at university: the practicalities of organising and preparing for an exhibition. I got the whole package, from creative direction to packing and crating, from setting up the ceramics to some basic marketing and sales tips. He told me that, no matter what it cost in time and effort, everything had to be as I envisaged. When David arrived at the gallery in Cape Town, he was not happy with the stands. Without any complaint, he rolled up his shirtsleeves, went to the hardware store, bought all that was needed and worked all night, sawing, nailing and painting. By the morning the stands were perfect, with his ceramics displayed to best effect. David showed me that you do not compromise. I was lucky to have learnt from a professional at such an early stage in my development, and to have found someone I could count on, that I could phone any time of the day or night when necessary.

At the end of 1982, David left Pietermaritzburg in the same whirl-wind of activity that had marked his arrival. From South Africa he went to Italy and, at Pietrasanta, where he still sometimes works, he discovered the magic of marble. He went on to make a name for himself as a specialist in large-scale contemporary artworks that weigh anything from twenty-three kilograms to fifty tons. I gained so much from him, not only in the field of art, but in other respects too. I learnt to listen to my inner voice and how to function in the big, wide world as an artist. Most important, David gave me the confidence to believe I could succeed.

Armed with degrees and a diploma, I left university life behind me, but was at a loss as to what to do next. Before I could take a step

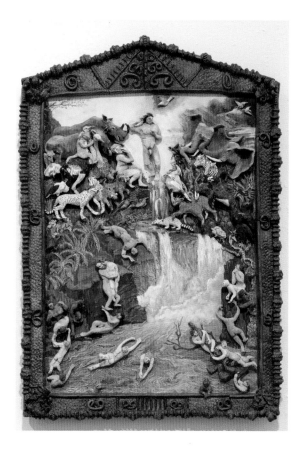

Above: In September 1987 floods washed away the Caversham Mill. This wall sculpture by Fée Halsted, *The Deluge,* was created shortly thereafter. The work is in the collection of the Tatham Art Gallery in Pietermaritzburg.

Above: Snakeskin was used in this artwork, *Expulsion,* by Fée Halsted, commissioned by the Heart and Stroke Foundation, 1988.

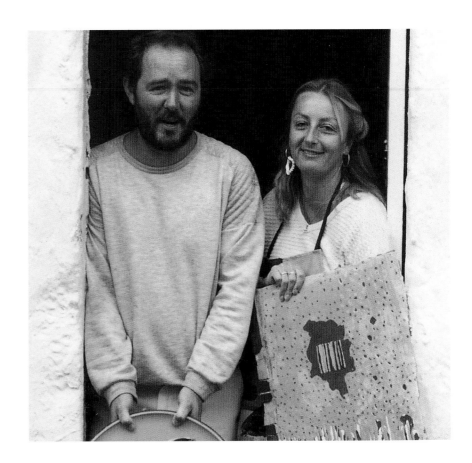

Above left: Phineas Mweli worked in David Walters's pottery studio at the Caversham Mill. He later joined me at Ardmore.

Above right: With David Walters in 1984. David was about to depart for an extended overseas visit, leaving me to my very first responsibility, that of managing his pottery studio at the Caversham Mill. During this time I spent many hours with his father, Taffy. Even though he was nearly eighty years old at the time, Taffy would drive from Howick to check on me and make sure that I was coping with the work. After David's return and my relocation to Durban, Taffy often wrote to me, giving advice and sharing his views on life. He also introduced me to the philosophy of the French writer and playwright, Voltaire. I have kept all his letters. Although he had no knowledge of my grandmother, he sensed my spirit of daring and adventure. In one letter he wrote that he could see me being heralded 'into the circus arena, one foot upon each of her supple, plunging Arabs'.

in any direction, I met David Walters, who had lectured in the ceramics department. David had tried to teach me how to throw clay on a wheel, but I was useless at it. Nearly everything I tried to make ended in the recycle bin. David had established a successful ceramic pottery studio at Caversham Mill near Lidgetton in the KwaZulu-Natal Midlands. He was planning an extended overseas trip to explore the possibility of working in the United Kingdom and, much to my surprise, he asked if I would take care of his studio while he was away. It was a wonderful opportunity for me to have studio space to do my own work and to learn what it takes for a ceramicist to earn a living. I was also fortunate that Phineas Mweli was on David's staff. Like Eric Mtshatsha, Phineas was experienced in preparing clay, packing kilns, glazing and many other studio tasks.

David really understood the foundation on which any small business rests. His wonderful sense of family made him a generous and caring man. He had a flair for occasions, and taught me how to host exhibitions. He held regular craft fairs, and invited other crafters to participate. Later, I was included in this select group. His fairs always had a happy energy and people enjoyed his hospitality. The fairs were the forerunner of today's Midlands Meander, the arts, crafts and food route that he co-founded and which has become a major attraction in KwaZulu-Natal.

Just before David returned from England, another man came into my life: Andries 'Boet' Botha. He and David had become good friends while at university. Boet had gone on to lecture in the sculpture department at Technikon Natal in Durban. One day, out of the blue, he arrived at Caversham to tell me that he wanted me to apply for a teaching post at the same institution. My application was successful and when David returned I was ready to move. James Berning, who had started farming at Ardmore, a small farm in the foothills of the Drakensberg that his family had bought, suggested that I move into a little *khaya* (home) in the backyard of his sister's home in Durban. It was within walking distance of the technikon and the rent was cheap. At the weekends I would drive up to Ardmore, frequently with Boet. He and James had great fun playing rugby with the local team. Boet would also bring students with him and run workshops. We all became firm friends and developed a camaraderie that attracted an array of artists, many of whom later became well known in the art world.

I loved teaching and really felt that I had found my vocation. I had anticipated being given a permanent post, but at the end of my first six months of teaching, to my consternation, the technikon authorities took a decision to retrench all temporary female staff. I was devastated. I had become a victim of a system that used discrimination and not intelligence or ability as a measure. Since then, I have always hated decisions taken on any grounds other than plain and straight ability and truth.

I did not know what to do. Should I go home to Zimbabwe, a country that was in the grip of a war? Should I look for another job, which would be difficult to find in such a specialised field as ceramics? Then James suggested that I move to his farm. Perhaps I could make things there, he said. We both agreed that he was doing me a favour. It was also clear that the move would not be a prelude to marriage as neither of us was ready for such a commitment. Farming at Ardmore was not easy. The weather at the foot of the great Drakensberg escarpment was not conducive to crops, and cattle theft was rife. Yet James, determined to make a go of it, tried his hand at everything: cattle, dairy, even tomatoes. Before he arrived, Ardmore had been, in turn, a stud farm and a guest farm, with the latter probably the most profitable option. All things considered, I knew that if I was going to live at Ardmore, I had to earn a living.

As soon as I had unpacked my belongings, I got down to work. The two Davids in my life had shown me the way. Now I had the opportunity to use my skills and talents. I wanted to show the people who had retrenched me just how wrong they were. I would take the local people, who knew nothing about ceramics, and I would teach them. I was determined to rise to the challenge. Perhaps I was foolhardy, but I was intent on succeeding. To start, I needed a student. I approached the woman who worked in our home,

Above: Bonnie Ntshalintshali had many qualities that made her special. She had a wonderful character and was naturally disciplined and steady. She listened to my advice and took criticism without animosity. In the fifteen years that we worked together, Bonnie and I had cultivated a trust in, and respect for, each other's creative instincts.

Below: Bonnie's well-known Plaka-painted sunbird, 1998.

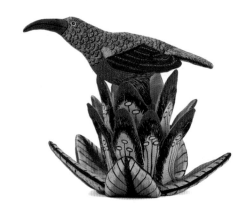

Top and opposite bottom: These small sculptures, showing an elephant and a crocodile carrying presents, were sculpted and painted by Bonnie Ntshalintshali for a Christmas sale in 1991.

Above: Petros Gumbi's miniature replica of Bonnie Ntshalintshali's sculpture of a crocodile, snake and zebra, 2008. This miniature was created for the reopening of the Bonnie Ntshalintshali Museum at Caversham in 2008. The original, made in 1987, is in the collection of the Iziko South African National Gallery in Cape Town.

Opposite top: Working in the old studio on Ardmore farm in the mid-1990s are (from left) Octavia Mazibuko, Cecilia Dlamini and Paulina Hadebe.

Janet Ntshalintshali. She suggested that I meet her daughter, Bonakele, who had contracted polio as a child. Bonnie, as we called her, worked as a tomato picker on the farm but, with her deformed foot, found it difficult to perform physical labour. When I met this charming, unassuming young woman, I knew without hesitation that I wanted to work with her. I immediately set about employing her as an apprentice.

About a year later, James's mother, Min Berning, brought her brother, John Glenton, and his American wife, Louise, to the farm. Like Bonnie, John was a polio victim and suffered from ill health. I found Louise a great companion and fun to be with. She has been a most kind and sympathetic friend. She fell in love with Ardmore and from the start saw its potential. After guiding her around the studio, I took her outside to show her my other pride and joy, my horse. I broke a cardinal rule. I walked behind him, which gave him a fright, and he lashed out. Two broken arms and several bruises left me pretty useless. As always, my family stepped in to help. Mum arrived from Zimbabwe, and a few days later we were on our way to set up an exhibition at the Helen de Leeuw Gallery in Hyde Park Corner, Johannesburg. One way or another, we managed.

It was an eventful week – two broken arms, a successful show, and then James produced a diamond ring that his mother, who had inherited it from an aunt, had given him. She thought it high time that James made 'an honest woman' of me. Poor guy! At the end of the year I went home to spend Christmas with my family, and there I decided that it was not the best way to start a lifelong relationship. On my return to Ardmore I told James that I did not want to pressure him into a marriage. A few weeks later, though, my fate was sealed. Our son, Jonathan, was on his way.

We had a small country wedding at my family home, Happy Valley, in Harare in March 1987. Three months later, in June, I mounted another exhibition at Helen de Leeuw's showroom in Johannesburg and, despite my advancing pregnancy, everything went like clockwork.

Jonathan was born on 7 September 1987 and I had everything a young woman could dream of. I loved my husband. He was young, handsome, independent and very special. I had my baby son, and Bonnie and I were selling well. Bonnie was a gifted artist and I felt privileged to work with her and bring out her potential. Once she mastered the technical aspects and gained more confidence, nothing could stop her from forging her own creative path.

We worked closely together for four years before we were joined by two of Bonnie's school friends, Punch Shabalala and her sister, Mavis. Their mother, Lefina, had also worked in our home at Ardmore. Like Bonnie's mother, Lefina thought that her daughters should be given the opportunity to learn from me. When Bonnie started out, she made little

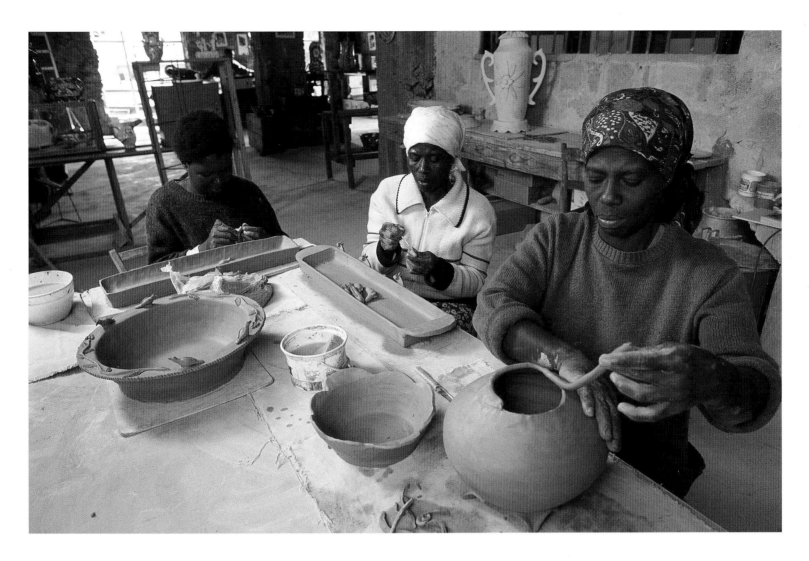

Above: Punch Shabalala, 1986.

Below: We created little ducks that were sold for R2 each. These were our bread and butter.

Opposite top: We moved into this old stone stable on Ardmore farm in 1989.

Opposite bottom: Plate made by Mavis Shabalala and painted by Punch Shabalala, 1990 (left), and a moulded bowl made by Paulina Hadebe and painted by Osolo Ntshalintshali, 1992 (right).

birds, animals and flowers, which she then decorated with Plaka water-based paints. When Punch and Mavis arrived, I decided that they should make something completely different. They started producing functional ware – egg cups, espresso cups, jugs and vases – and I brought in the Amaco underglaze paints that David Middlebrook had introduced me to as a student. With Punch and Mavis steaming ahead with the creation of saleable items, Bonnie and I had time to concentrate on the more complex art pieces that would become Ardmore's signature.

Once again I was fortunate. Punch, in particular, developed a terrific painterly style, expertly blending flowers, insects, birds and animals into an exotic tapestry of colour. Her painted works are reminiscent of the densely patterned designs of Persian carpets. Punch has become the most prolific winner of Ardmore's Triple A Award for Excellence. Apart from being truly talented, she is passionate, diligent and determined to do her absolute best. She is intensely loyal and has a deep integrity. These qualities have given her the necessary strength to face adversity and overcome truly dire circumstances. They have also been harnessed to help and teach others. As a result, she has become Ardmore's most respected and loved artist.

Mavis was determined to follow her older sister Punch's example. Through sheer dedication and perseverance she developed rich, complex designs that resemble Zulu beading and basket work. It is a style that has been copied by many other painters at Ardmore. If I compare the works of the two sisters, Mavis's style is looser and more African in origin, whereas Punch's reveals a distinct Eastern influence.

As the demand for our ceramics increased, I started to teach other young women. Two of Bonnie's friends joined us early in 1989. Phumelele Nene showed an aptitude for drawing and painting, while Paulina Hadebe learnt to coil and model clay. They were followed by two wonderful, motherly women. Elizabeth Ngubeni and Beatrice Nyembe both enjoyed working with clay – hand-coiling their forms. Elizabeth's work was particularly feminine and radiated excellence. Beatrice, on the other hand, produced bold, functional pieces. Both women were passionate about their creativity and became good friends as they worked and talked together. The next artist to join us was Beauty Ntshalintshali. She was a builder and sculptor, creating hand-coiled teapots, tureens and large-sized bowls that frequently featured animal heads. She formed a wonderfully creative partnership with Bonnie, her sister-in-law, who painted nearly all Beauty's work in the 1990s.

We soon outgrew the small cottage and decided to move into the old stone stable, which we had converted into a rough-and-ready studio. We named it after the farm – the Ardmore Ceramic Art Studio, 'Ardmore' being a Gaelic name that arrived with farmers from Scotland in the nineteenth century. It means a 'high place'.

I really thought my life was complete. By mid-1989 my son, Jonathan, was starting to talk and I was carrying my second child. I had my beloved horses on the farm and I was doing what I loved most: teaching and being creative. The artists knew each other well; they were friends, sisters or cousins and had much in common. We would often sit outside in the winter sunshine or in the shade of the trees in summer, working, talking and laughing together. There were no precedents for the work we were doing and, one after another, new designs started to emerge. It was an exciting and happy time for all of us.

My life was a roller-coaster adventure as the Ardmore name started to spread. Because we used paint and glue, the ceramic purists excluded us from exhibitions. It did not matter. My Dutch dressage trainer, Peter Perlee, had told me, 'If you can't go in the front door, go in the back.' This is exactly what we did. We found another door to enter the world of fine art. Our work was accepted for the 1985 and 1988 Cape Town triennials, I won the Corona del Mar Young Artist Award in 1987, and Bonnie won the Corobrik National Ceramic Award in 1988. As our work became more widely known, invitations to exhibit our ceramics followed one after another.

One day, between watching over my young son, running my home, and teaching and guiding my small group, I took an unexpected phone call. Professor Alan Crump from the Department of Fine Arts at the University of the Witwatersrand asked if he could visit Ardmore later that week. I had no idea why he was coming. With so much to do, the few days passed quickly. Before I knew it, Alan Crump arrived along with Dr Marion Arnold. Together they broke the news: Bonnie Ntshalintshali and I were the joint winners of the prestigious Standard Bank Young Artist Award. We would have a year in which to prepare for an exhibition that would be shown at the Grahamstown National Arts Festival the following year, in June 1990. Thereafter the exhibition would tour the country.

My visitors left me in a state somewhere between shock and utter bewilderment. The judges had broken with tradition. Not only had the Standard Bank Young Artist Award never been given to a ceramicist, but it had never been awarded to a black artist, nor had it ever been granted to two people working collaboratively. The judges had decided that, although our work was so different, the close creative bond between us as well as our reliance on each other's technical and creative influences were motivation enough for awarding a joint prize. Looking back, I think that we happened to be in the right place at the right time. We were, in effect, a forecast of the future. I felt a bit like Johnny Clegg, the so-called 'white Zulu', who formed a partnership with Zulu musician Sipho Mchunu. Together, they entranced the world with their song and dance performances.

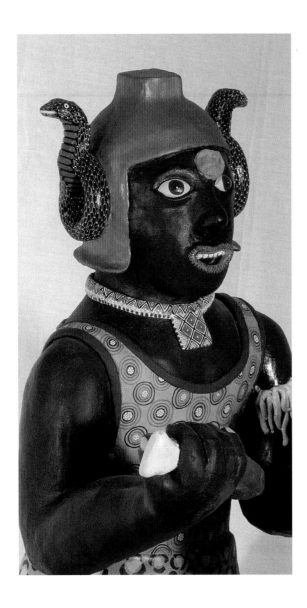

Above: Detail of Bonnie Ntshalintshali's *David and Goliath*, showing Goliath with the stone shot from David's sling in his forehead, 1990.

Opposite: Always meticulous in her approach to work, Bonnie Ntshalintshali used colour plates from a bird guide book as reference to paint these artworks.

Previous spread: This detail of Bonnie Ntshalintshali's *Lobolo* tableau illustrates the captivating naivety of her art, 1988. The work is in the collection of the Tatham Art Gallery in Pietermaritzburg.

Alan's visit was hugely exciting and emotional, but it was what he told us that made the biggest impression on me. 'Believe me, Fée,' he said, 'your life will never be the same again.' Alan was right. He was a visionary and made a huge contribution to South African art. He was always a great help to me and remained a confidant and mentor until his death in 2009.

In South Africa change was in the air. We knew that the country's state president, P.W. Botha, who had suffered a stroke in January 1989, would have to resign. Most South Africans believed that when the next president took office, a new era would dawn. But few thought it would happen so quickly. In August 1989, F.W. de Klerk was sworn in as acting state president; eight weeks later, Walter Sisulu and seven other political prisoners were released. Then, in February of the following year, Nelson Mandela was released from prison. The apartheid years were at an end. Looking back, I realise that teaching the rural Zulu people and helping them discover their own artistic talents was exactly the right initiative at the right time.

Bonnie and I had a busy time ahead of us. We had to prepare for the National Arts Festival exhibition in Grahamstown and would not be earning any income. In effect, we would have stock on the shelves but no money in the bank. However, the young artists making functional ware would take care of that problem. They would make all the little ducks, espresso cups and egg cups that sold so readily. The news that we had won the award was published in magazines and newspapers and was repeated on radio and by word of mouth. As a result, people flocked to Ardmore to see what we were doing and to buy our little pieces. We were focused and having fun. More than that, we knew where we were going. Yet, little did I know that we were laying the foundation of the Ardmore brand and that I had put my foot on the first rung of a ladder that would eventually carry Ardmore's name all over the world. There was no stepping down.

In the middle of the following year, 1990, we set off for Grahamstown, with James driving the cattle lorry filled with crates containing our exhibition pieces. Mum came from Zimbabwe with her cook, Peter. Also travelling with us were Bonnie and my aunty Pat, my father's sister who had taken me to painting lessons when I was a child. On top of that I had Jonathan, now at an age when young boys find trouble without looking for it, and Catherine, my tiny baby who was less than two months old and let us know, in no uncertain terms, that she hated being in the confined space of the car. We planned to overnight in Aliwal North on our way to Grahamstown. Although we had made reservations at a guesthouse, when we got there the owners refused to accommodate Peter and Bonnie. Apartheid was still alive and kicking. I was so angry. It did not matter to them who Bonnie was or what she had achieved, or that Peter had lived with my parents for over thirty years and was part of the family. They were black and they were not

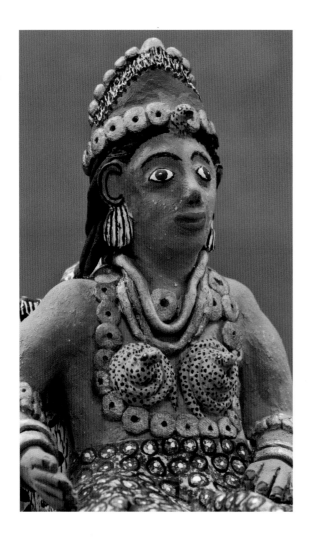

welcome. We hunted around and found a wonderful Afrikaans couple who ran a hotel in the town's main street. They were more than happy to house Peter and Bonnie and were most kind and warm-hearted.

When we got to Grahamstown, we stayed in a school dormitory. It was freezing, but we all coped – even Catherine, who was constantly fussed over by her grandmother and great-aunt. James's mum and dad, Min and John Berning, as well as Louise Glenton and Terry Donnelly, my first art teacher, also came to give their support. Andries 'Boet' Botha flew in to lend a hand. He and James started on drilling holes in the wall to hang my heavy murals. In their enthusiasm, they drilled right through the wall into the ladies' toilet! To celebrate their achievement, James and Boet downed tools and started playing touch rugby in the exhibition hall. Adding to the chaos was Jonathan, riding up and down on a black plastic scooter that Mum had bought for him. Miraculously, nothing broke and the show was a great success. When the exhibition closed, James returned home – not with an empty truck, but with a load of goats for a neighbour. That was our life, giving and receiving help from friends and fellow farmers.

We were all excited by the interest shown in our ceramics and keen to get home and back to work. There was so much we wanted to do and it seemed that there was never enough time.

Above: Detail of a tableau of Herod Antipas and his wife, Herodias, whose daughter, Salome, so delighted Herod with her dancing that he promised to grant her 'whatsoever she would ask'. Instructed by her mother, whose marriage to Herod, her former husband's brother, was criticised by John the Baptist, Salome asked for the head of John on a platter. This work by Bonnie Ntshalintshali, created in 1992, is free from outside influences and shows a freedom of expression that is highly original. She makes us aware of the evil intentions of the queen by giving her a bra of green mambas.

Right: A miniature vase of flowers and leaves created by Bonnie Ntshalintshali for the tableau of Herod Antipas and his wife, Herodias, 1992.

Opposite: Detail of a sculpture of Jonah and the whale created by Bonnie Ntshalintshali, 1989.

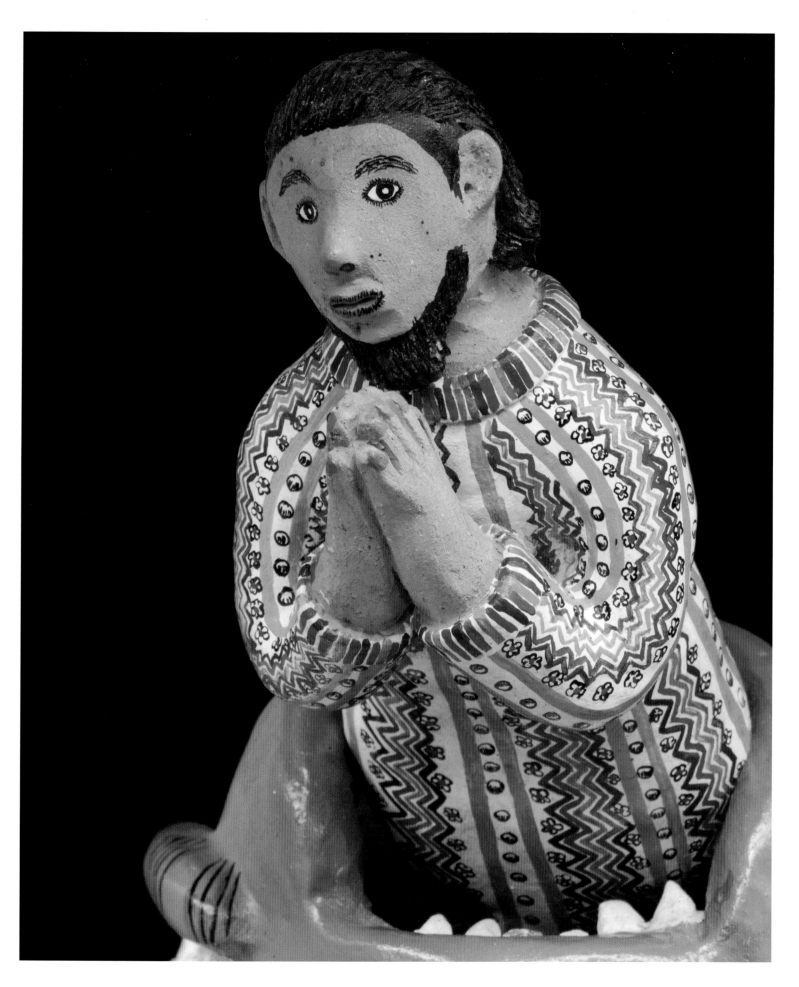

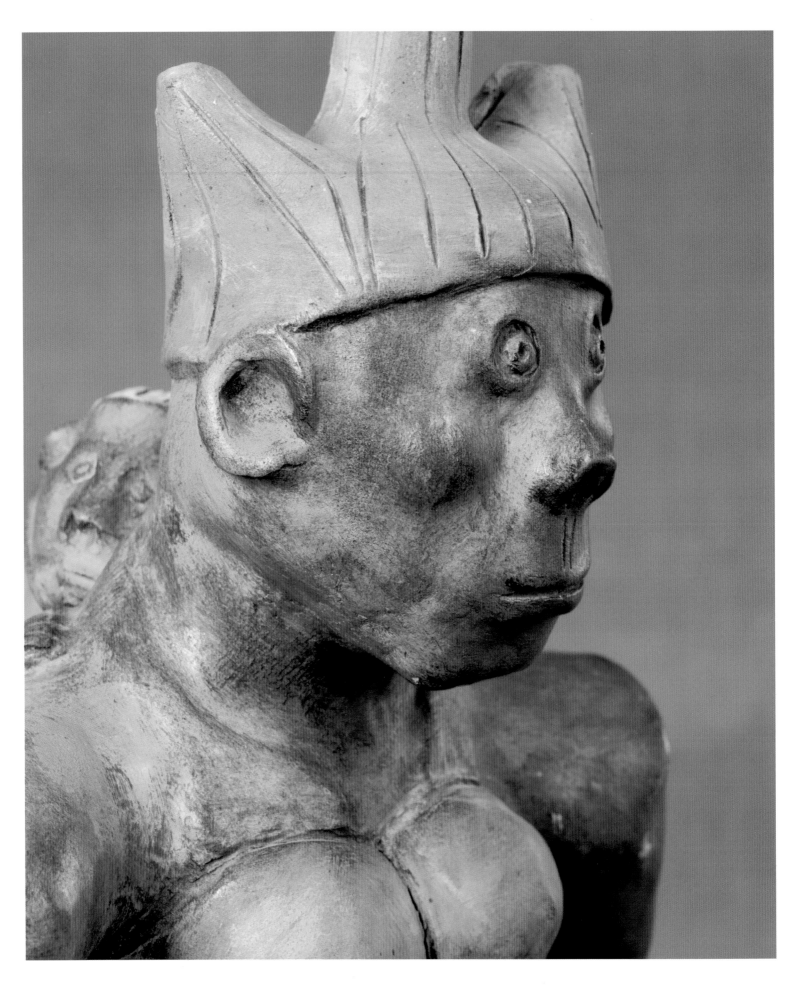

ate one afternoon in 1990, when we were still working in the thatched cottage at Ardmore, we saw a young woman in the driveway with a baby on her back. The artists gathered there that day spoke to her and discovered that she had walked down the mountains from Lesotho in search of work. Her name was Josephine Ghesa and she had nothing with her besides a blanket, which was used to strap the baby to her back. In true Zulu style, Bonnie and her cousins rallied around her, showing her where she could wash herself and her baby. We gave her nappies, clothes and food.

I learnt that her grandmother had taught her to make clay vessels. Bonnie, who preferred to make small doll-like figures, taught Josephine to hand-coil large forms and I showed her some wooden sculptures made by a Zimbabwean, Zepharia Tshuma. Within a short time, Josephine started producing large mythical figures unlike anything I had ever seen.

She was a true sculptor. She modelled terracotta clay into strong, primeval figures that might have been inspired by the myths and legends her grandmother told her as a child. After her sculptures came out of the kiln, she would not finish them, nor would she mend broken pieces. At first we tried to paint her figures with Plaka poster paint, but I realised that the intense decoration destroyed the power and form of her work. It was then that I took on the job of finishing her figures with boot polish and oil paint, which gave the work a wood-like effect.

Josephine had a strong, gutsy spirit and no inhibitions whatsoever. She would laugh at the girls who used an apron or plastic wrapping from a loaf of bread to cover the genitals of a male figure. Josephine would often go to the other extreme, exaggerating a man's penis until, for example, it wound around his buttocks. She was not prim and proper, and when the first male artists started arriving at Ardmore, she, unlike the Zulu women, would sit and work with them. Although I recognised and admired her sculptural ability to the extent that I hated parting with her figures, I had no idea that they would one day catch the attention of the art world.

Her works were radically different from anything else produced at Ardmore. I placed her unsold figures outside the studio in our vegetable garden and on our gateposts. I felt no urgency or desire to sell them. Quite the opposite: I felt a need to keep them close to me. One day, Josephine's work caught the eye of Ned Smith and Nina Wilke, who were on a visit to Africa from the United States to collect traditional Sotho art and artefacts. They admired the primitive strength inherent in Josephine's work and offered to hold an exhibition of her sculptures in San Diego, California. Unexpectedly, Josephine had walked back over the mountains to Lesotho to visit her family and we had no idea when she would return. So, in search

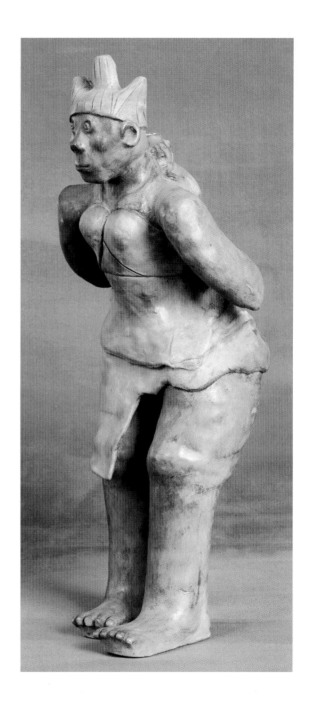

Opposite and above: Sotho artist Josephine Ghesa's self-portrait of her arrival at Ardmore, with her baby tied to her back in traditional African style, 1990. This work is in the collection of the Tatham Art Gallery in Pietermaritzburg.

Above and opposite: Because Josephine Ghesa would have nothing to do with her sculptures after they came out of the kiln, we started to paint them with Plaka paint. I soon realised that her forms were too powerful for busy decoration and that her unique, atavistic pieces needed a far simpler treatment. The solution lay in boot polish and oil paint, which I used to complete her artworks. They immediately gave her pieces life and warmth. In 1996, when I moved to Rosetta, Moses Nqubuka continued where I had left off, leaving me to put only the slightest of finishing touches to each piece. I learnt much later that none of Josephine's works had been signed, as this is a job left to the painter.

Right: From time to time Josephine Ghesa would visit her home in Lesotho. One day, giving no advance warning, she left for Johannesburg, where she decided to settle.

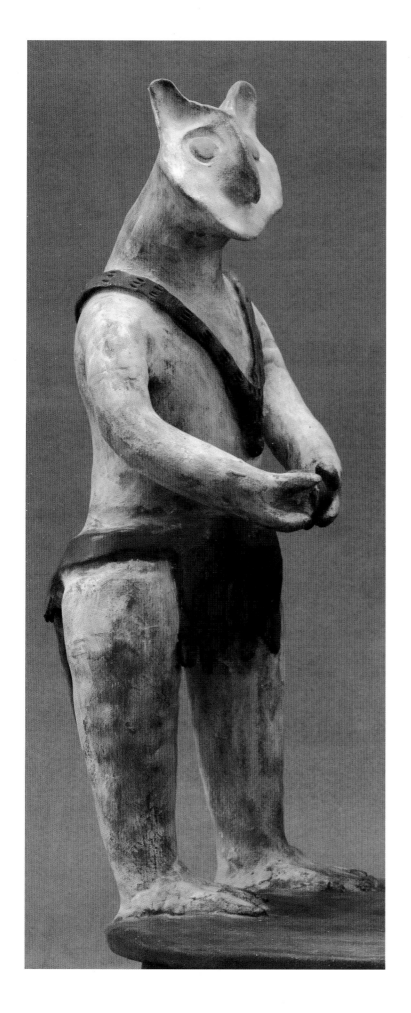

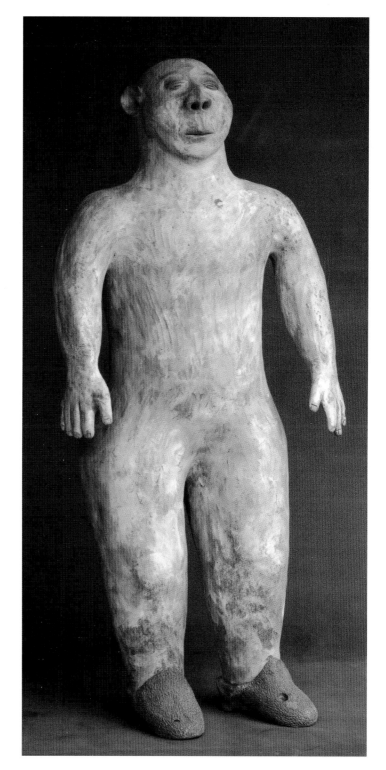

These three works, boot polished and painted, were created by Josephine Ghesa between 1993 and 1995, and are on display in the Bonnie Ntshalintshali Museum at Ardmore Caversham. On the opposite page is a sculpture of three half-animal, half-human figures; even their hands have been sculpted with the faces of strange beasts. The owl man (left) is another striking mythological creation. A figure with weathered shoes (above) was moved to the museum from the gallery at Springvale, where it stood in the rain and sunshine at the entrance for seven years.

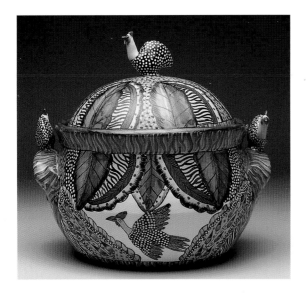

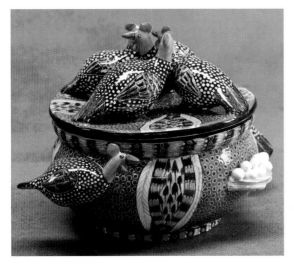

Top: Guineafowl tureen created by Phineas Mweli and painted by Punch Shabalala, 1992.

Above: Guineafowl tureen created in memory of Phineas Mweli by Lovemore Sithole and painted by Punch Shabalala, 2009.

Opposite top: Members of my team in 1992 included (back, from left) Nhlanhla Nsundwane, Phineas Mweli, Beatrice Nyembe and Paulina Hadebe, and (front, from left) Mavis Shabalala, Matrinah Nsundwane and Josephine Ghesa.

Opposite bottom: Crocodile tureen made and painted by Phumelele Nene, 1991. The work is in the collection of the Tatham Art Gallery in Pietermaritzburg.

of works for the San Diego show, I collected Josephine's pieces from the garden and the gateposts, mended them and finished them off with boot polish and paint before shipping them to the United States. Later, we were delighted to learn that the exhibition had been a success.

In 1991, Wilma Cruise, a top South African ceramicist, included Josephine's work in a book she wrote entitled *Contemporary Ceramics in South Africa*. Two years later Wilma asked if she could include Josephine's work in the exhibition *Earthworks/Claybodies*, which was to be held at the Pretoria Art Museum. Josephine repeated her disappearing act and, once again, we had to make do with what we had. The exhibition attracted a great deal of attention and Wilma described Josephine's work as 'part animal and part human and challenging the boundaries of ceramics'. She added that they 'tap an atavistic cord that leaves a strong sense of discomfort, as if one has witnessed a taboo'.

In the wake of Josephine's arrival, and at more or less the same time that Bonnie and I had started preparing for the Grahamstown exhibition, I once again crossed paths with Phineas Mweli, with whom I had worked at David Walters's studio in 1984. Three years later, in 1987, when a devastating flood destroyed David's Caversham Mill studio, he decided to leave South Africa for England. The property was sold to an English bookbinder who employed Phineas as a gardener. On a visit to South Africa in 1989, David suggested that I employ Phineas. 'Fée, it's such a waste. This man could be of so much use to you,' he said. I agreed.

No sooner had Phineas arrived than I asked if he would like to try his hand at throwing, suggesting that he could use the wheel that Josephine had won in a Corobrik competition and which was gathering dust in our storeroom. Phineas accepted my invitation. Out came the wheel, the cobwebs were dusted off, and within a short time he was throwing mugs, cups, saucers, vases, tureens – items that became our mainstay in those early years. He was a wonderful asset to Ardmore. Not only did he turn out basic forms, but he would also sculpt little bird and animal heads on coffee cups. His miniature guineafowl, like those he had made at Caversham Mill, became his trademark, appearing on platters, dishes and egg cups.

Phineas was followed by Nhlanhla Nsundwane and Wonderboy Nxumalo. Both men had discovered their creative spirit as children and could not have been happier when they found that they could earn a living through art. In their early years they did not make big waves at Ardmore. But, after a little trial and error, they found their own styles and became exceptional artists, ushering in a new phase in Ardmore's development.

Nhlanhla is a man whose life is anchored in his rural upbringing and the pride he has in his people. He contracted polio when he was a child and, like Bonnie, was left physically handicapped but with a huge

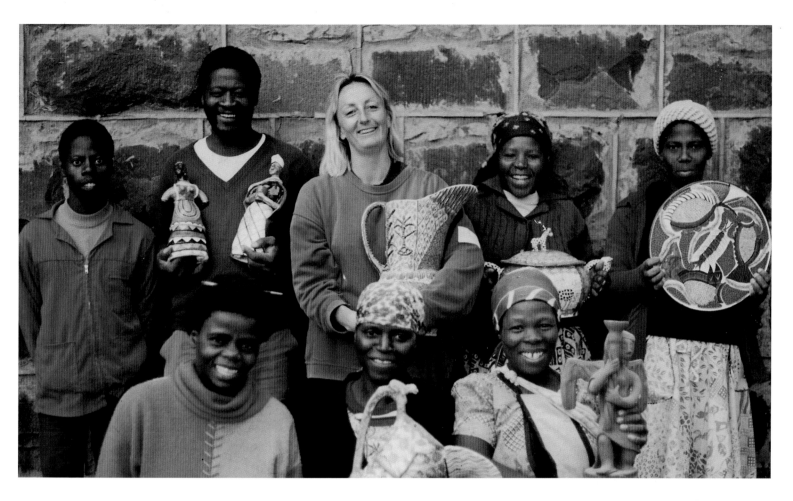

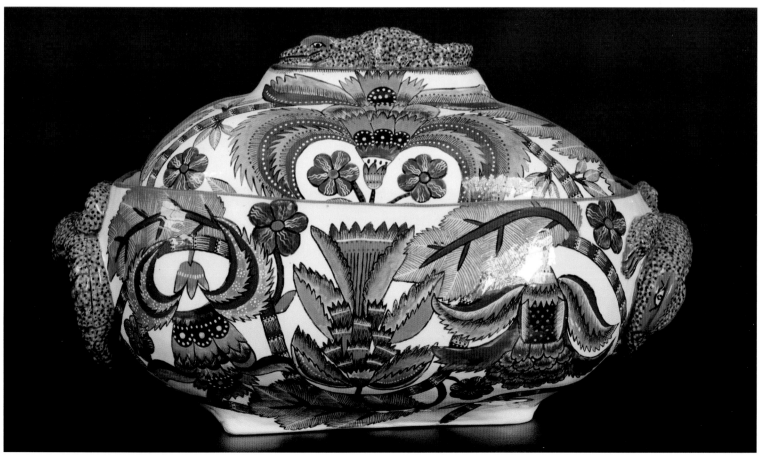

During the 1990s, my young children – my son, Jonathan, and my two daughters, Catherine and Megan – started to take greater notice of the world around them, and the Ardmore studio in particular. They would follow me into the studio and watch me and the others work. They were loved by all the artists.

Left and opposite bottom: Inspired by Staffordshire figurines and the comings and goings of my little family, Nhlanhla Nsundwane sculpted several family portraits of us, with grooms, dogs and horses. The series, painted by Punch Shabalala, included a figurine of me bare-breasted on Windsor Forever, with my dog, Lily (left); me on my horse, Magic, with Amos, our groom, and Rosie, our whippet (opposite, bottom left); and Catherine on Coco with Amos and Rosie, and, hidden from the camera, Meg on her pony, Halfpenny (opposite, bottom middle).

Below: Megan, Catherine and Jonathan playing with Rosie the whippet and Simon the daxie outside the studio at Ardmore in 1994.

Opposite top: Taking care of Megan in the midst of a photographic shoot with Doreen Hemp. On display are three interlinked figures that illustrate the relationships and tensions in my life. Sitting astride a Brahman (left), I depict myself as a hyena and provider to many.

Opposite, bottom right: Megan, at three years old, watches from the door of the old stone studio on Ardmore farm.

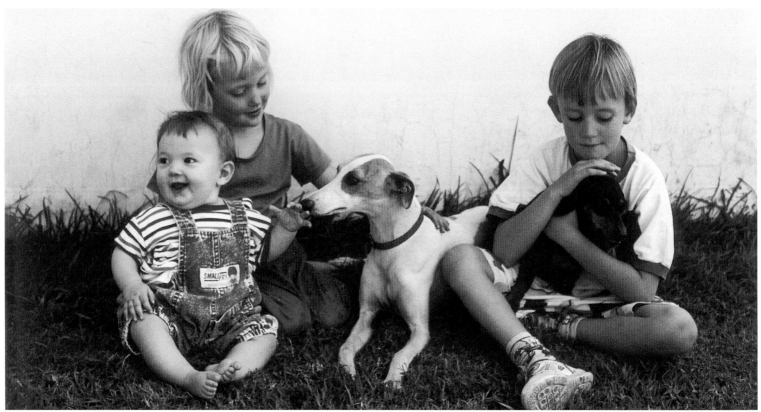

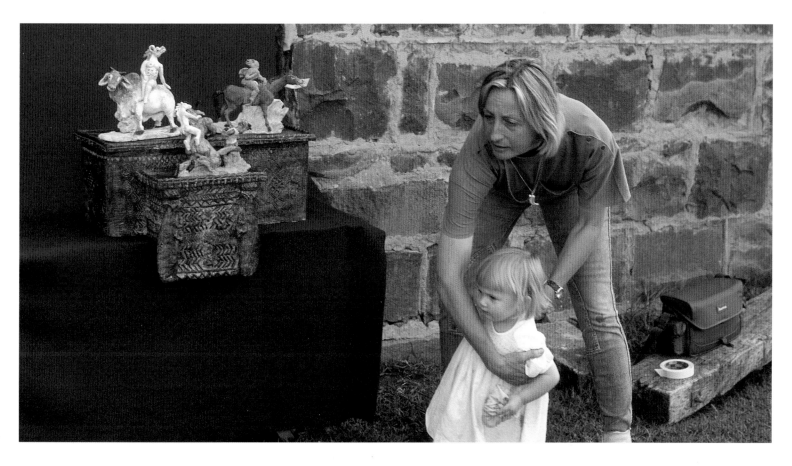

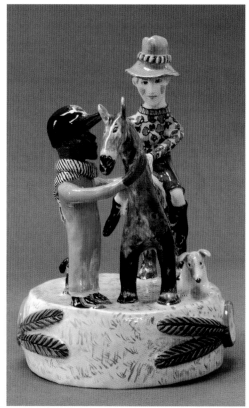

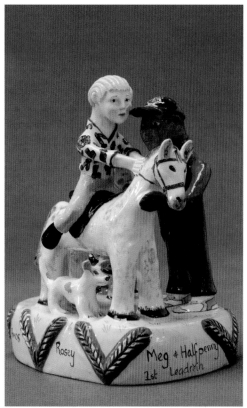

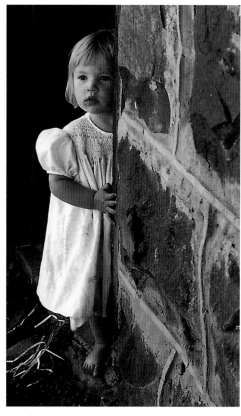

Above: Nhlanhla Nsundwane, 2008.

Below: Nhlanhla Nsundwane introduced human figures in his artworks, beginning with this vase painted by his wife, Matrinah, in 1990. 'Nhlanhla' means 'good fortune'. Despite many hardships in his life, Nhlanhla's real fortune lay in the discovery of his extraordinary talent.

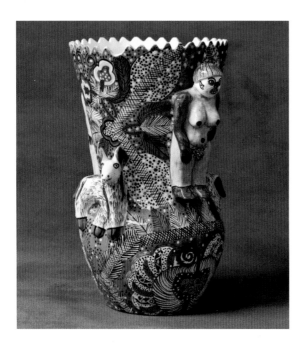

talent for sculpting. Despite a superstitious mother, who destroyed his work, he continued creating figures in secret. Nhlanhla was able to spend only one year at school due to a lack of family support. Then, in 1992, after a difficult early life, Nhlanhla, together with his wife, Matrinah, found a home at Ardmore. While still alive, Matrinah painted all Nhlanhla's sculptures. Their special relationship ended tragically in 1994 when Matrinah was fatally struck by lightning while in their little thatched house. Electric storms in the Drakensberg are spectacular but sadly are a major cause of death.

Nhlanhla found his true vocation as an artist when he started focusing on the human figure in his work. He takes his inspiration from a world he knows intimately: traditional Zulu life in all its simplicity. It is as though he wants to capture forever a way of life that, to him, is filled with far more happiness and pleasure than the modern world could ever offer.

One day, as his works stood lined up in the studio, waiting for someone to paint them, I noticed how good they looked without colour. I decided that they could either remain unpainted or be partially decorated. These more restrained works have received critical acclaim and some are on display in the Bonnie Ntshalintshali Museum at Caversham.

When Nhlanhla was still at Ardmore Champagne, his foot started to give him trouble. I bought him a horse so that he could ride to work rather than walk the ten kilometres down the mountain. Unfortunately, the horse got stolen. Despite the pain, he was reluctant to have his foot amputated. At one stage his friends tied him to a tree because he was totally out of control from the pain. That was when I decided to bring him to stay at Caversham, where I had been living since 2005. This meant that he could be close to the studio and receive proper medical care for his foot. Soon after he arrived, Lovemore Sithole, who had witnessed the effects of gangrene during the Zimbabwean war, took Nhlanhla under his wing and persuaded him to have his foot amputated. Lovemore took him to hospital and helped him when he had his prosthesis fitted. Nhlanhla also learnt that Ardmore would continue to provide him with an income until he was better. This was a turning point in his life.

Nhlanhla is a very spiritual man and, along with Punch Shabalala, has become an elder at Ardmore. He shows his kindness to others in teaching the many recruits he introduces to the studio. At one stage he told us that he had received a calling to train as a sangoma. When he got back to Ardmore, this man of remarkable integrity admitted that he did not have sufficient power within him to practise as a sangoma. He said he could not 'see' who had stolen his neighbour's cattle, and so he returned to continue making sculptures.

The next man to join Ardmore was Wonderboy Nxumalo. During his school years in Greytown, KwaZulu-Natal, he discovered a creative talent,

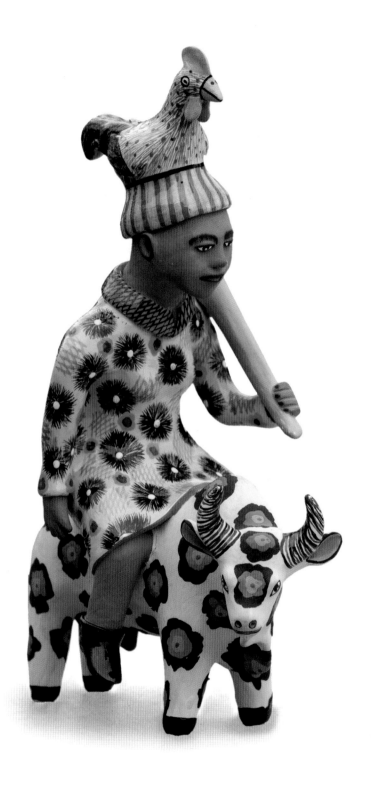

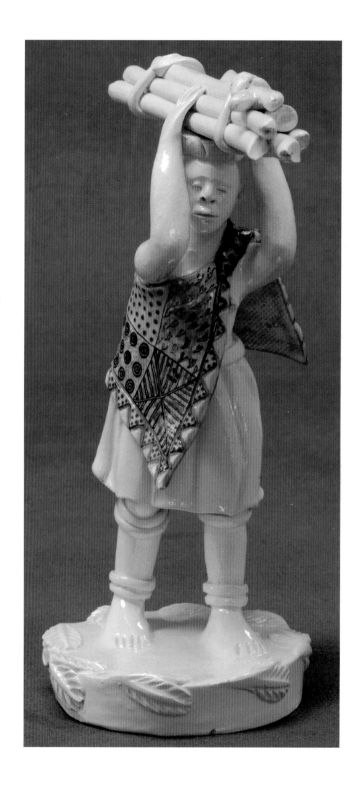

Above left: An early work sculpted by Nhlanhla Nsundwane and painted by Mirriam Ngubeni shows a woman on the back of an ox, 1996. It is in the collection of Ronnie Kasrils.

Above right: Sculpture of a young woman carrying firewood created by Nhlanhla Nsundwane and painted by Wonderboy Nxumalo, 2008.

Above and opposite: Nhlanhla Nsundwane's work is filled with integrity and is an expression of the world as he knows it. His sculpture of a young Zulu hunter with his knobkerries and a dog closing in on a small antelope (above) was painted by Wonderboy Nxumalo, 2008. In the sculpture of young men hoeing a maize field (opposite top), created in 2008, the field is inscribed with Wonderboy's words: 'We must go back to our culture and eat healthy food. We have to catch back life. Then survive.' The sculpture depicting a young man ploughing with oxen (opposite bottom) was painted by Mickey Chonco, 2009.

spending his free time drawing, painting, writing verse and reading comics, which he described as 'art in action'. At the age of twenty, this gentle, soft-spoken man was introduced to Ardmore by his mother's employer, Pam Royden Turner, who brought him to the studio in March 1994.

Wonderboy started out emulating the women – painting decorative flowers, birds and animals. But when I looked at his sketchbooks, I saw a depth and potential that needed to be uncovered. His drawings were full of action and exclamations created in a comic-strip style. I suggested that he should incorporate these into his ceramic painting style. I also showed him the lino prints by Namibian artist John Muafangejo, who used a combination of writing and sketches in his work. This was the starting point for the development of a scratched, scrafitto technique that Wonderboy used to incorporate verse into his designs. His passion for perfection, his artistic skill and his love of verse started to show in all his work. I also suggested that he should use less colour – two or three primary colours at the most – and in a short amount of time he had found his own unique style. The simplicity and elegance of his painting matched the truth of his writing. I encouraged him to continue, even with the misspelling of English words, which added charm and sincerity to his messages. Through his painting, Wonderboy became a storyteller, commenting on social problems and history as well as creating inspiring messages of love.

A true artist, Wonderboy was always special. He could work only when he felt like it; it was not money that motivated him. He loved his art. He looked for perfection, and each piece that he produced seemed like a part of his soul. He also painted functional pieces, still applying only a small selection of colours and adding the short messages that became his signature. He started off using greys, blacks, earthy tones and hints of orange. Later on, he added bright blue and aquamarine. Wonderboy's works were bought by a select group of people who invariably became compulsive collectors of his art. Even after his death in 2008, his works continued to attract a loyal following.

Despite its ups and downs, the decade was one of fun, of learning and of laying the foundation for Ardmore's entry onto the world stage.

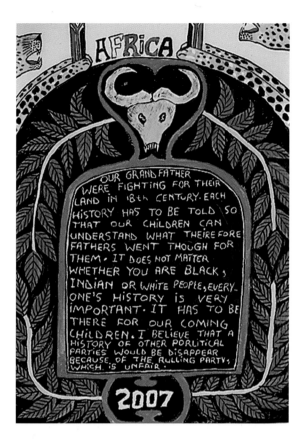

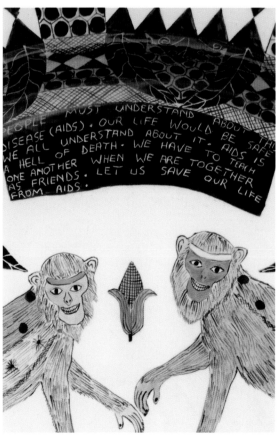

Opposite: Wonderboy Nxumalo holds a plate that depicts Queen Victoria's power over the captured King Cetshwayo, represented by the diminutive figure to the right of the queen. Wonderboy has clad the king in the colours of the new South African flag, as if to say that the tables have been turned.

Right: Wonderboy developed his own unique style by combining painting and writing, 2007.

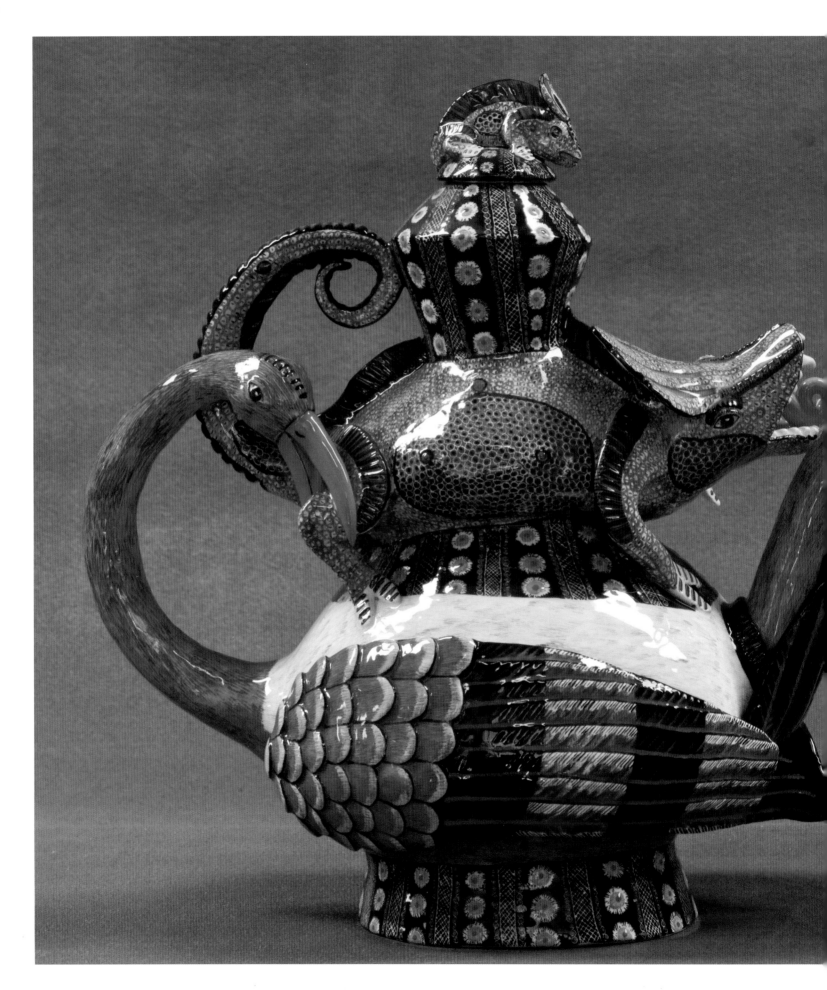

T he six years I had spent at university taught me a lot about drawing, painting and history of art. But I learnt nothing about business. Words like profit margins, marketing and branding did not feature in my vocabulary. Even though I had no business training, I had a creative instinct and knew that I had to start at the beginning – with the simplest and easiest things. Not least, I would have to be willing to make mistakes and take them in my stride.

What I had learnt through people I had met in Zimbabwe, Ireland and South Africa was that friends can make all the difference. My father was a great host at the big Zimbabwean bird shoots. David Walters was equally hospitable at his country craft fairs. What they had in common was that they gave of themselves. When I started Ardmore, I made friends with many people and was always open and honest about the product I was selling. If there were cracks, I said so. If I felt the price tag was too high, I changed it. Increasingly, Ardmore gathered friends who were both kind and understanding and were willing to share their knowledge and lend us a helping hand. Ardmore would not be where it is today without friends who have given of themselves in so many ways, all without thought of reward.

Alan Crump did far more than simply warn me that my life was about to change when Bonnie and I won the Standard Bank Young Artist Award. He also advised me to get out into the marketplace and not tie myself exclusively to one gallery. I was to make my own running. I took his advice to heart, relying on my gut and intuition, but was always prepared to ask for business advice from the experts.

We walked a financial tightrope in those early years. Ardmore shouldered the responsibility of paying the artists as they completed each piece, even if their works were going to be held back for months prior to a show. I believed that paying the artists on completion of their pieces was important. Not only did it liberate them from material responsibilities and demands, but it also gave them freedom and space to explore their own creative spirit and inner strengths. My job was to get the show on the road, and then to make sure that people loved our creations.

Min and John Berning were always hugely supportive, as were Min's brother, John Glenton, and his wife, Louise. Louise invited us to Johannesburg to participate in a Christmas fair that she and John held around the swimming pool at their home in Federation Road in the suburb of Parktown, famous for the spectacular homes built by the gold-mining magnates of the early twentieth century. We felt we had arrived in the heart of the 'mink and manure belt'. People loved our ceramics and they bought everything we had, making our first showing in Johannesburg an instant success. The next year, one of James's aunts, Jane, and her husband,

Top: Eleanor Kasrils helped bring international recognition to Ardmore.

Above: With Eleanor's aid, we held a major exhibition at the Presidential Guest House on the Bryntirion Estate in Pretoria in 1997.

Opposite: Giraffe and flower vase thrown by Elias Lulanga, sculpted by Petros Gumbi and painted by Punch Shabalala, 2004.

Previous spread: Bird and chameleon coffee pot sculpted by Somandla Ntshalintshali and painted by Jabu Nene, 2008. The work is in the collection of Mark and Brenda Ilbury.

Gavin Relly, followed suit with an exhibition at their Johannesburg home, Melrose House, giving us another opportunity to display our work to the wealthy Johannesburg set. Another of James's aunts, Rilda, who lived with her husband, Basil Hone, in New Jersey, had heard about our work from their daughter, Lynn. Rilda suggested that we exhibit in the United States. Through Rilda and Basil's generosity, we were able to showcase Ardmore to American society. We even had a piece bought by the Newark Museum in New Jersey. More than ten years later, in 2008, the Hones and their large social network ensured the success of our first exhibition at the Amaridian Gallery in New York.

Soon after our shows in Johannesburg, I met Eleanor Kasrils through Juliet Armstrong, my former ceramics professor at the then University of Natal. Eleanor had bought an Ardmore platter in Johannesburg and was immediately interested in our story. She asked Juliet, who was a friend of her father's, Jimmy Logan, to arrange a visit to Ardmore. I was somewhat surprised that the men who came with Eleanor never got out of their car and looked askance at me when I invited them in for coffee. I thought I had lost some of my people skills. After they left, it dawned on me that they were Eleanor's bodyguards. She was, after all, the wife of the then deputy minister of defence, Ronnie Kasrils!

At that first meeting I did not know that I had found a dear friend who would mentor and guide my own development in the new South Africa. She made Ardmore her special 'baby' and took great pride in all we did, understanding that we were not just selling ceramics but that each piece carried its own story, which was best told by its creator. In 1996, while preparing for an exhibition at her home, Meklenburg, on the Groote Schuur Estate in Cape Town, Eleanor suggested that Moses Nqubuka, Mavis Shabalala and Bonnie Ntshalintshali join me at the event. She understood their needs and showed me how to give the artists so much more than technical skills. I never stopped learning from Eleanor. Her humility was truly humbling. She always supported and promoted others, creating opportunities for people to excel. It was a sad day for me when she died in November 2009.

Eleanor grew up in Durban and, after the Sharpeville massacre in 1960, joined the Congress of Democrats. She was passionate about the need to build a new South Africa free of racial and sexual discrimination. Eleanor was arrested in 1963 but, with great daring and bravery, escaped from custody and went into exile with Ronnie Kasrils, whom she married the following year. Eleanor worked for the African National Congress in Tanzania and Britain and for its former president, Oliver Tambo. Throughout this time she never lost her cheerfulness, honesty and infectious humour.

Eleanor, whose mother had died of cancer just prior to the exhibition, asked if we would donate a portion of our proceeds to the Cancer

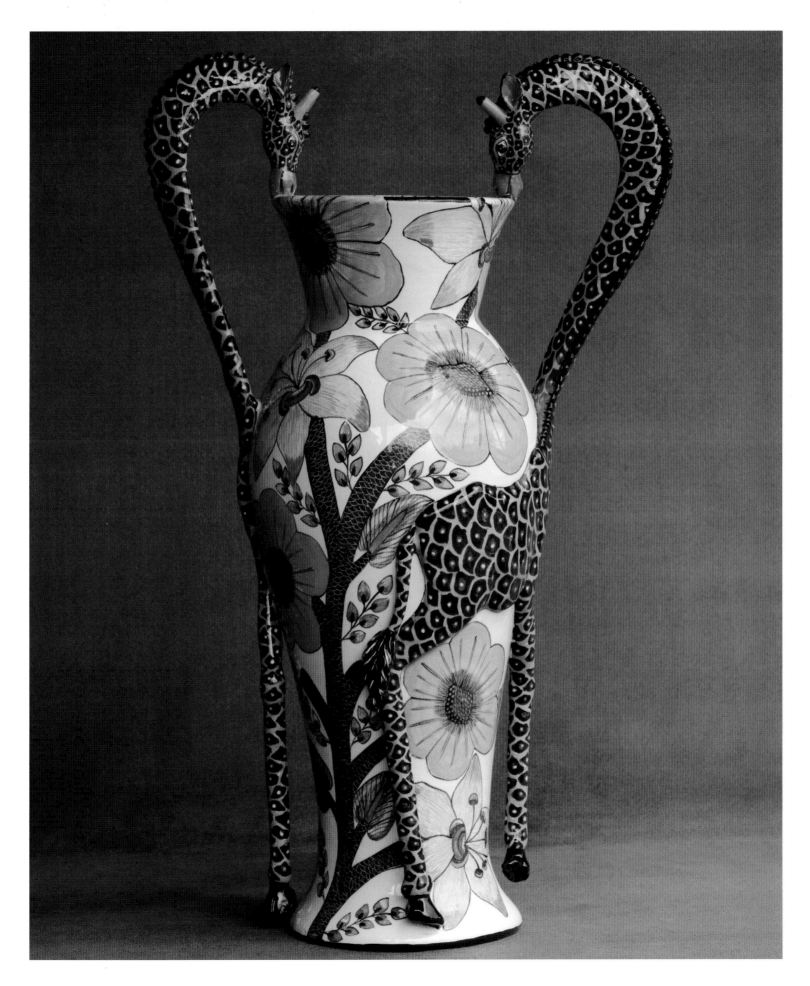

Association of South Africa. This was the start of Ardmore's fundraising efforts for other needy organisations. From then on – until we had so many pressing needs of our own – we gave ceramics to many charitable institutions, which they could auction to raise funds. After Meklenburg, Eleanor organised an even bigger show at the Presidential Guest House at Bryntirion Estate in Pretoria in 1997. The event, with 400 pieces on display, was opened by South Africa's first lady of the time, Mrs Zanele Mbeki. It was a sellout. We made R42 000 in sales and were thrilled. Through Eleanor we met many influential people, one of whom was Dr Lindiwe Mabuza, then a senior member of the government's erstwhile Foreign Affairs Department.

Lindiwe is another extraordinary woman: imaginative, sensitive, far-seeing, a poet, and a true patron of the arts. Over the years she has selected the best South African artists, singers, dancers, musicians and storytellers to showcase to the world. On a visit to Ardmore, she invited us to Bonn, where she had taken up residence as the South African Ambassador to the Federal Republic of Germany in 1995. She wanted to 'show us off' and asked us to make her 800 pieces for an exhibition to be held in August 1998. At first I said yes, but then realised that it would be impossible. I quickly corrected myself and told her we might manage half that number. We did.

We worked flat out from January to August. All the ceramics were sent ahead and arrived in Bonn the day before the exhibition opened. When we arrived at the ambassador's residence, we found that Eleanor, who had come to Germany to help us, had already unpacked the entire collection and had laid the pieces out in the dining room. The room was so bright and colourful that it reminded me of the Dolmabahçe Palace on the Bosphorus in Istanbul. In contrast, Eleanor was black from the newsprint we had used for packing – unlike the luxurious white tissue paper and Ardmore-designed boxes that we use today.

Above: Detail of a flower and bird jug sculpted and intensely decorated by Mavis Shabalala with a bead- and basket-like pattern that she originated at Ardmore, 1995.

Right: Flower teapot sculpted by Beatrice Nyembe and painted by Punch Shabalala, 1999.

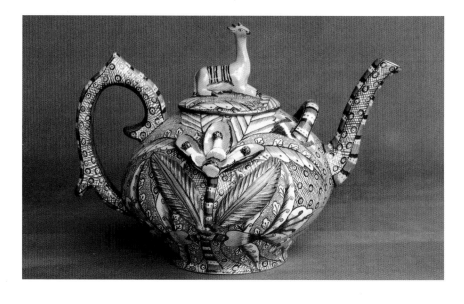

As excited as I was, I had no idea what was about to hit us. Lindiwe and I were two innocents walking into disaster. I had been thoroughly spoilt and had become reliant on my friends and family to do all the spadework necessary to hold an exhibition. I was unaware just what it takes to organise a successful show. The next day I found out. Only two women came to see the exhibition. Each bought an egg cup. That was the sum total of our sales. I burst into tears. Imagine working solidly for eight months, transporting pieces halfway across the world, and selling only two small items.

I had to dry my tears quickly. Feeling sorry for myself was not the answer. I needed help and turned to Eleanor, who saved the day. She called friends in Düsseldorf and they offered to hold an exhibition, but only in November. Lindiwe, too, had been busy. She arranged for us to go to Marl, a coal-mining town in the Ruhr region. We were told we could exhibit our pieces in the foyer of the concert hall where a performance was being held the next night, only to discover that the star of the concert was Yehudi Menuhin, the world's leading violinist. There was not a seat to be had.

We realised that we had been given a marvellous opportunity. Lindiwe's driver helped us create display boxes and cover the grey walls with bright South African flags. At the interval, the audience, all lovers of art and culture, viewed our exhibition. They had never before seen anything like our ceramics and just loved them. And they bought. Soon after that I had to get back to South Africa, leaving Moses Nqubuka on his own in Germany. He was thrown straight in at the deep end, but managed successfully to stage two other exhibitions, in Essen and Siegen respectively, on his own.

Three months later I returned to Germany with another load of ceramics for the exhibition in Düsseldorf. This time the marketing job had been handled by professionals, the invitations had gone out, and computers, posters and brochures were all waiting for me. During the exhibition,

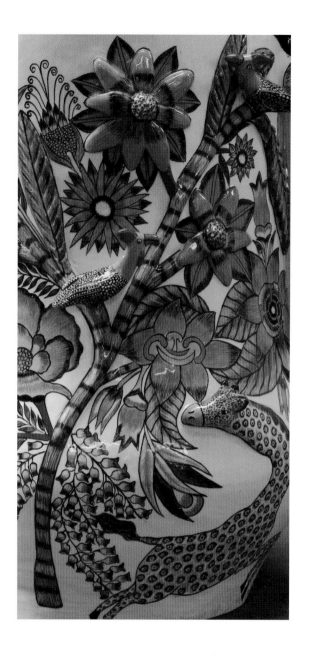

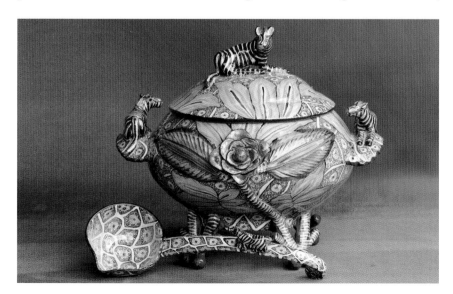

Above: Detail of a giraffe and flower jug sculpted by Beatrice Nyembe and painted by Mirriam Ngubeni, who was influenced by the fabrics in my home, 1995.

Left: Zebra soup tureen and ladle sculpted by Beauty Ntshalintshali and painted by Mavis Shabalala, 2000.

hosted by the Thyssen Forum, I met the controversial shipping tycoon, Tony Georgiadis. He asked me to show him the best piece on the exhibition. When I pointed to a sculpture by Josephine Ghesa, he requested that I put out my hands and then dropped a heap of Deutschmarks into my open palms. Then he went around selling Ardmore to all his friends until there was nothing left.

A year later, in 1999, Lindiwe was transferred to Malaysia and invited us to set up an exhibition in Kuala Lumpur in 2001. This time I travelled with Elizabeth Ngubeni, Petros Gumbi and Moses Nqubuka. We had our doubts about selling our ceramics there because the culture is so different. We had not taken into account all the embassy people – the French, Italians, Germans, Chinese and Japanese. They bought enthusiastically and left us with very little to take home.

Lindiwe's next appointment was as High Commissioner to the United Kingdom in 2001. Soon after her arrival in London, she held a dinner in honour of Mark Shuttleworth, who was preparing for his First African in Space mission. Another guest was Christopher English, curator of the Queen's silver, who complimented Lindiwe on her Ardmore collection after confessing that he, too, was a fan. Without missing a beat, Lindiwe asked Christopher to see what he could do to get his friends at Christie's to take an interest in Ardmore.

Top: Detail of a flower platter sculpted by Sondelani Ntshalintshali and painted by Nondumiso Mfuphi, 2008.

Above: Frog butter dish sculpted by Nkosinathi Mabaso and painted by Fiko Mfuphi, 2008.

Right: During our exhibition in Kuala Lumpur, Moses Nqubuka presented a gift to the Queen of Malaysia. Petros Gumbi (back) watched on.

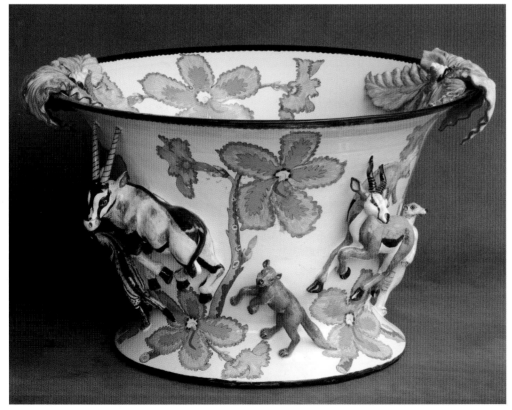

Above: Lindiwe Mabuza is a woman of great elegance and stature and was one of South Africa's most loved and admired ambassadors. The photograph was taken at her residence in Kuala Lumpur in 2001.

Left: Flower and wildlife bowl thrown by Elias Lulanga, sculpted by Petros Gumbi and painted by Mickey Chonco, 2004. Commissioned for a game lodge in the Northern Cape, the bowl shows the fauna and flora of the region. Our customer did not like the dominant pink flowers on the bowl, but I loved them. In fact, the bowl is one of my favourites and I have kept it ever since.

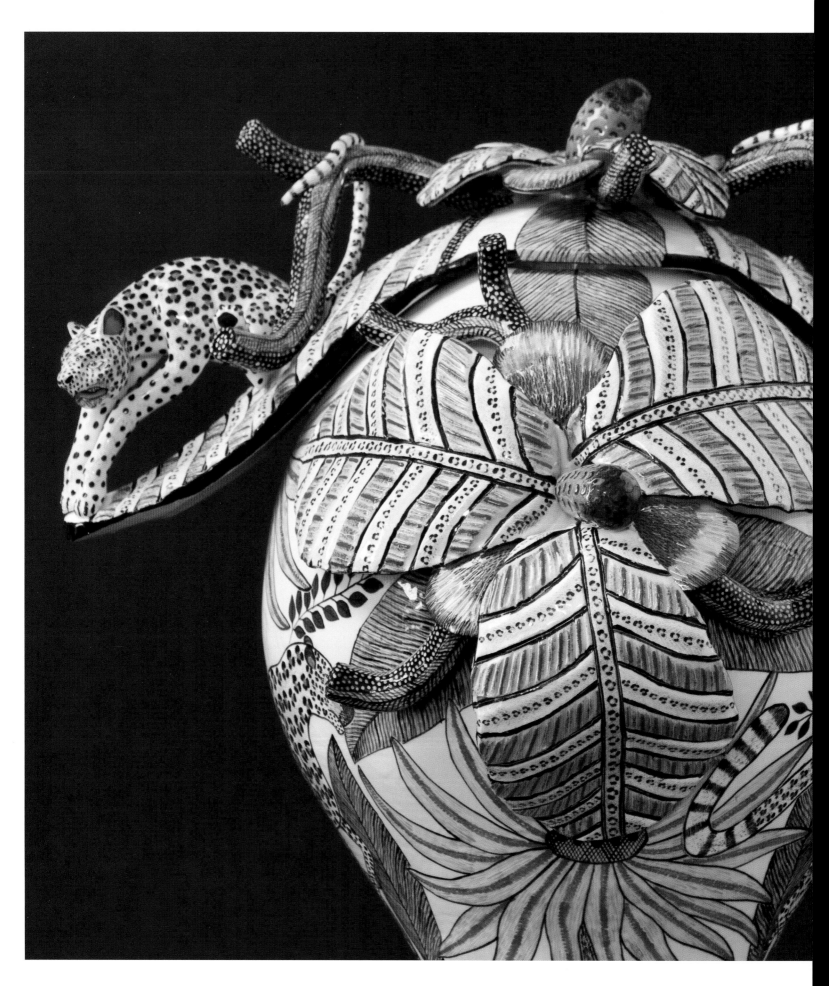

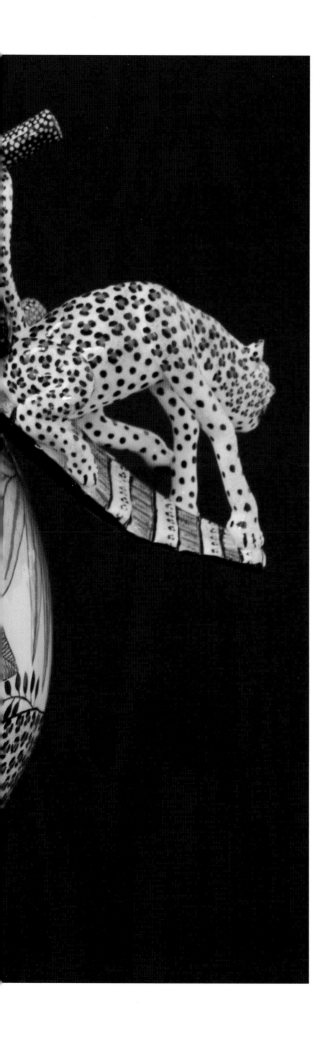

he first I knew about Lindiwe Mabuza's discussion with Christopher English was when Ardmore received an invitation from Christie's to mount an exhibition in January 2003. It was a bit of a grace and favour affair – 'Let's support South Africa'. But I certainly was not going to refuse the opportunity, even if not much was going on in London at the time. Although we had full use of the facilities at Christie's, we had to do our own marketing, prepare our own publicity material, send out our own invitations and set up our own displays. One thing that did help was that we were allowed to put our pieces in their Old Brompton Road street windows. We also had great support from the South African High Commission, which arranged a spectacular opening evening for us at Christie's. They sent one of the most beautiful flower arrangements I have ever seen, mixing proteas from South Africa with deep red English roses. Excellent South African wines, superb catering and a live African band set the tone for a vibrant atmosphere and an event remarkably different from anything Londoners would normally experience in a cold, dreary January.

Among the first people I met after the exhibition had opened were Mark and Deirdre Simpson. They recognised the Ardmore pieces on display in the Christie's windows and came into the building to find me. Mark had first bought Ardmore ceramics from the Dorp Street Gallery in Stellenbosch while working at the university there. They persuaded their friends to visit Christie's, and many of them eagerly bought our wares.

While packing up at the end of the exhibition, Wonderboy Nxumalo, Petros Gumbi and Moses Nqubuka began singing. We could have been back home, where Zulu voices are sometimes heard resounding from the hilltops in the countryside. It had a remarkable effect and, before I knew it, everyone who was in Christie's at the time came to listen.

Hugh Edmeades, chairman of Christie's South Kensington, and his colleague, Victoria Wilcough, were obviously surprised and delighted by the success of the exhibition. They took us to lunch and invited us to have an auction of our work in 2004. It was the opportunity of a lifetime. Once again Mark and Deirdre came to our aid, throwing a cocktail party for us at their home in Kensington on the day before the auction. The following day, Sunday, everyone went to the auction, including the Simpsons and their friends. The Simpson party played a significant role in the excitement that was generated during the bidding.

Far more important to us than the prices reached was the fact that Christie's really branded Ardmore's ceramics. In their catalogue they described Ardmore's artists as 'creating unique pieces based on the fusion of Western and African cultures'. They then went on to describe our ceramics as 'modern collectibles'. Art galleries all over the world sat up and took note.

Above: Zebra bowl sculpted by Sfiso Mvelase and painted by Zinhle Nene, 2006.

Below left: Deirdre Simpson was a great support at the Christie's exhibition in 2003.

Below right: With Christopher English, who introduced us to the team at Christie's.

Opposite: Frog urn sculpted by Elias Lulanga and painted by Nelson Khuzwayo, 2007.

Previous spread: Leopard tureen sculpted by Somandla Ntshalintshali and painted by Jabu Nene, 2007.

Shortly after the auction, Moses, along with Jabu Nene and Mickey Chonco, flew in to a chilly London with another crate of Ardmore ceramics for display at the City Arts Council exhibition in the Scottish capital city, Edinburgh. There was, however, a small, unexpected hiccup. They were detained by the immigration officials at Heathrow and asked to draw elephants to prove that they were indeed artists! I am sure Jabu and Mickey surprised everyone. The following week we were in an even colder climate, setting up our exhibition in the Arts Council Hall, a very beautiful venue in Edinburgh. Once again, people loved the colour and gaiety of Ardmore's pieces, which added an element of cheerfulness to the event.

The success of our first Christie's auction secured us an invitation to a second one, scheduled for 2007. Although prices achieved for artworks had soared in the intervening years, by the time we got to London for the second auction conditions were very different. Expenses had increased and buyers and sellers were being more cautious. To compound our problems, we did not have access to the street windows and internal security had been tightened, cutting us off from passing trade. The auction took place on a Sunday in January and, while it was not a sellout, sales were good. We ended the day watching the slim figure of Virginia Xaba walk down Old Brompton Road with an unsold Ardmore pot on her head.

People who buy art want to be reassured that they are not throwing their money away. Thus, what was more important to us than selling all our auction items was having the Christie's name behind us. We had been branded by the most respected name in the art world. Since then, Bonhams has auctioned our work, with images of our sculptures appearing alongside photographs of the works of Irma Stern and other great South African artists

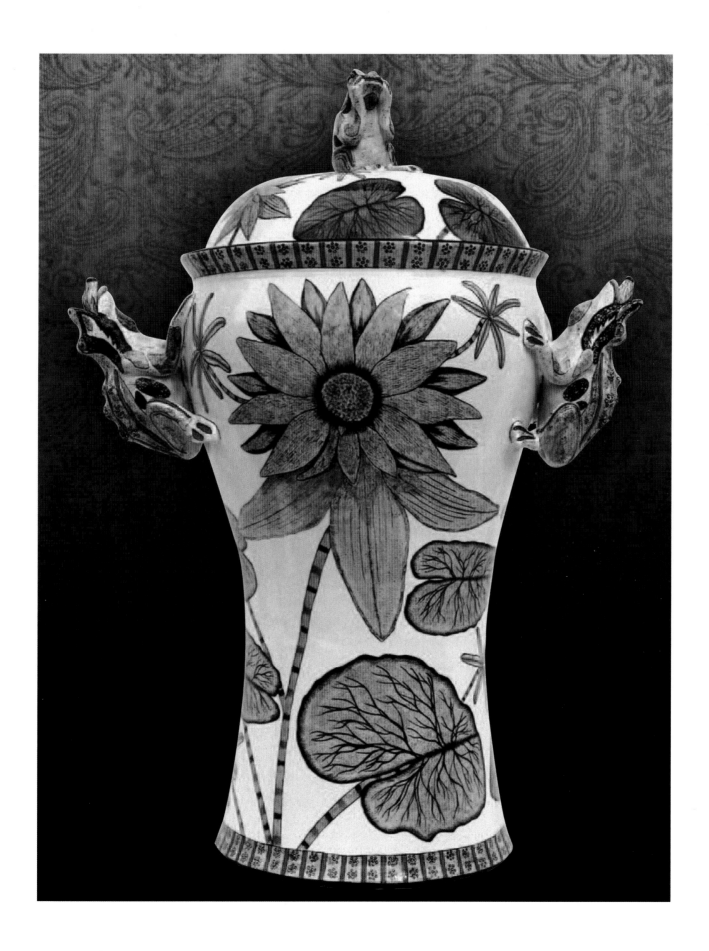

in its catalogue. Sotheby's, too, has auctioned our work, thereby further endorsing the value of our art.

Back home, in parallel with events in London, Ardmore discovered a very special friend in Johannesburg. We first met Pam Cornwall at an exhibition of Ardmore ceramics hosted by Jane and Gavin Relly at their home in Johannesburg. Pam loved our ceramics and told Christopher Greig to have a look at our 'stuff'. Christopher is the grandson of Charles Greig who, in 1896, founded one of the most successful jewellery businesses in South Africa. There are now shops bearing Charles Greig's name in Johannesburg's Hyde Park Corner, run by Christopher; in Sandton, run by his brother Billy; and at Cape Town's V&A Waterfront, run by another brother, Donald. There is also a shop at the Palace of the Lost City at Sun City, an international resort about two hours' drive north of Johannesburg, developed by hotel magnate Sol Kerzner. Christopher was fascinated with our ceramics and realised that the colourful pieces would complement the beautifully designed jewellery for which the Charles Greig brand is known. The first display of Ardmore ceramics in the jeweller's upmarket stores was in 1991. Since then Charles Greig and Ardmore have collaborated on many other exhibitions.

Christopher not only sells jewellery. He is also a superb designer who understands both structure and colour. From time to time, in planning for a joint show, he would suggest different themes and colour combinations to match the jewellery that would be on display along with our works. On one occasion, a tanzanite collection called for ceramics painted in blues, earthy browns and oranges. The result was an exhibition marked by simplicity and elegance. The window display at Charles Greig's Sandton showroom, where the collection was being showcased, was very effective and achieved the desired objective: it really drew people in and, lucky for us, they were keen buyers. When Christopher asked us to prepare for the next major exhibition, *Great Cats of the World*, which was to be held in 2007, he challenged us to do something different. He wanted us to paint from nature and not from the imagination. We had to be sophisticated and realistic yet retain the charm that is the hallmark of Ardmore's ceramic art. For the first time we were exploring the exotic, including painting on black backgrounds. Christopher even wanted tigers and panthers. Blues and browns were out. Greens, golds and red corals were in – and they were a sensation.

Christopher inspired and challenged us with his ideas, and the artists were excited about the change in direction and the opportunity it gave them to explore new areas of creativity. They responded with enthusiasm. Without any suggestion from me, they took themselves off to find reference material in the local library. Then they got down to work, sculpting and painting the great cats in jungle-like scenes. The ceramics really were magnificent and the exhibition was a huge success. The centrepiece of the

Opposite: Promotional material for two Ardmore exhibitions held at Charles Greig Jewellers in Johannesburg.

Above: Christopher Greig (centre), with his brothers, Donald (left) and Billy (right). The portrait of their grandfather, Charles Greig, hangs behind them.

Right: Flower and bird dish sculpted by Beauty Ntshalintshali and painted by Punch Shabalala, 1996.

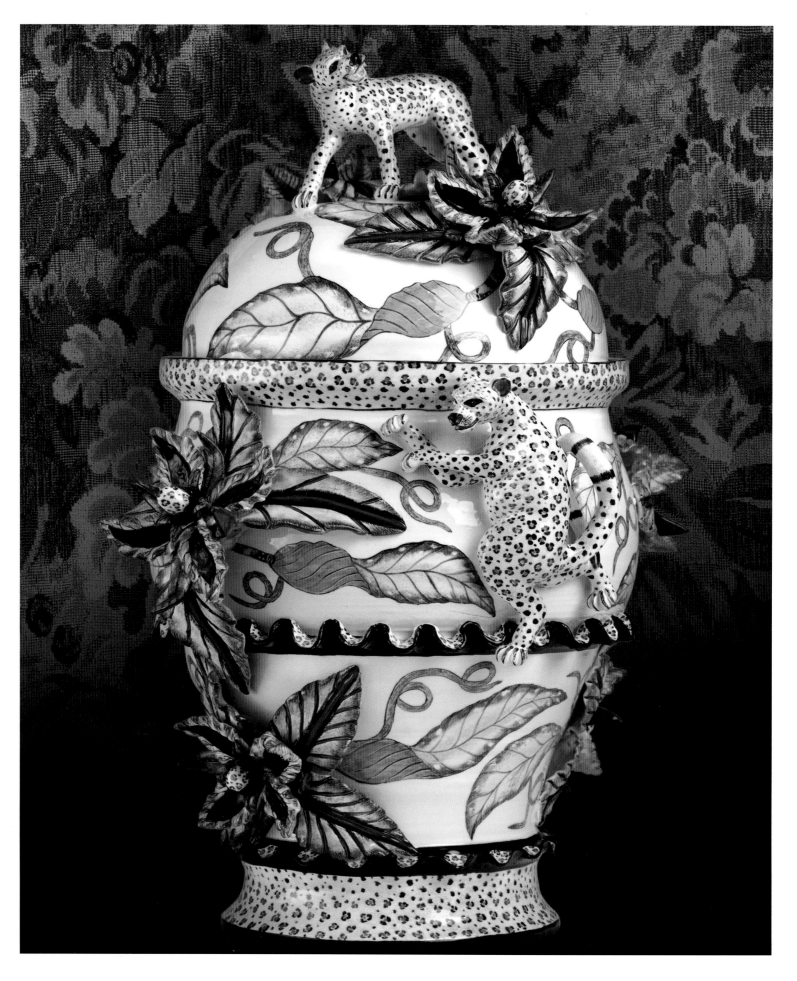

show – a leopard urn painted by Mickey Chonco – was sold to a buyer from Moscow. A panther urn, painted by Wiseman Ndlovu, who had joined us at Caversham only the year before, fetched the highest price ever achieved for an Ardmore work. Our success ensured that we moved up another rung on the art world ladder.

The *Great Cats of the World* exhibition opened in July 2007 at Hyde Park Corner in Johannesburg – the same centre where we had exhibited Ardmore's work at the Helen de Leeuw Gallery some twenty years earlier. Christopher's marketing was superb. The colourful invitation demanded that you attend. Huge billboards caught everyone's attention. The guest list included everybody who was anybody. Even before the champagne corks were popped and the guests could help themselves to mouthwatering snacks or oysters in an ice-filled mokoro, the exhibition was assured of success. I was thrilled beyond measure.

Over the years Christopher has played a big role in Ardmore's development, always encouraging us to reach greater heights. He is a perfectionist and expects only excellence. But, whatever his involvement, he does it with style and charm. It is an honour to be associated with him and the rest of the Greig family.

We have also had great support from many art and craft retailers in South Africa. Art Africa and Delagoa, both which have outlets throughout South Africa, Tribal Trends, Africa Nova and the Twelve Apostles Hotel and Spa in Cape Town, Imibala in Somerset West, Londolozi in the Sabi Sand Game Reserve, The Collection by Liz McGrath in Cape Town, Hermanus and Plettenberg Bay, Bushmanskloof Wilderness Reserve and Wellness Retreat in the Cederberg Mountains near Clanwilliam, and The Oyster Box hotel in Umhlanga have regularly placed orders for our ceramics over many years. We are grateful for their appreciation of our work and for placing Ardmore in their galleries, showrooms and stores.

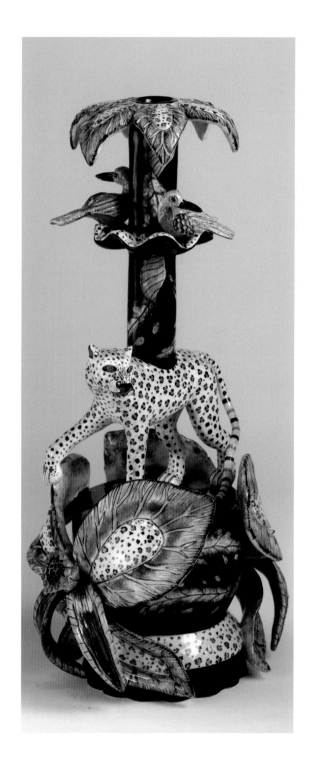

Opposite: Leopard urn thrown by Sabelo Khoza, sculpted by Sondelani Ntshalintshali and painted by Mickey Chonco, 2007. Christopher Greig sold this urn to a visitor from Moscow.

Right: One of a pair of leopard and bird candlesticks made by Sabelo Khoza and painted by Mickey Chonco, 2007.

Left: The team responsible for putting together the *Great Cats of the World* exhibition, held at Charles Greig in Johannesburg in 2007, gathered for a photograph in my lounge at Caversham. Standing behind me is Christopher Greig. On the wall is a painting by Mick Allard showing my 'flight' from the Ardmore studio in the Drakensberg in 1996.

Below: Tiger urn sculpted by Petros Gumbi and painted by Virginia Xaba, 2007, for the *Great Cats of the World* exhibition. It was the first time that the artists worked on felines found in other parts of the world, such as tigers, jaguars and panthers. It also had an influence on our style: we followed nature more closely and brought in black backgrounds.

71

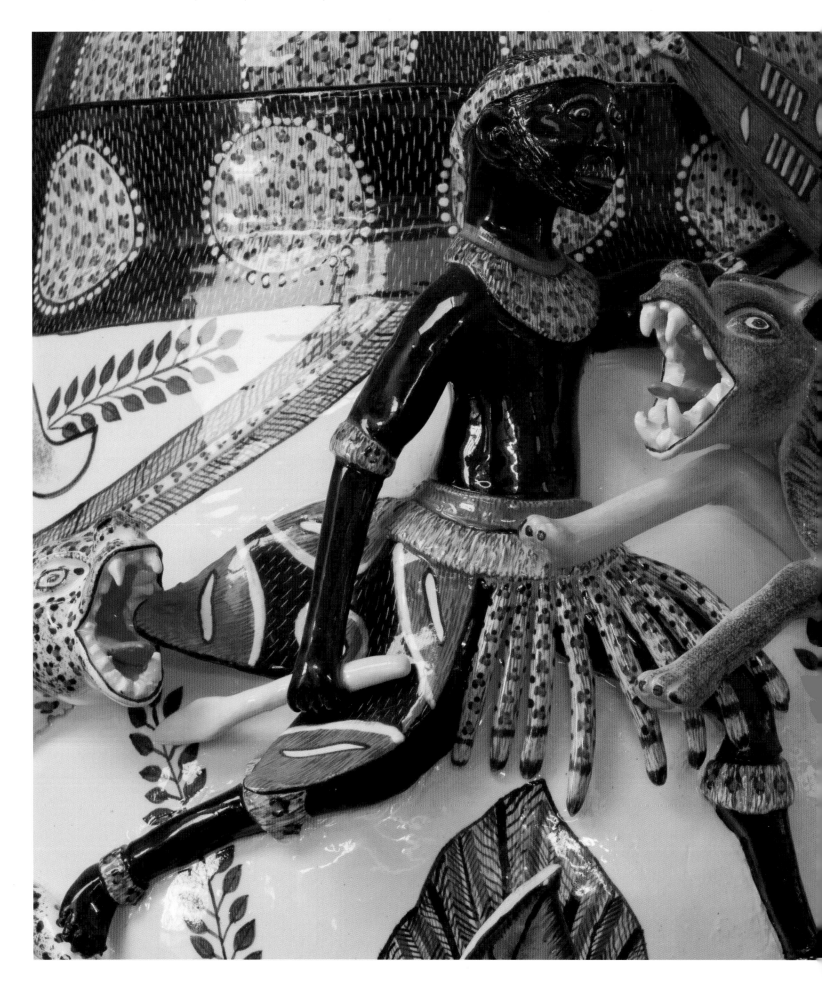

y life started to change in 1995. James's parents were planning to retire and asked if he would like to take over their Midlands farm, Springvale, near Rosetta. After thinking it over, James decided to start a dairy farm at Springvale. The property had abundant water in its rivers and dams, an essential resource for any farming enterprise. James had worked hard at Ardmore and, through no fault of his own, had enjoyed little success. Now it was his turn. I thought it was a marvellous opportunity and I could see the advantages for the whole family. We would be close to the main highway, and the urban centres of Pietermaritzburg and Durban would be more accessible. Our three children would be close to good schools, making it easier for them to participate in sporting and social activities. It also had advantages for me and the ceramics business. A few years earlier, James's mother had opened an Ardmore shop on the farm. Since the farm was close to the Midlands Meander, it was easier for people looking for our ceramics to find their way there than to travel all the way to the Champagne Valley.

I told James that I would continue to run the studio at Ardmore and would commute there once or twice a week to spend time with the artists. I had also already begun to train Moses Nqubuka for the position of studio manager; now it seemed that he would have to take over the reins earlier than I had anticipated. Phineas Mweli and Wonderboy Nxumalo asked if they could come with me to Springvale so that they could be closer to their homes in Pietermaritzburg and Greytown, respectively. I had no plans to take any of the other artists with me and the thought of setting up a full-scale studio at Springvale had not crossed my mind. My hope was that the artists would remain at Ardmore and become more self-reliant, and that I would have more time for my family.

James leased Ardmore to a friend of his brother's, Paul Ross, who wanted to establish a guesthouse there – a far more practical use for a property adjacent to the uKhahlamba-Drakensberg Park, which, a few years later, in 2000, was designated a World Heritage Site. We agreed that the studio would remain on the farm, and I realised that having a steady flow of visitors on its doorstep would be good for business. We made the move to Springvale in 1996, and by then I was well organised.

I first met Moses Nqubuka in 1995 when filling up with petrol at The Nest, a resort hotel in the Champagne Valley. I recognised his energy and enthusiasm, his friendly smile and intelligent approach to customers. I soon learnt that he had far more to offer. As well as being a petrol attendant, he was also a part-time switchboard operator and a walking guide. He had taught himself to speak and write English and had a curriculum vitae a mile long. He had worked as a receptionist, labourer, groom, waiter,

driver, painter, gardener and bar steward. It was obvious that anyone so versatile would not be daunted by the prospect of becoming the manager of a ceramic art studio. Most of all, Moses was a people person and had a mountain of charm. He started visiting Ardmore on his days off. While he was there, he would dabble in painting. I took note of his willingness to help and offered him the job of manager of the Ardmore studio. I started teaching Moses all aspects of studio management – from preparing the clay, organising the paint and firing the kiln to assessing quality, pricing merchandise and marketing. He was sharp and quick to grasp everything he was being taught. He would listen to me selling an artwork and in two minutes flat would have it down pat and even better!

When we moved to Springvale, I was almost, but not quite, prepared for the extra workload. I soon realised that we had reached another milestone in Ardmore's development. We were getting busier and were attracting scores of people from Durban, Pietermaritzburg, Johannesburg and overseas. Soon after we moved, some of the artists who liked my daily involvement in their work drifted in from Ardmore. In addition, people from the surrounding area as well as the daughters of local farm labourers came knocking at my door, desperate for work. To accommodate them all, we turned the old stone buildings on the farm into a showroom and workroom for the artists. Before I knew it, there were two studios on the go.

Two years later, after returning from a trip to Germany, I found that I faced losing the Ardmore studio altogether as Paul was buying the property. Understandably, I was not happy about this and I begged James not to sell my studio. I felt I had a responsibility to Ardmore's artists and could not leave them in the lurch. Bonnie Ntshalintshali had been working with me for thirteen years and she and more than twenty other artists were dependent on me for their livelihood. Eventually our old friend and neighbour, Steve Gawith, who had previously practised law in Johannesburg, persuaded James to subdivide the land, separating my old stone stable, which housed the studio, from the main farm.

With two studios in full swing, the demands on my time increased exponentially. The artists at Ardmore needed me. Moses required my input. Marketing became more important than ever. On top of that, I was teaching art at the Clifton Primary School at Nottingham Road to help pay for my children's education. They were growing up and needed my time. In between, I was also riding competitively. I was living life at a furious pace and had no option but to keep going. Looking back, I do not know if I had any time left for James. It was one of a number of reasons that led to a rift in my marriage. Whether I liked it or not, this rift would deepen.

There was another problem. My advisors periodically reminded me that I was running a business on land I did not own and that I had no

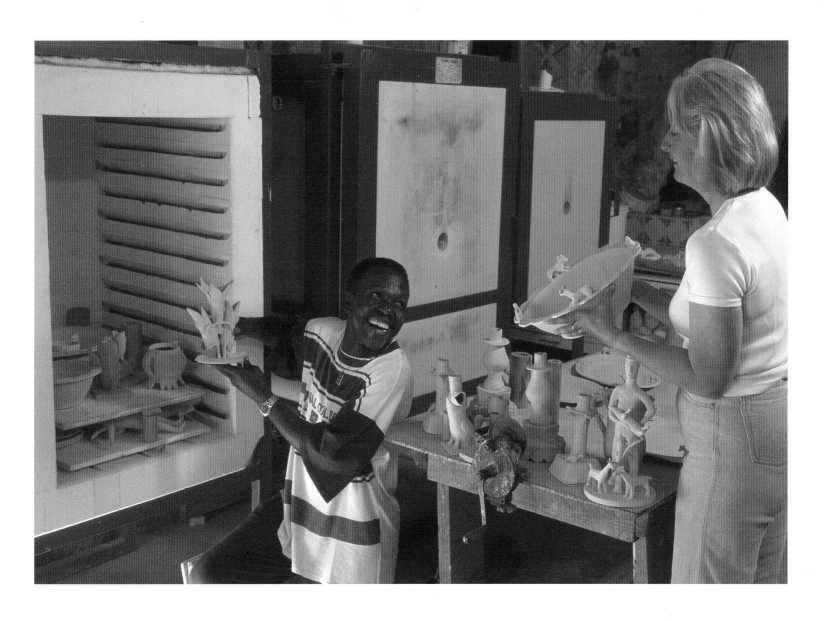

Opposite: Bird tiles painted by Bonnie Ntshalintshali, 1996.

Above: Moses Nqubuka helping with the packing of the kiln at the studio on Ardmore farm.

Right: Badger and genet teapot sculpted by Beauty Ntshalintshali and painted by Bonnie Ntshalintshali, 1998.

Previous spread: Detail of a traditional Zulu hunting scene sculpted on an urn by Somandla Ntshalintshali and painted by Jabu Nene, 2007.

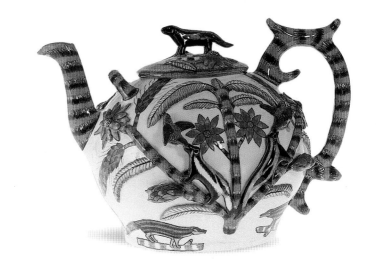

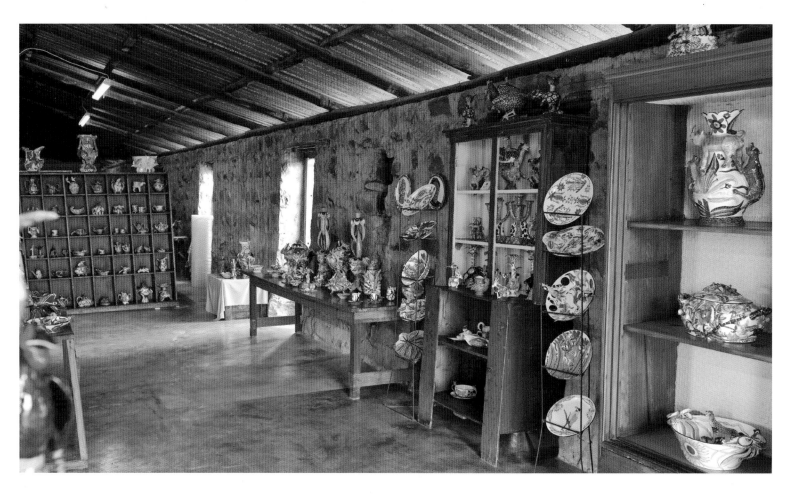

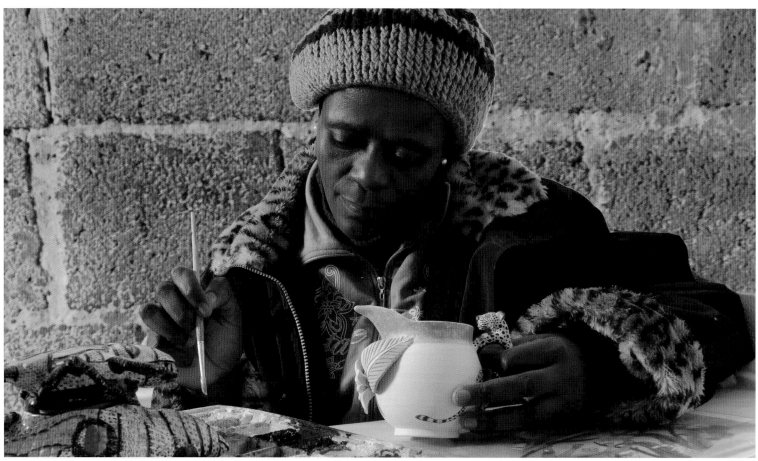

assets. If I needed capital for development, I would find it difficult, if not impossible, to raise funds. I also felt that working from home was unfair on my children. They needed their own space. Our family life was continually disrupted by the business and I began to think about buying a property in the Midlands. But I was flat-out busy with one exhibition after another and had no time to explore the possibility.

Around this time, a friend of James's wanted to sell her smallholding on the bank of the Lions River, opposite the Caversham Mill. The property was in a beautiful location, wedged between the Lions and Mpofane rivers. There was a thatched house, a small cottage and some outbuildings that had been used for the production of lavender oils. I loved the French provincial style of the house and was thrilled at the thought of having the space to accommodate overseas visitors. More important, though, the property was ideal as a location for Ardmore's gallery and museum

I went off to London at the beginning of 2004 and returned home more than a month later. I was overjoyed: our first auction at Christie's had been an unbelievable success and we had done well at the City Arts Council exhibition in Edinburgh. I was riding the crest of a wave. But I had been away for far too long. When James picked me up at the airport in Durban I realised that my marriage was over. I still find it hard to think about that awful and painful time.

My first priority was to keep my family together and to ensure that the lives of my children were not disrupted to the extent that mine was. Jonathan would soon finish matric and be off to university, and he needed to concentrate on his studies. My second priority was the artists. During the years I had spent travelling between Rosetta and the Drakensberg, I had trained another fifty artists – altogether there were about seventy artists. Now I faced losing both studios. Just when I thought there was nothing I could do, I received a package from Steve Gawith. In it was a sale agreement. Unbeknown to me, Steve had persuaded James to sell me the strip of land with the studio at Ardmore for the price of the transfer costs. It was a relief to know that the artists still had a home there. But what about the studio and the museum at Springvale? Where would the children and I go?

The solution was right in front of me. The house at Caversham was large enough for me and my children. The cottage could be used for the shop and office, and the museum pieces would have to be stored. There were no stables for my horses and they would have to stay at Springvale. There were outbuildings that had been used for processing lavender oil; these could now be used by the artists. I would just have to make a plan. It would all take time and I had no idea where I would find the money.

I borrowed from the bank but the money went nowhere. There was just too much to do. Then the family came to my rescue. My very practical

Opposite top: The showroom at Ardmore Champagne was managed by Moses Nqubuka after I moved to Springvale in 1996.

Opposite bottom: Punch Shabalala painting a jug in the studio at Ardmore Champagne.

Above: Virginia Xaba carrying a bisque work on her head to paint at home. Every day the painters would set off up the hillside for a ten-kilometre walk to their homes.

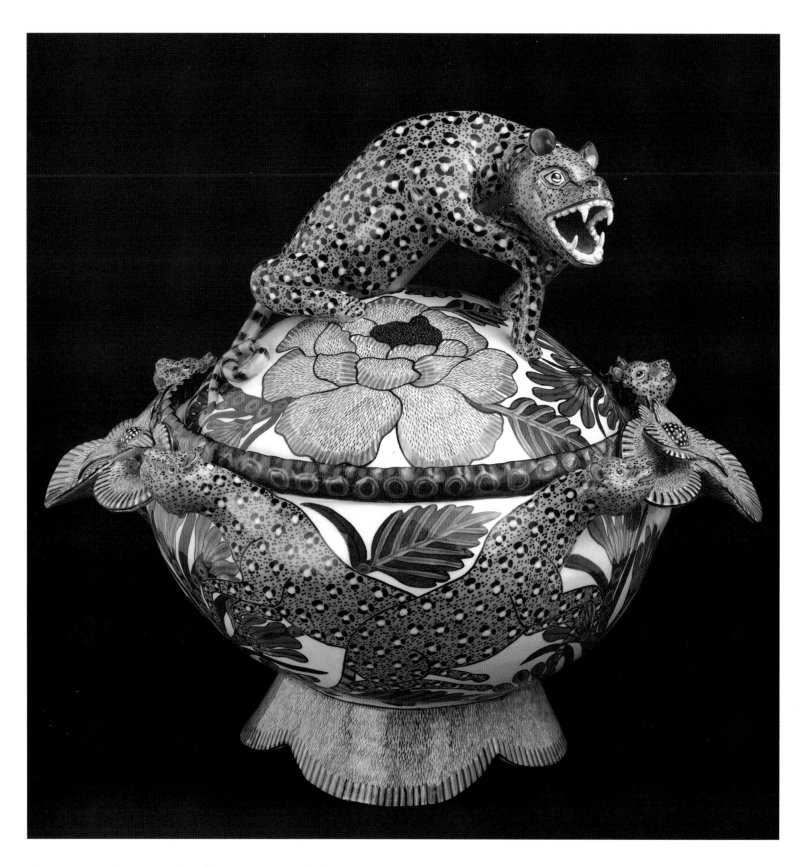

Above: Leopard tureen sculpted by Somandla Ntshalintshali and painted by Jabu Nene, 2005. They worked at the studio on Ardmore farm in the Champagne Valley while I was based at Springvale in the KwaZulu-Natal Midlands. Their independence and ability – and that of the other artists at Ardmore Champagne – thrilled me.

Opposite: Among the many artworks sent to the Christie's auction in 2004 were a leopard urn sculpted by Sondelani Ntshalintshali and painted by Jabu Nene (left), a large elephant urn sculpted by Nkosinathi Mabaso and painted by Nelly Ntshalintshali (middle) and a pair of giraffe candlesticks sculpted by Raphael Njoko (right), 2003.

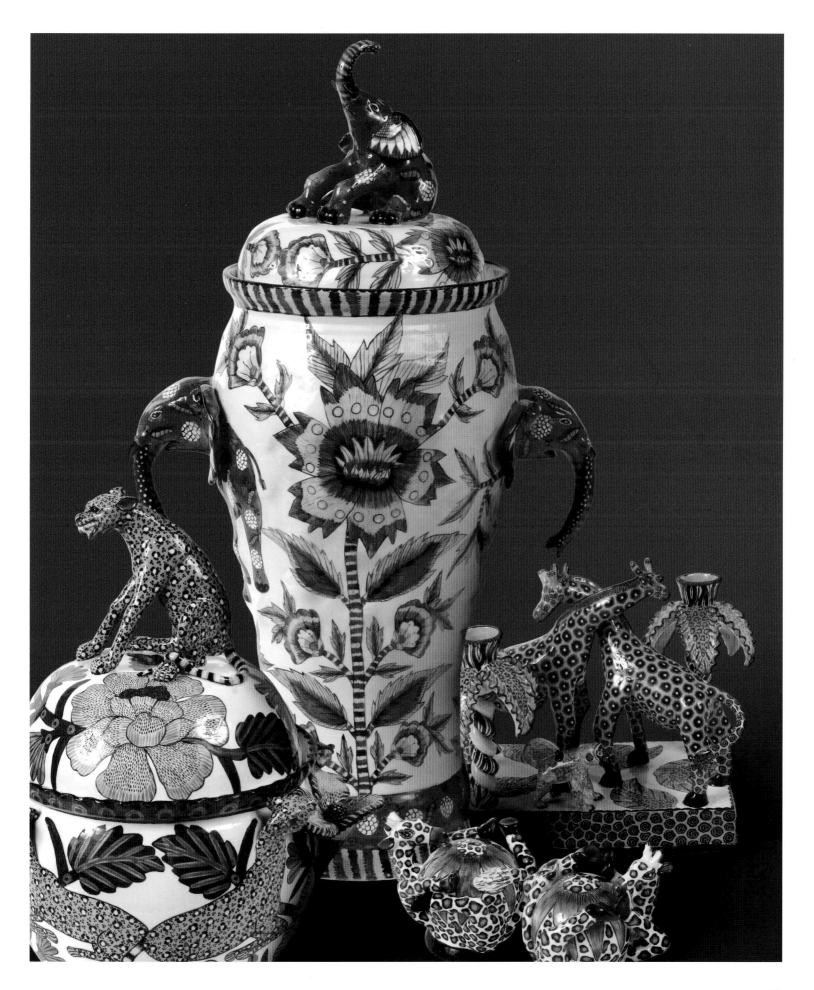

younger brother, Charles, told me that I had to think about my business. Not myself. Not my children. Not even my horses. Then Charles offered me a loan and told me to go ahead and make a plan. With the help of my creative, elder brother, Paul, an experienced builder, I set about designing a studio, a workshop and stables for the horses. It would take time. But Charles was right. If I did not focus on my business, we would have nothing and I would be letting down all the people who relied on me.

Throughout the decade, marked by the move from Ardmore to Springvale and then to Caversham, we held more than thirty exhibitions in no fewer than five countries. That is an average of three major exhibitions a year. Many of these shows required 300 to 400 pieces each, usually created around a specific theme. I was always looking ahead and it was no wonder that I did not have the time to see what I was leaving behind.

What got me through the unhappiness were my children. They gave me their unconditional love and support. The artists also helped me, especially Jabu Nene and Virginia Xaba. What was remarkable about these two women was the extent of their understanding, kindness and loyalty. When I was distracted and unable to focus on Ardmore, they simply got on with what needed to be done, without looking to me for help. I realised afterwards that the exquisite beauty of their work also played a role in lifting my spirits and carrying me through.

Most of all, I was happy that Jonathan, Catherine and Megan were with me and that we had a home. My mum, who came down from Zimbabwe, provided me with much-needed support. Despite the rough ride, we were all going forward successfully. There was nothing to hold Ardmore back – or so I thought!

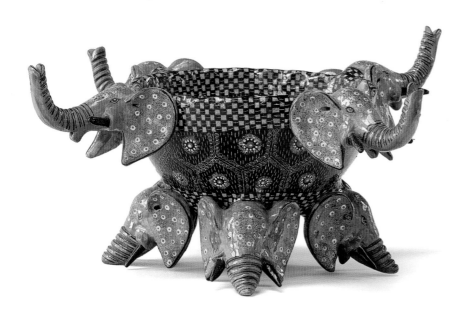

Opposite: My home at Caversham (top) and the new gallery (bottom), which was built in 2005. The gallery building also houses the Bonnie Ntshalintshali Museum and the painting studio.

Left: Elephant bowl sculpted by Fundi Mathebula and painted by Jabu Nene, 2008.

Above: In my new home with my children, my dogs and my horses.

Left: An aerial view of Ardmore Caversham shows the Lions River in the foreground. The river flows past the Caversham Mill and is our southern boundary. It is joined by the Mpofane River on the eastern boundary. The main house, gallery and stables can be seen just right of centre. The cottage below the dam is used to house guests.

Below: Leopard jug made by Beauty Ntshalintshali and painted by Punch Shabalala for the *Great Cats of the World* exhibition, 2007.

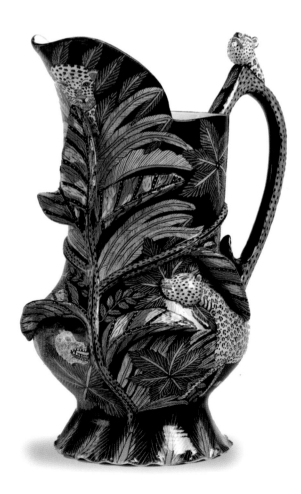

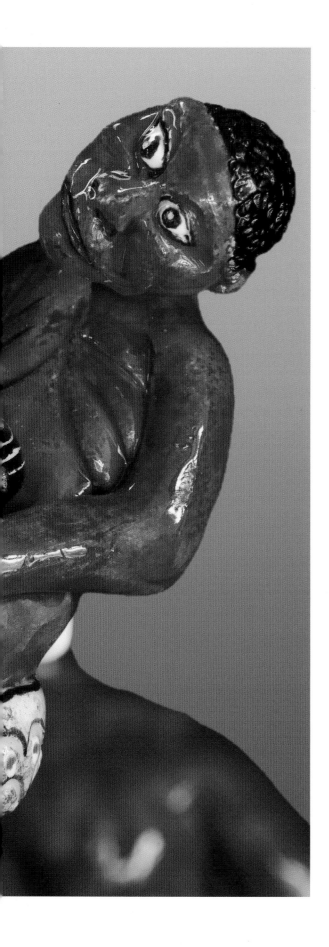

After Bonnie Ntshalintshali and I won the Standard Bank Young Artist Award in 1990, life took a new turn. Many more potential artists found their way to Ardmore where they were given an opportunity to earn a living and express themselves creatively. Not least of all, we were becoming known internationally.

Amid the success, a farm neighbour came to see me at Ardmore to tell me that one of his workers had tested HIV-positive. He was motivated by a sense of good neighbourliness, as the worker's partner was Phumelele Nene, one of Ardmore's talented painters. Although it was a warning to me, I had no idea that we were facing an epidemic. We were totally unprepared – as was the rest of the world – to handle the catastrophe. Governments and drug companies were throwing everything they could into finding a cure, but in those days the availability of ARVs in South Africa was still a long way off. Phumelele was the first of Ardmore's artists to die of an AIDS-related illness and there was nothing we could do to help her. In the early 1990s the number of people affected in rural KwaZulu-Natal seemed to be few and far between, or so we thought. As the decade progressed, we started to find more and more cases of full-blown AIDS.

In 1996, when I moved to Springvale and opened a second studio, a number of artists elected to come with me. Looking back, I realise that nearly all those who accompanied me were carrying the virus. It was as though they wanted my help but did not know how to ask. Bonnie was an exception. She chose to stay at Ardmore, where her mother could look after her little boy, Senzo. Two of the people who came with me were Mirriam Ngubeni and Phineas Mweli; they had started our stock lines and helped set us on the road to commercial success. I was aware that Phineas was ill. At the same time as I was learning the extent of our helplessness, I was also learning something else: Ardmore was not a factory where output was all-important. Ardmore was about people – special people with extraordinary skills and unique talents.

It was a busy time for me, working with new artists, getting my kids accustomed to new schools and setting up a new home. Nevertheless, I made time to visit Ardmore every week, where preparations were under way for an exhibition that was going to be held at the residence of the South African ambassador, Lindiwe Mabuza, in Bonn, Germany, in 1998. Lindiwe had arranged for Bonnie, Punch Shabalala and Moses Nqubuka to travel with me. We were all very excited, especially Bonnie. She was such a lovely person. Everything about her was neat, attractive and ladylike. I believed that we were locked into Ardmore for life and that we would grow old together. I was aware that Bonnie had health problems resulting from the polio she had contracted as a child and that she often visited her doctor.

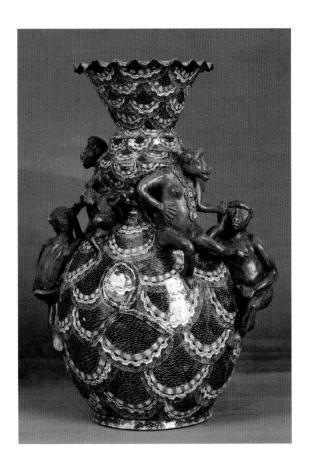

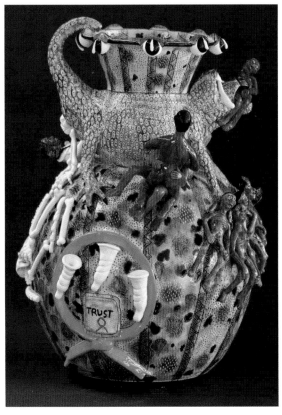

Nonetheless, when I noticed that she had lost weight, it never occurred to me that she might have AIDS. To me it was inconceivable that Bonnie could have caught some deadly virus. I asked Moses if she was ill and he told me that she had some 'women's problems' and that she had seen a doctor. I did not take it further.

We arrived back in South Africa in August 1998. Over the next fifteen months I saw less and less of Bonnie; she had asked if she could work from home as she was finding the long walk to the studio difficult. I told her, 'Of course. You are free. Do whatever suits you.' Right from the outset, when Ardmore was established, I considered it important to respect the artists' needs as creative people and to be guided by an understanding of the physical hardships they experienced on a daily basis. They had no electricity and had to collect firewood for cooking and heating in winter, and they had a ten-kilometre walk to and from the studio each day. I did not expect them to be in the studio at any particular time or even be there all the time. If they made only a few pieces a month, it did not matter. What I wanted them to know was that I cared about them and that, if they needed support, I would do anything to help them.

Throughout that year Bonnie continued producing her decorative artworks. She maintained such a high standard that there was no need for my involvement. Then, in November 1999, out of the blue, Moses told me that Bonnie was not well and that she wanted to see me. Even though there was no sense of urgency to his message, I suggested that he bring her to Springvale so that I could get her to a good doctor and a hospital. I still thought that she had some medical condition that might require surgery, or that her foot was troubling her. I was not prepared for what I saw when Moses arrived with her at the farm. Bonnie was lying like a skeletal little bird on a mattress in the back of his bakkie. She was blind and seemed to have slipped into a coma. I do not know how I managed, but we took Bonnie to a doctor in Howick, about twenty minutes away. He took one look at her and told us that meningitis had set in and that there was nothing he could do. She was too far gone. The shock was huge. My heart felt like it was breaking and I could not stop crying.

Even then I was in denial, hoping that the doctor had been wrong. I thought that, if I took Bonnie to the best hospital possible, something could be done for her there. Moses said no, that it would be wrong. He suggested that Bonnie would be far more comfortable at Northdale hospital, where she usually went for treatment for her deformed foot. He felt that she would be much happier with people she knew. So we went to Northdale. That was another experience. People were dying at the reception counter. I nearly put Bonnie back in the car, it was so horrifying. I should have done so, but I felt helpless and just followed orders. The intern wanted to do

his work the only way he knew how. He wanted X-rays and blood tests. I asked if he would give her morphine. I was desperate. My instinct was to take Bonnie home to die. When I look back, I believe I was right; I should have followed my gut and taken her home. There was nothing they could have done. But they did the X-rays and blood tests – it was four hours of hell. Then I was ordered out because I was white, and not family. I totally lost it and told the nursing sister, 'This woman is my daughter and I don't care what colour skin she has.' I was functioning on automatic, getting her into a comfortable bed and demanding clean sheets and a decent blanket. Then she came round and said she was hungry. We got her a banana drink, which she sucked through a straw. She held onto my arm the whole time I was with her; at some point she told me she was going to be fine. I could see she was at peace. She died a day or so later.

Bonnie's funeral was beautiful and poignant. The drums kept a steady rhythm throughout, like the beating of a heart. There were so many people. Bonnie's son, Senzo, would not leave me. He sat on my lap, nestling into me. I could tell by his affection and trust how Bonnie had portrayed me to him. It was a wonderful feeling. Our relationship was based on trust and respect for each other's traditions and cultures. She had been my hope for Ardmore's future. Africa is a cruel place.

Two weeks earlier, towards the end of October, Agnes Ndlovu, Bonnie's sister-in-law, had died. Now Bonnie, too, was dead. Their deaths were a wake-up call for me. I thought I had nearly all the answers to life, yet I had failed my friend. A few weeks later, as I had anticipated because he was so desperately ill, Phineas Mweli died. And then I had another shock. Mirriam Ngubeni, who had been painting at Ardmore for a decade, also passed away. Here I was, at the deep end of the AIDS pandemic and without answers. I felt so helpless. I also felt guilty. How and why did it happen? What was I to do? I could only guess at the extent to which the virus had spread. But I was clear on one thing: I had to do something about it.

To start with, I realised that the belief held by most of the artists, that AIDS was a *tagati*, an evil spell that could be cast on a person, had to change. At the same time, I had to dispel the thought in my own mind that a witch doctor might have cast a *tagati* in my direction. I knew I had to discuss the issue of AIDS with the artists, even though I had been warned that it was a taboo subject and to talk about it might be viewed as disrespectful. The biggest problem we faced was denial.

We had one big factor in our favour. I had already discussed how we could best help the artists with Alan McGregor, Ardmore's marketing and financial manager at the time. There were so many things the artists needed; without a plan, the business would never be able to cover the costs of even their most urgent requirements. Our artists needed help

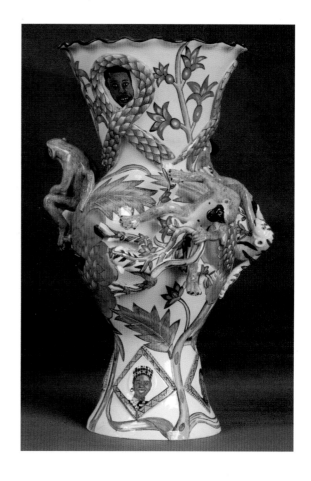

Opposite top: Ardmore sculptor Sfiso Mvelase and painter Mavis Shabalala tackled AIDS education using the baboon as metaphor in this vase, 2004. The artwork was auctioned at Christie's and is now in the collection of Charles Halsted.

Opposite bottom and detail on previous spread: Vase sculpted by Sfiso Mvelase and painted by Roux Gwala, 2008. In this satirical sculpture of an 'AIDS monster', the full tragedy of the pandemic is portrayed: the horror of a monster devouring the people, the weeping eyes on the rim of the vase, and a doctor struggling in vain to kill the beast. Painter Roux Gwala added parachutes and tadpoles, symbolising the speed with which the disease has spread.

Above: Made in memory of some of the Ardmore artists who died of AIDS-related illnesses, this monkey vase was sculpted by Vusi Ntshalintshali and Sfiso Mvelase and painted by Virginia Xaba, 2008.

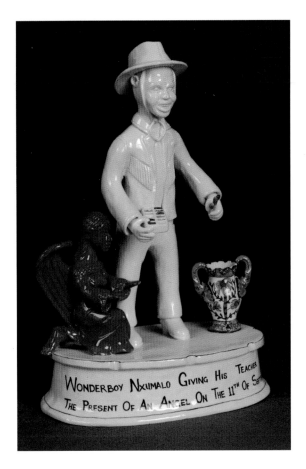

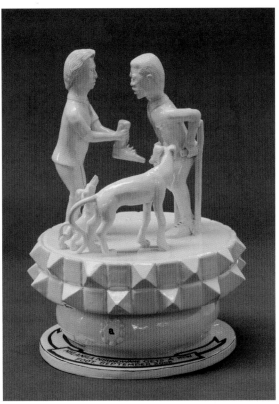

with medical expenses, education and training, funeral costs and more. There were other expenses looming: ARVs, good nutrition and care for orphans whose parents had died of AIDS. To help the artists, Alan set up the Ardmore Excellence Fund. This not-for-profit entity was also to lever us, with the help of Lori Khorts, an American friend of Alan's, into the PEPFAR programme – the United States President's Emergency Plan for AIDS Relief – the largest international health initiative dedicated to a single disease by any government in history.

For an initial five-year period, Ardmore worked in conjunction with professionally trained people to provide ARV medication to AIDS sufferers and train our own people in AIDS awareness and prevention. Moses Nqubuka was exactly the person we needed to head up our fight against the illness. He lectured, talked, preached and took people to Bergville, both to attend lectures and to see Dr Johan During, a good friend of Ardmore's and a staunch supporter of our fight against AIDS. Moses gave talks on AIDS prevention and on how to live with AIDS. With help from Angeline Mathebula and, later, Christopher Ntshalintshali, he handled all the administrative tasks pertaining to the artists' health care, completing the paperwork so that they could go to the doctor, dentist or optician and ensuring that all those who were on ARVs got their pills. With his charismatic personality, Moses reached many people and was a positive influence throughout the Bergville and Winterton districts in the KwaZulu-Natal Midlands.

Because the artists work closely together, sharing their problems helps allay their fears. However, talking about AIDS is not easy. It requires quiet diplomacy, not straight talk, which is considered impolite. The most difficult task of all is to encourage everyone to take an HIV test. Some do, but sadly, too many people go for testing when it is too late.

Many of the artists that I came to love have died over the past two decades. Phumelele Nene, Bonnie Ntshalintshali, Phineas Mweli, Agnes Ndlovu and Mirriam Ngubeni all died early on. Then many of those who followed me to Springvale died: Nomusa Mazibuko, Nelly Ntshalintshali, Sindy Mazibuko, Hlengiwe Ntshalintshali, Tiny Ngubeni, Zodwa Mazibuko, Angel Gabela, Promise Mabaso, Raphael Njoko and Cecilia Dlamini. Bonnie's two brothers, Robert Ntshalintshali and Phelawake Ntshalintshali, who drove the tractor on the farm, also died. James Dlamini had full-blown AIDS before he admitted he was ill. A month later, he was dead. Christopher Ntshalintshali's parents, Africa and Paulus, succumbed to the disease. These people were my friends; we had laughed and cried together. Their deaths left me grief-stricken, and I could share my pain with only a few people.

Looking ahead, my hope was that things would change, that the memory of these talented individuals would remain alive and inspire us in our efforts to save lives in the future.

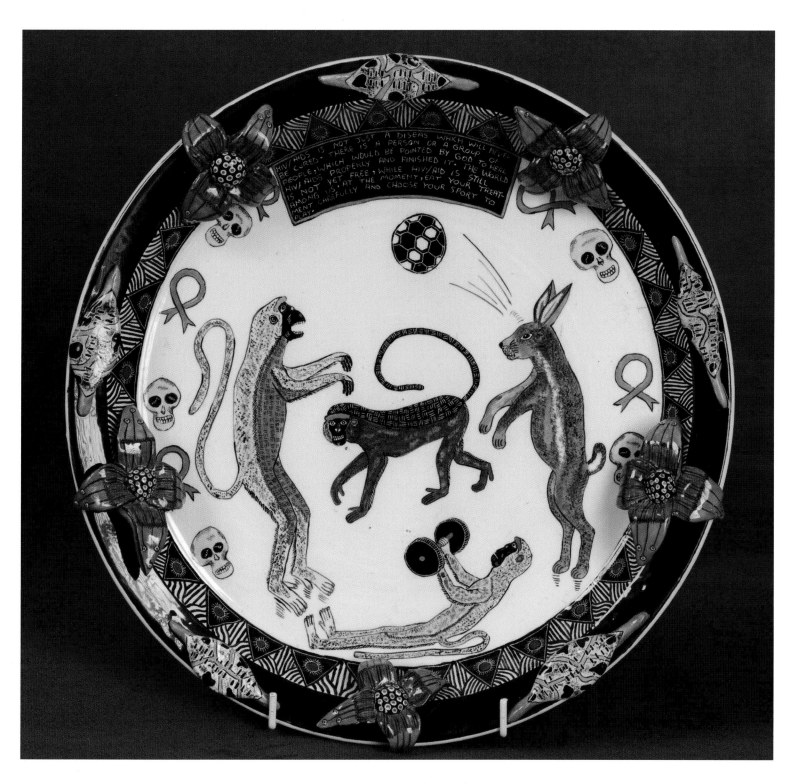

Opposite top: Sculpture of Wonderboy Nxumalo presenting me with a gift of an angel, created by Nkosinathi Mabaso, 2008.

Opposite bottom: Sculpture of Nhlanhla Nsundwane receiving his prosthesis from me after his foot was amputated, created by Petros Gumbi, 2008.

Above: This plate, painted by Wonderboy Nxumalo, illustrates ways of staying healthy while living with HIV, 2007. The plate formed part of *Ardmore Positive*, an exhibition on the theme of International AIDS Day held in December 2008 at the Tatham Art Gallery in Pietermaritzburg. International AIDS Day is observed on 1 December each year.

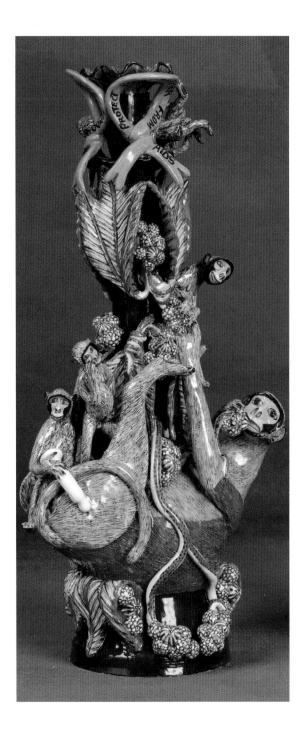

Above: One of a pair of monkey candlesticks sculpted by Sfiso Mvelase and painted by Punch Shabalala, 2008. In an attempt to educate the artists about HIV and AIDS, we started work on an AIDS awareness campaign. The collection that grew out of this initiative has been exhibited all over the world. The pieces tell a visual story, sometimes bringing touches of humour to a serious subject.

Today I am able to recognise the signs of AIDS. I know what the sores mean. I can see the thrush, the colds and flu, the weight loss and the depression. I can even see it in the work. It loses an energy, a vitality. The little animal sculptures look forlorn. It is one of the toughest things to watch people dying and be unable to do anything to help them. But could I teach them to take responsibility for their own health?

When Nelly, Bonnie's sister, died in December 2002, and when I saw that Jabu Nene was ill, I was beyond sensitive talk. The gloves came off. I did not care whether I hurt Jabu's feelings or not. I wanted her to live. I challenged her, asking whether she wanted my help or whether she wanted to be taken away in a box. I was angry that this terrible disease was killing so many people – the majority of whom had contracted the virus through no fault of their own. Among women, rape is one of the major reasons for the spread of AIDS. Another is the refusal of men to use condoms.

Jabu took up the challenge, becoming an active participant in the fight against AIDS. She gives support to HIV-positive women, many of whom live in a secret world as a result of their illness. Jabu is strong and is not afraid to speak up. She is also a fantastic support to me at Ardmore, where she teaches all the newcomers.

In 2006, despite the work we were doing and the fact that ARVs were available through the PEPFAR programme, I discovered that Punch Shabalala had AIDS. Punch's boyfriend had refused to allow her to participate in the programme because he was ineligible. At the time, the South African government was still unwilling to make ARVs freely available, thus preventing the poor from having proper access to AIDS medication. Punch became so seriously ill that the Ladysmith hospital, where she had been a patient, called her family to take her home to die. I have since learnt that hospitals treating AIDS patients discharge them when there is no hope of recovery. Keeping them in the overcrowded wards is just too costly – in terms of medication and treatment as well as the space they occupy. When I fetched Punch from the hospital I thought that all I would be able to do would be to give her comfort and dignity in the days she had left on this earth – two qualities desperately missing in overcrowded hospitals.

Yet I refused to give up. I called Caversham and asked Angeline Mathebula and my driver, Gordon Mbanjwa, to pack Angeline's clothes and join me at Ardmore farm. 'I need you,' I told them. They could have refused, but they did not. Angeline had started work at Ardmore many years earlier before leaving to train as a nurse. After qualifying and working in hospitals for a while, she decided to return to Ardmore and continue the painting work she so loved. When Gordon and Angeline arrived at Ardmore, we made a little hospice for Punch in the back room, next to the studio. She weighed less than forty kilograms and was so weak she could not walk. Angeline was

Above: In 2002, when she was at death's door, Punch Shabalala was discharged from the Ladysmith hospital. This sculpture by Nhlanhla Nsundwane shows Moses Nqubuka and me carrying her home to Ardmore, 2008. After treatment with ARVs, and much love and care, Punch recovered and was able to paint the blanket in this sculpture. Her strength, love and fight for life make her an example for others.

Right: *Mother's Lament* sculpted by Petros Gumbi, 2009. The sculpture is in the collection of Cathe and John Kobacker.

able to give her round-the-clock nursing, seeing to her nutrition, ensuring she took her ARVs and, most important of all, showering her with love and care. I visited her two or three times every week. Secretly, I had my doubts that she would pull through. After three months a small miracle began to unfold. Full of determination, Punch began gaining weight. Before long, she asked if she could start painting again. Her fight for life brought tears to my eyes and I was so proud of her. It seemed to me that the act of creating beauty became a form of therapy that took her mind off the misery and depression that accompanied her illness.

Punch has always been an exquisite painter. She loves her work and continues to produce magic. Every month she wins a Triple A Award – the highest award for excellence we give at Ardmore. She is living proof to everyone at Ardmore that one can live with AIDS. She has become a mother figure, giving comfort, developing fellowship among AIDS sufferers, and showing them that they are not alone. She is also wise and sensitive to the needs of others. Despite her own problems, this charming woman always finds time to listen and guide others. Punch is deeply respected and carries the status of an elder.

I have asked myself many questions about this plague. If former president Thabo Mbeki and his government had given their full backing to the roll-out of ARVs, would it have made a difference? Has politics been the sole reason for a lack of solutions to this great fight for life? Or is there a cultural barrier; a distrust of the medicine of the *umlungu* (white person)? Or does the disease carry a shame deeply entrenched in the spirit of the people of Africa? In *Three-letter Plague*, Jonny Steinberg explores a man's reluctance to test for HIV. He writes: 'The corrosiveness of AIDS was expressed in the wasting away, not only of one's body, but of one's lineage, and, thus too, of the lineage of the dead ones who walked this earth in years gone by.' Respect and love for the ancestors, as well as fear of them, are integral aspects of African spiritual beliefs. Could this, and the shame associated with the disease, explain why AIDS continues to be a leading cause of death in Africa, despite the fact that it is no longer considered a threat to life in other parts of the world?

Punch's illness made us consider what else we could do for people with HIV and AIDS. Although ARVs are crucial to the management of the disease, good nutrition is equally important. We started providing hot meals in the middle of the day at Ardmore and at Caversham. We added natural forms of Vitamin C and lots of fresh vegetables. Within a few months we started to see an improvement. But was that enough? Could we establish a hospice to nurse people back to health? Could we raise sufficient funds to build a social and health-care centre where our artists could relax and feel safe enough to talk about their problems? There were other costs too.

Many Zulu men have multiple families. A survey revealed that each of our artists, on average, supported ten people – among them, parents, siblings, wives, children and husbands. If an artist died, we would not be able to take care of all the dependents. As much as we would have liked, our resources would not stretch that far.

We also encountered another problem. The people in the nearby settlement where some of the artists lived resented the fact that the *isigiwili*, the fortunate ones, were receiving food. They felt that, if Ardmore was giving food away, it should be to the less fortunate people in the community – those out of work. So often, when I thought I was doing the right thing, it was impossible to predict what the repercussions would be and how people were going to react.

There were other developments too. Increasingly, many of the artists who had left us in search of greener pastures started coming back, asking if they could paint or sculpt again. What they really wanted was free access to doctors and free meals. How wonderful it has been that we have managed to do so much with no funding from anyone. But it is a backbreaking task and there are limits.

Wonderboy Nxumalo's death in August 2008 was another tragic event and another sad day in my life. He was only thirty-three years old when he died – on the eve of paying *lobolo* for the young woman, Sibongile, who was to become his wife. Perhaps he wanted children. Perhaps he thought that he would be able to please his ancestors through his offspring. I would never know the answers.

During the fourteen years he spent with us, he made a very special contribution to the development of Ardmore. He earned the love of many people. We all miss his kindness and generosity of spirit. Throughout the pages of this book, we celebrate his huge talent, his love of life and his great success. His works are found in private collections and galleries around the world, and range from large pieces, one of which is displayed in the White House in Washington, DC, to small objects, such as the giraffe egg cup perched on a desk in a private home, with the words 'Let us trust love and see our love grow' written on it. His messages were almost always poignant: 'Remember true love is the one never failed, / never broken, never sleeps, never bring you tears / and never keep your face unhappy. / Smile is only needed between two people in love, / as they love together.' Sometimes his messages also mirrored the waning of his own life.

More deaths of young people were to follow, and I continued to feel sad at the loss of so many lives and so much potential. Early in 2009, Gordon Mbanjwa, our driver, died. In July 2009 I attended the funeral of Nomali Mnculwane. As with many of the other funerals I had attended, I was the only white person at the gathering. When I addressed Nomali's

Opposite and above: Wonderboy Nxumalo used the monkey as a metaphor to illustrate his message in the AIDS-awareness works he created from 2000 until his death in 2008. His plates shown here are (opposite, top to bottom) *Love Story, Can We Talk About It, There Is No Rest* and (above, top to bottom) *Believe In Me* and *Our Nation. Our Life Is On Our Hands*. In 2011 works from Ardmore's AIDS collection were included in *ARS 11*, an international exhibition held at the Kiasma Museum of Contemporary Art in Helsinki, Finland, and in a solo exhibition at the Istanbul Biennale.

family, I thanked them for giving me the opportunity to teach such a lovely young woman, and I gently reminded them that her spirit still travelled all over the world in the beautiful pieces she had painted.

AIDS has focused my mind more sharply on the sustainability and future of Ardmore. Towards the end of the twentieth century, the need to train young people had virtually fallen away. Everyone knew what they were doing. All I needed to do was come up with ideas and mentor the artists. It meant that I had time to spend on marketing and, as a result, Ardmore grew. Then, one day, I woke up to the fact that Ardmore was facing a severe talent loss. I needed to roll up my shirtsleeves and start over again, working alongside young men and women, just as I had done with Bonnie in the 1980s.

Despite the sorrow, we have one big advantage at Ardmore. Our artists love their work and are proud of their achievements. The beauty of the work they do gives their lives meaning and provides an escape from the silence, or stigma, that surrounds their illness. They have a great role model in Punch Shabalala. Punch is living testimony of the fact that it is possible to face the truth, to accept the reality of a compromised immune system, and to move out of self-denial. She knows that to take ARVs is to conquer the disease. At Ardmore she is leading a change in attitude and helping to end the silence. We can only hope that, as Wonderboy writes: 'There will be an answer at the end.'

Left top and middle: Espresso saucers painted and inscribed with messages by Wonderboy Nxumalo, 2001.

Left: Wonderboy Nxumalo, with his much-loved cowboy hat, always reminded me of Puck, the mischievous imp in the Shakespeare play *A Midsummer Night's Dream*. In 2001 Wonderboy travelled to Aberystwyth in Wales to participate as a demonstrator in the International Ceramics Festival, where he stole everyone's heart. I am thrilled that he was honoured in this way as one of the world's leading ceramicists.

Above: Wonderboy Nxumalo writes from his heart about his own ill health, hoping that there will be an answer in the end, 2006. Sadly, the end came too soon; he died of an AIDS-related illness in August 2008 at the age of thirty-three.

After Bonnie Nthsalintshali died, I wanted to honour her memory by sharing my collection of her work with visitors to Ardmore and with the artists, who could learn from her unique talent. In addition, through the works of Petros Gumbi, Nhlanhla Nsundwane and Wonderboy Nxumalo, we had started to develop special collections on Zulu history and culture. I felt that it was important to preserve these collections in a far safer place than in my home, where wagging tails and running feet frequently resulted in broken bits. Establishing a museum at the studio at Springvale was the answer.

As well as display Ardmore's work, such a facility could also serve a broader educational purpose, particularly for the many schools in the KwaZulu-Natal Midlands. The children would relate to the religious stories told in many of Bonnie's larger pieces – like those of Adam and Eve, Daniel and the lion's den, Moses in the bulrushes, and Jonah and the whale. Without further ado, I asked my sister-in-law Gillian Scott to help me start an educational centre in the old stone cow shed on the farm. She agreed, and in 2001 started assembling a collection for the centre. Gillian knew Ardmore well. Some years earlier she had worked at the Local History Museum in Durban and, when she gave up her job, I suggested she write a book on Ardmore. The book, *Ardmore – An African Discovery*, published in 1998, is now out of print and, much to my surprise, a signed copy fetched a good price at a sale at Sotheby's.

The Zulu history collection came about when we were asked to make a series of works that would promote French interests in South Africa. For inspiration, we listened to an audio programme on the Anglo-Zulu War, *Day of the Dead Moon*, written and narrated by David Rattray. The collection started with the moving story of Eugene Louis Jean Joseph, Prince Imperial of France. The son of the exiled Emperor Napoleon III, he joined the British forces in Natal as a volunteer during the Anglo-Zulu War but was killed by a Zulu *impi* in June 1879 while on a reconnaisance in Zululand.

As the collection grew, Wonderboy became increasingly fascinated with the story of Major Anthony Durnford and the amaHlubi and Phutini, who had lived in the foothills of the Drakensberg in the 1800s, near present-day Ardmore. Durnford is famous for the role he played in the Langalibalele rebellion in 1873. When Langalibalele, the chief of the amaHlubi, refused to obey the colonial government's order for his clan to register their firearms, he was declared an outlaw. Along with his tribe, he fled over the Drakensberg to Basutoland but was pursued by a mounted force, including a unit of the Natal Carbineers, led by Durnford. When they caught up with the amaHlubi at the top of the Bushman's River Pass (now Langalibalele's Pass), a skirmish broke out, leaving Durnford injured and five of his men dead. The unit was

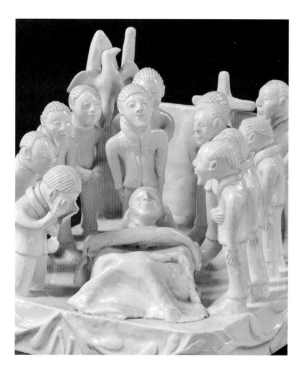

Opposite: *The Murder of Shaka* sculpted by Petros Gumbi, 2002.

Above: *The Funeral of the Prince Imperial* sculpted by Nhlanhla Nsundwane, 1999.

Below: Sculpture of a Zulu warrior and British soldier by Sondelani Ntshalintshali, 2005.

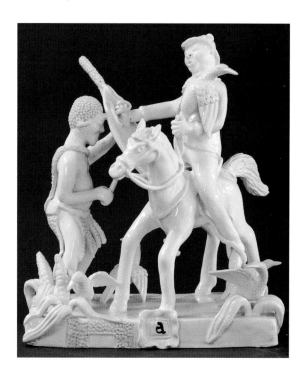

Below: Sculpture of the Prince Imperial facing his death created by Nhlanhla Nsundwane, 2001.

Right: Nhlanhla Nsundwane sculpted this commemorative bowl, which illustrates the story of the death of the young Prince Imperial at the hands of Cetshwayo's army. The eagles on the rim of the bowl are symbolic of the Napoleonic era. The bowl was painted by Wonderboy Nxumalo in 1998.

My own interest in the story of the Prince Imperial of France grew when I learnt about his passion for horses, with which I could identify. The prince was said to have been a magnificent rider and had ranked first in this skill when he graduated from the Royal Military Academy at Woolwich, England. When the young prince arrived in Durban at the end of March 1879, one of the horses he brought with him was killed on landing and a second one took ill. The very next day he happened to look out of the window of his hotel and saw a stunning grey. He promptly bought Percy, and a second horse whose name was Fate.

Two months later, the prince, riding Percy, other mounted soldiers and a Zulu guide set out on a routine patrol into Zululand. At about 4 p.m., the guide reported that he had seen a Zulu near the river. Scarcely had the order to mount been given than a volley of fire ripped through the long grass nearby and about forty Zulus charged the group. The prince made a desperate effort to mount his frightened horse and then ran with him, holding onto the stirrup leather. When it broke he turned to face his enemy. The odds were overwhelming and in a few minutes he was stabbed to death.

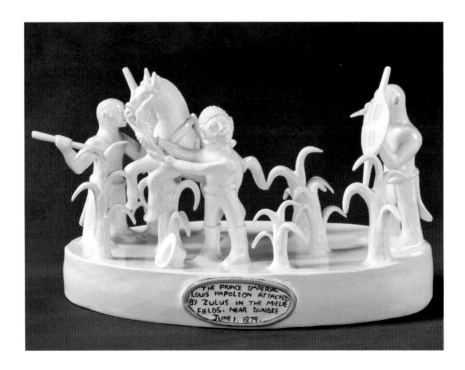

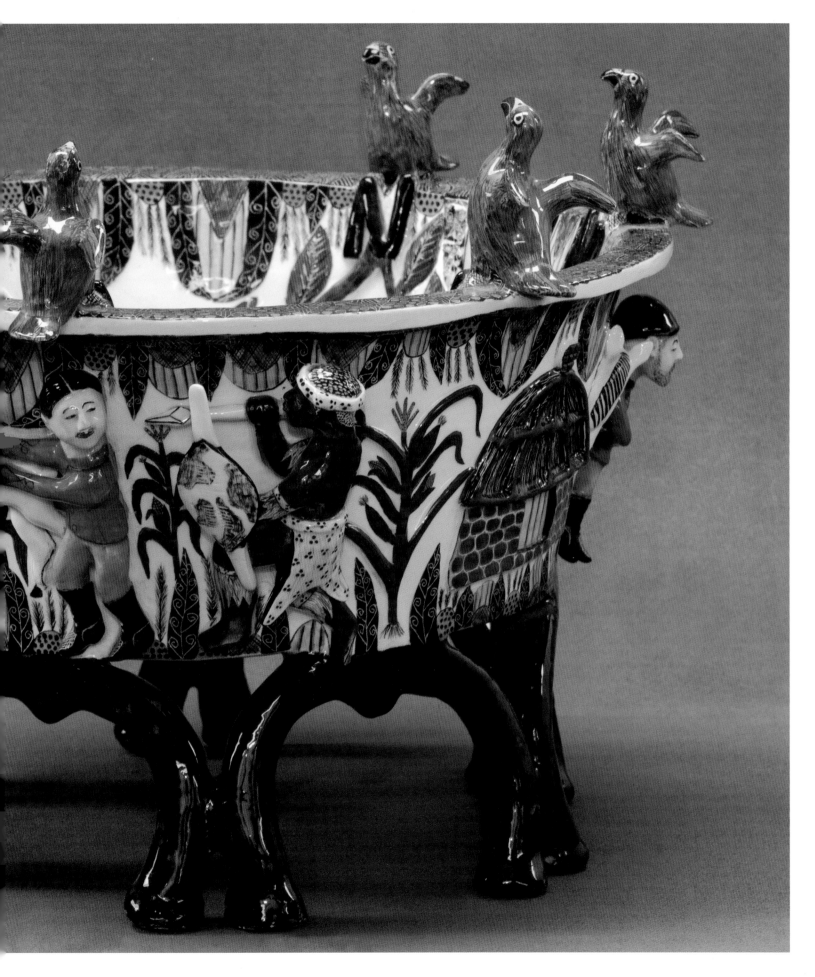

Above: Petros Gumbi models one of the figures for the group sculpture *Young Boys Riding Oxen for Fun* (below right), 2007.

Opposite top: Petros Gumbi created a series of sculptures inspired by David Rattray's audio programme on the Anglo-Zulu War, *Day of the Dead Moon*. This sculpture, 2001, depicts the crowning of Cetshwayo by Theophilus Shepstone in 1873, which took place a few days after Cetshwayo had been crowned in a traditional Zulu ceremony.

Opposite bottom: *John Dunn With His Izindunas* (advisors) sculpted by Petros Gumbi, 2002. John Dunn was a principal advisor to Cetshwayo prior to the Anglo-Zulu War. He became the largest landowner in Zululand when he was appointed one of eleven Zulu chiefs to control the territory after Cetshwayo's imprisonment following the Battle of Ulundi in 1879. Cetshwayo believed that he had been betrayed by his friend.

compelled to retreat. Langalibalele eventually surrendered and was sent to Robben Island. Durnford died six years later, in January 1879, at the Battle of Isandlwana. Inspired by all that he had learnt, Wonderboy could not wait to get started. The collection was first shown at the Natale Labia Museum in Muizenberg in 2001.

Ardmore was a hive of activity the following year: with the Anglo-Zulu War plates and AIDS Awareness Monkey collection completed, we could focus our attention on the opening of the Bonnie Ntshalintshali Museum. Afterwards, I realised that we had established the first museum in South Africa dedicated to a black artist. The museum attracted a steady stream of visitors, including schoolchildren from the district.

When we moved to Caversham three years later, we were fortunate enough to be able to recreate the museum in the new gallery. It includes all the original museum items as well as many special pieces that have been sculpted and painted by a new generation of artists.

One of these artists is Petros Gumbi. Petros had been working in Johannesburg for a while when, at the end of 1998, he returned home to KwaZulu-Natal to visit his family. During the visit, his uncle, Nhlanhla Nsundwane, introduced him to Ardmore. Petros had loved playing with clay as a child and felt that God had given him a special talent. Although he had no previous art training, I gave him the opportunity to learn and he quickly became a sculptor of some renown.

Petros admits that he was impatient when he was young. He wanted to complete his work quickly so that he could see the results. Looking back, he says that Ardmore taught him the value of time and patience. Many of his sculptures, some of which are on display in the museum, show the influence that both his uncle and Bonnie have had on his style. He also learnt from the work of a visiting American ceramicist and sculptor, Matthew Stitzlein, who had spent time at Ardmore as an intern in the late 1990s.

Petros has surpassed the sculptural skills of the legendary Bonnie Ntshalintshali. His instinct and abilities are so far-reaching that he has yet to

ARDMORE – WE ARE BECAUSE OF OTHERS

The Prince Imperial project and Wonderboy Nxumalo's passion for history inspired us to create a collection of works focusing on the Anglo-Zulu War of 1879. Wonderboy and I sat in my car for days on end listening to the tapes of David Rattray's series on the Anglo-Zulu War, *Day of the Dead Moon*. Few of the artists knew much of their own history and David's series, which contains several moving descriptions of the war, awakened their pride. David grew up in Zululand and collected many tales about the war from Zulu people whose forefathers had fought against the British. He also drew on written accounts, such as the letters sent home by young Welshmen who later lost their lives at Isandlwana. Wonderboy's plates, created in 2001, eloquently illustrate the turmoil of the war.

1. The Battle of Isandlwana erupted on 22 January 1879 at the foot of the sphinx-like mountain known as Isandlwana. It has been described as the greatest military disaster in British colonial history. Armed with Martini-Henry breech-loading rifles, more than 1300 British troops were annihilated by the 20 000-strong Zulu army wielding short stabbing spears.

2. Wonderboy was particularly entranced by the role played by Colonel Anthony Durnford in the Battle of Isandlwana. Durnford led a mounted column of men but was killed on his horse, Chieftain, during the battle.

3. Lieutenants Melvill and Coghill, who fled the battle scene at Isandlwana to save the Queen's Colour, died while attempting to cross the swollen Buffalo River. They earned the first posthumous Victoria Crosses in history.

4. Immediately after Isandlwana, Cetshwayo's half-brother, Prince Dabulamanzi, attacked Chelmsford's camp at Rorke's Drift, where 139 men, including patients and hospital staff, fought bravely against the Zulus. The highest number of Victoria Crosses ever awarded for a single battle were won that day.

5. On 1 June 1879, just prior to the final battle of the war – the Battle of Ulundi – the young Prince Imperial of France was killed.

6. After their defeat at Isandlwana, the British called for reinforcements. The final battle in the war took place at Ulundi on 4 July 1879. The power of the modern rifle proved devastating, and an estimated 1500 Zulus lost their lives. The battle effectively ended the war and the Zulu kingdom.

1.

4.

2.

3.

5.

6.

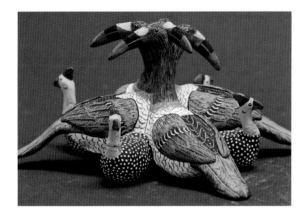

Top and middle: Saddlebilled storks and guineafowl sculpted and painted by Bonnie Ntshalintshali, 1998.

Above: Inspired by Bonnie's work, Petros Gumbi sculpted a bird posy which was painted by Nomali Mnculwane, 2008, for the reopening of the Bonnie Ntshalintshali Museum.

Opposite: Sculpture of Bonnie surrounded by her work created and painted by Petros Gumbi, 2002.

settle into one particular mode of sculpting; he employs the same technique his uncle uses to create solid, small figures, while also applying hand-coiling to produce larger figures. His work has been bought by several collectors and art institutions, including the Koninklijk Instituut voor de Tropen in the Netherlands, the Design Museum Holon in Israel and, at home, the Tatham Art Gallery in Pietermaritzburg. In turn, Petros has influenced the work of Nkosinathi Mabaso and Sondelani Ntshalintshali, both of whom have worked closely with him since the move to Caversham.

In preparation for the reopening of the Bonnie Ntshalintshali Museum at Caversham in 2008, I asked each artist either to produce a replica of a work done by Bonnie or to make a new piece inspired by her creativity. The artists could choose what they wanted to do and what size they wanted their works to be. This process became far more than mere preparation for an exhibition. It took the artists out of their comfort zones and into a different style of creativity. It taught them about Ardmore's history and gave them a better appreciation of Bonnie's beautiful work and her sense of style and balance. It also gave them the opportunity to review their own approaches, ideas and styles.

Lindiwe Mabuza, who flew in from London, thirty-two artists from Ardmore Champagne, twenty artists from Caversham and a multitude of guests joined us on 20 September 2008 to celebrate the reopening of the Bonnie Ntshalintshali Museum. Despite the pouring rain and freezing temperatures – it was snowing just ten kilometres away – we had a wonderful day. We had to abandon our plans for a garden party and had no choice but to huddle together in the gallery. Luckily, there was enough room for everyone. The camaraderie and fellowship, the fun and the goodwill made the day one of the most memorable in the history of Ardmore. The event was a huge learning experience for the artists; they mingled with the visitors and were proud to be part of Ardmore. Most of all, I was delighted that Bonnie's father, her sisters and her son, Senzo, were there to see her memory honoured. Senzo cut the ribbon to open the museum. The next day, people who came to see the snow made a detour to see us too.

In the years to come we will add to the Ardmore collection – both as we select pieces that we cannot bear to part with and as friends donate some of the works to the museum that they bought previously. The collection will never be complete as we will keep expanding it by adding some of the best works produced in the future. The problem is that we are already full to bursting; if we are to show any more pieces, we will need a bigger museum. That is another dream!

The museum is not just a showcase of Ardmore's history; it also pays tribute to the artists and their successes, and commemorates those who died of AIDS-related illnesses, most while still in their prime.

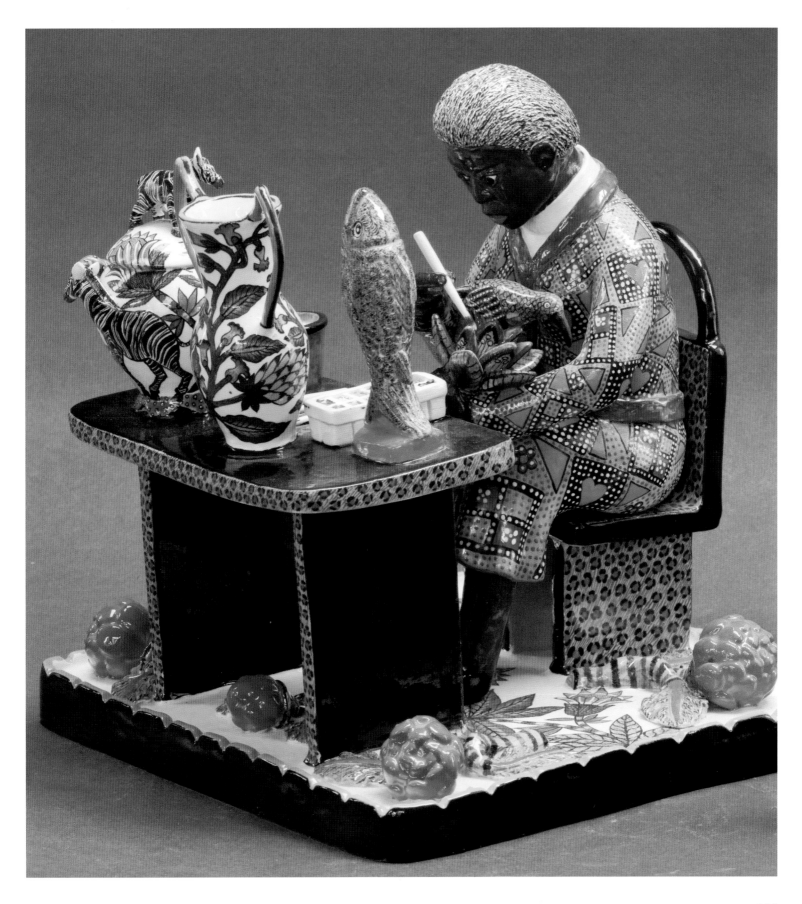

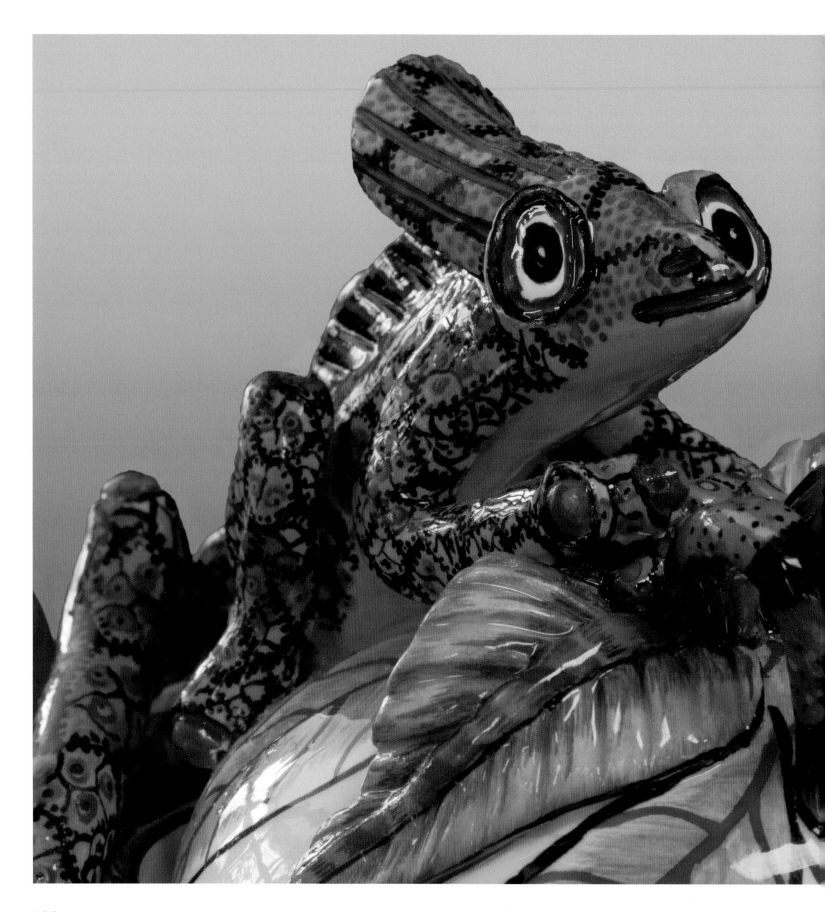

e were fortunate that among the first men to arrive at Ardmore were the hugely talented Wonderboy Nxumalo and Nhlanhla Nsundwane. Of Zulu origin, both men were small of stature, dignified and respectful. They were exceptions to the preconceived idea of the big, masculine, traditional Zulu warrior. Nhlanhla's nephew, Petros Gumbi, a giant of a man who arrived later in the 1990s, had the same gentleness and respect as his uncle. In no way did they prepare me for the next generation of young men who came knocking on Ardmore's door.

These newcomers took Ardmore by storm. They came with ego, verve and vigour. They challenged old ways and broke new ground. They resisted regimentation and really put me to the test. Many of them had headed for Johannesburg after finishing their schooling, hoping to earn a living from their talents in singing, music or art. When success eluded them, they returned home. Here they saw that the women in their communities who were working at Ardmore had everything they wanted themselves: freedom and money. They did not want constraints on their creativity and they were prepared to learn. At Ardmore they would soon become brilliant at the work they did, and their efforts would allow them to prosper.

These young men had grown up in an era led by Nelson Mandela and Thabo Mbeki and had received a far better education than the previous generation. Some of them had even done art at school. They wore jeans and knew about computers. They were ambitious and confident, and they wanted to learn quickly and expand their horizons. They were prepared to ask questions and voice their opinions. In their artistry, they were daring and dashing. They had the confidence to push the pliability of clay to its limit and were unafraid of failure. What a far cry from the apartheid era, when there was little hope of a decent future for black South Africans and fear was the order of the day.

Three sculptors, Somandla Ntshalintshali, Zeblon Msele and Victor Shabalala, soon started to make an impact with their astonishing creativity. Four other young artists followed their lead: Sfiso Mvelase with his satirical and sensual sculptures that make one laugh; Slulamile ('Slu') Mlambo with his wonderful originality; and Bennet Zondo and Mthandeni Mkhize whose hard work and determination were inspirational. The art forms that these men produced called for a new style of painting – that of embellishing the piece and allowing the sculpture to be the dominant art form. Two artists excelled in doing exactly this: Virginia Xaba and Jabu Nene, who paints sculpted pieces with scales, feathers, dots and beads. A third artist, Roux Gwala, has done exceptionally well too.

Victor Shabalala was born on Ardmore farm in the Champagne Valley in 1973. He grew up in the Magweni village on the hill above the farm

where the Shabalala and Ntshalintshali families have lived for nearly two centuries. By the time he left school, although he was well aware of the work being done by many of his friends at Ardmore, he headed for Johannesburg and found employment at a Shoprite store. But there was always a desire to return to his family and his friends, including Vusi Ntshalintshali, who had already made his mark as a thrower and sculptor at Ardmore. In 2001 Victor returned home to seek an outlet for his hugely creative spirit.

Victor has become a daring and passionate artist, and his artworks are particularly inventive. He pushes the frontier of what can be done with clay, testing the plasticity and malleability of his material to its limit. He brims with confidence and knows exactly what to do. He is not afraid; if a piece cracks or breaks, he does not mind starting all over again. The sculpted figures he puts onto a jug or vase dance and sway, giving his forms a rhythmic quality – the long legs of his giraffes and the long beaks and necks of his birds have movement and are dynamic. He often depicts the life cycles of animals, birds or reptiles in his sculptures, adding to the sense of rhythm and tension evident in his forms. His whimsical, sometimes grotesque, sculptures have a fascination of their own and are definitely not for the faint-hearted. Sometimes he adorns traditional ceramics with big-eyed frogs, chameleons, lizards, crocodiles or snakes, many of which he models on the gargoyles he encountered in London.

Victor's unusual pieces have been included in many of Ardmore's exhibitions around the world. His uninhibited 'bonking zebras' candlesticks, painted by Virginia Xaba, were loved and laughed about at the 2008 Groote

Above, below and previous spread: These works by Victor Shabalala were painted by Jabu Nene, 2006 (fish tureen); Zinhle Nene, 2006 (crocodile tureen); and Mthengeni Ntshalintshali, 2008 (chameleon tureen). The fish and crocodile tureens are in the collection of Susan Mathis.

Opposite: Victor Shabalala, 2009.

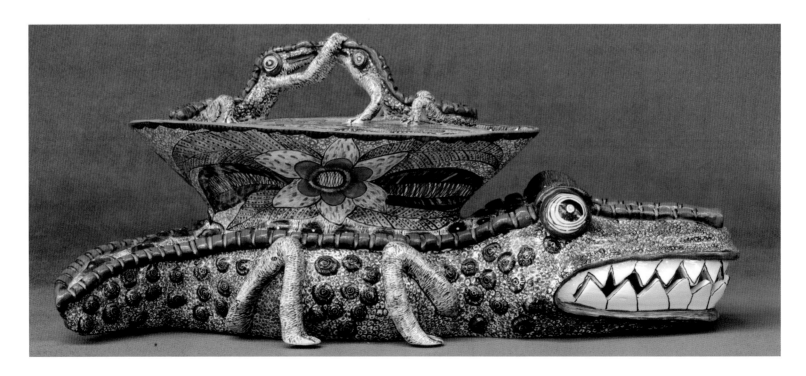

Schuur exhibition in Cape Town, as well as being frowned on by some of the more conservative members of society. Victor's unusual pieces include a pair of candlesticks showing the birth of an elephant, also painted by Virginia, who, although a realist, enjoys painting the works of Victor and Sfiso.

Victor shows independence, initiative and awareness, and has seized the opportunities that have come his way. Under his own steam, he drove to Johannesburg and tried, unsuccessfully, to persuade Josephine Ghesa to come back to work at Ardmore. Also on his own initiative, he entered the Absa L'Atelier art competition and, at his own cost, drove to Durban to submit two sculptures that he selected himself. He was one of ten finalists and was flown to Johannesburg for the awards dinner. He came home with a merit award, a R25 000 cheque and the confidence that he would do better next time. He has also gained valuable international experience as an Ardmore representative at exhibitions in London in 2006 and Miami in 2009.

Born in 1980, Somandla Ntshalintshali is the younger brother of Christopher Ntshalintshali. He started work as a gardener at Ardmore, but

Above: Mthengeni Ntshalintshali paints many of Victor Shabalala's sculptures, mixing his own colours and creating a distinctive palette.

Below, right and opposite: These works sculpted by Victor Shabalala were painted by Jabu Nene, 2008 (zebra teapot); Mbusi Mfuphi, 2007 (fish and heron lidded dish); and Mthengeni Ntshalintshali, 2008 (giraffe container).

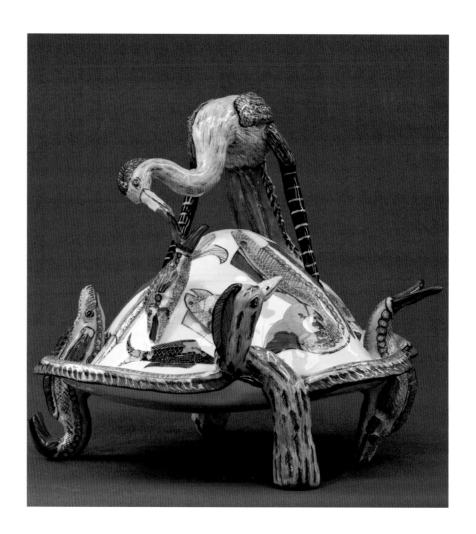

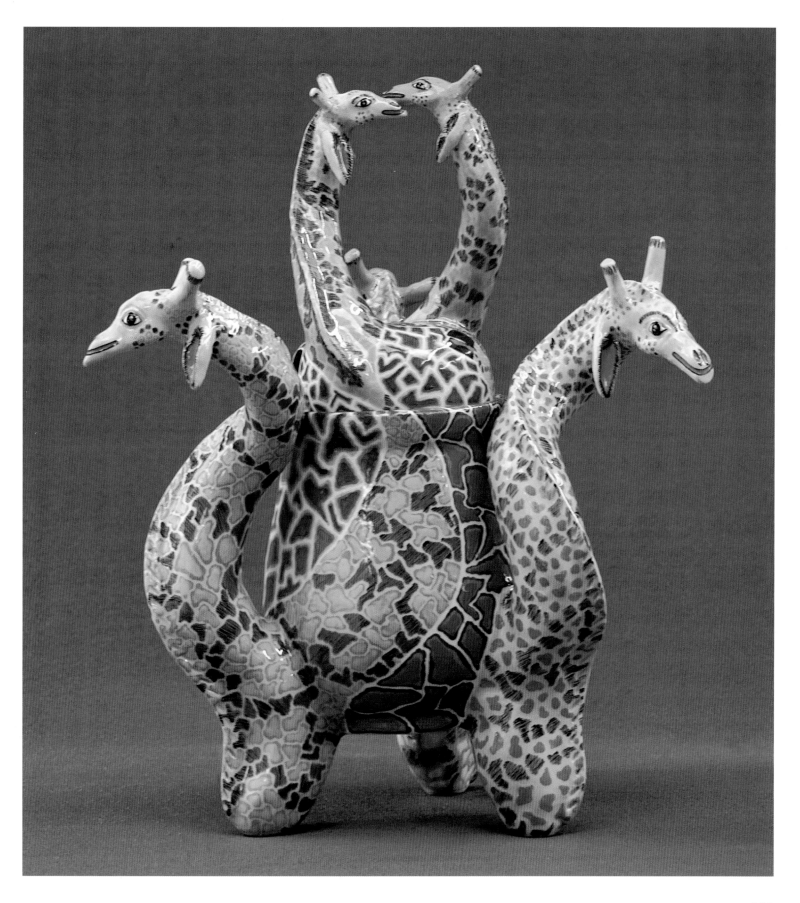

soon Moses Nqubuka discovered that he played with clay in his spare time. When I saw his work I immediately offered him a place at Ardmore. It has pleased me no end to see the joy and fun in his artistry. Another one of the new generation of young artists, he fearlessly pushes the limits of clay. Given his ability to create an elegance and lyrical grace that is simply breathtaking, I believe he has the potential to build a great future for himself in the art world. His big lotus flowers, upside-down elephant candlesticks and stylised birds and fish are full of rhythm and energy, and are remarkably beautiful. Often the figures he sculpts become an integral part of the form; they are not simply items glued onto his pieces. For instance, the elongated neck of a flamingo becomes a candlestick and the long tail of a crocodile swings around in a circle to create a bowl. When we travelled to London for our Christie's exhibition in 2003, I discovered, much to my delight, that Somandla shares my passion for horses.

Sfiso Mvelase was born in 1980 with a twinkle in his eye. Despite the difficulties of growing up in KwaZulu-Natal and the poverty his family suffered when his father deserted them, he never lost his sense of fun. He displayed a talent for sculpting at a very early age, sitting on a river bank tending cattle during the times when his family could not afford to send him

Above: Urn showing traditional Zulu lion and leopard hunting scenes sculpted by Somandla Ntshalintshali and painted by Jabu Nene, 2007. Somandla won a merit award for this work at the 2011 Gyeonggi International Ceramix Biennale in South Korea.

Right: Somandla Ntshalintshali's brilliantly elegant work, mostly painted by Jabu Nene, has caught the attention of the art world. He travelled to London when his sculptures were shown there in 2004 and 2007.

Opposite top: Fish platter sculpted by Somandla Ntshalintshali and painted by Jabu Nene, 2007.

Opposite bottom: Porcupine bowl sculpted by Bennet Zondo and painted by Virginia Xaba, 2007. When this artwork did not reach its reserve price at the Christie's auction in 2007, Virginia carried the sculpture back to the hotel on her head – an indelible image. The *gugumbane* (porcupine) is greatly disliked by Zulu farmers as it can destroy a maize field in a single night.

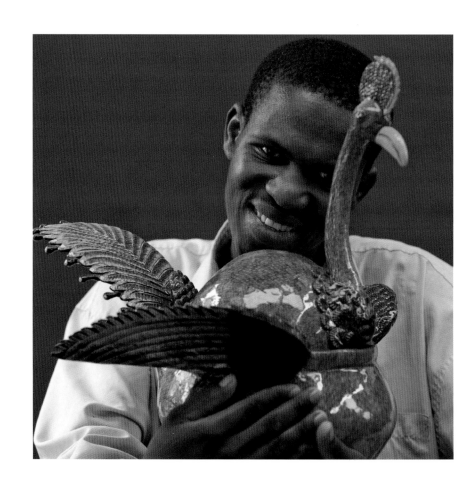

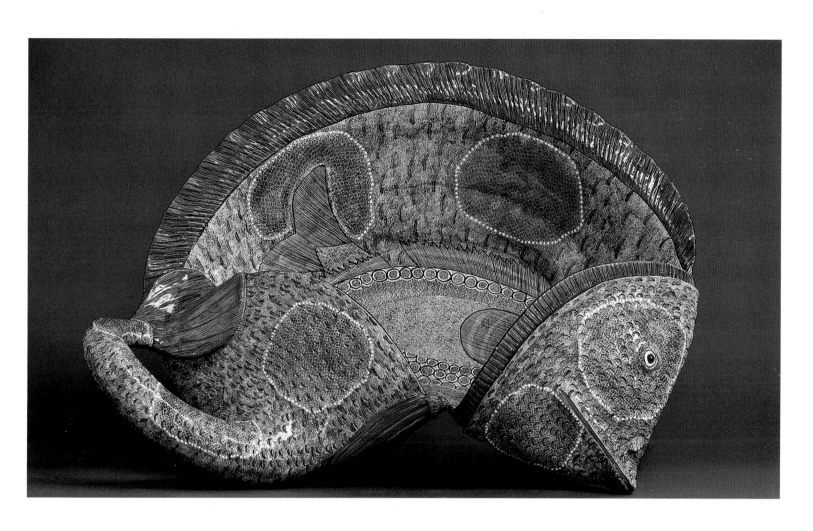

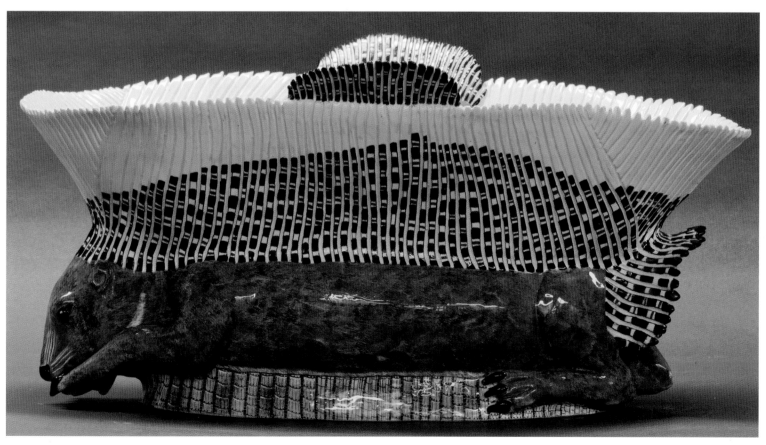

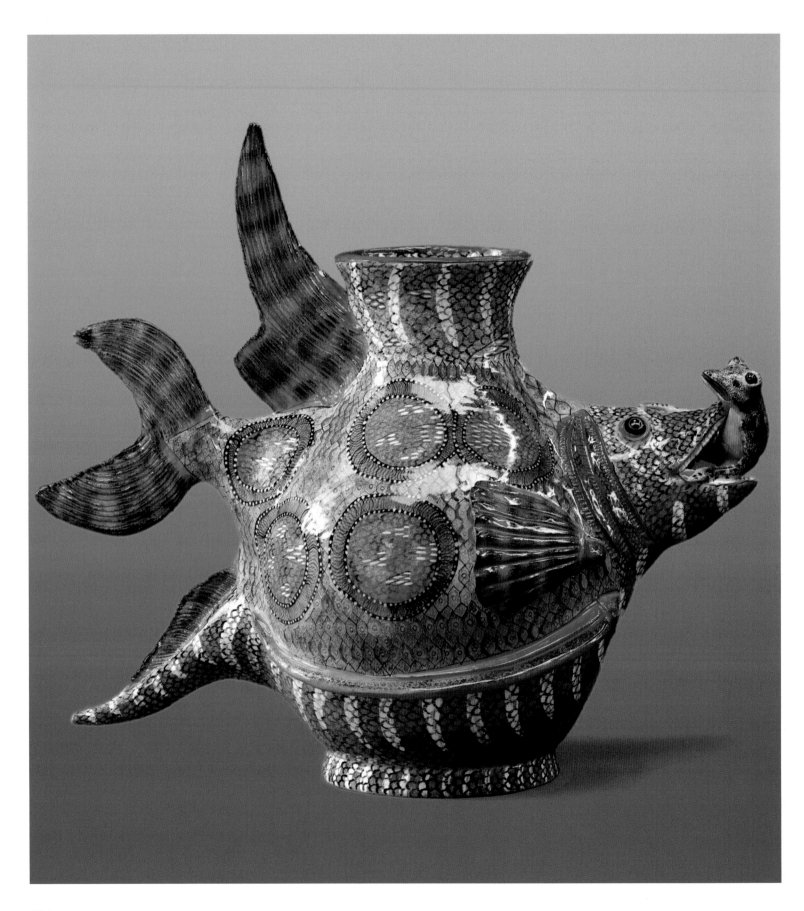

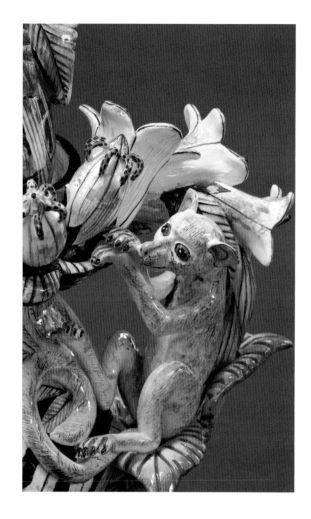

to school. After grade seven, this creative young man was forced to abandon school in order to find a job. When he eventually found work as a gardener, he used his paltry earnings to support his mother and three siblings.

In 2002, twenty-two-year-old Raphael Njoko, whose family lived in the Bergville district of KwaZulu-Natal, introduced Sfiso to Ardmore. I soon became aware of his amazing creativity. At first glance, it is almost impossible not to smile at his erotic animal sculptures. But, on closer inspection of his prolific work, one discovers that, embodied in his charming figures, there is often satire or a subtle message of significance. Roux Gwala paints many of the pieces sculpted by Sfiso, and Punch Shabalala and Wiseman Ndlovu also enjoy finishing his unusual work.

Slulamile Mlambo, with his wonderful originality, started sculpting clay at Ardmore over weekends when he was still at school. He is truly gifted and I hope that he will achieve his potential of becoming one of South Africa's great artists. But first he needs to sow his wild oats and, like most young men, he does not want to be told what to do. He is still young and has much to learn about life, but his ability is evident.

Opposite, above right and below: These works sculpted by Sfiso Mvelase were painted by Octavia Buthelezi, 2008 (fish and frog vase); Wiseman Ndlovu, 2008 (bushbaby and lily tureen); and Zinhle Nene, 2007 (insect bowl).

Above left: Sfiso Mvelase, Ardmore's 'naughty boy', is known for the fun evident in his work.

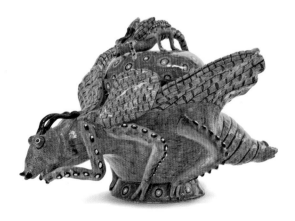

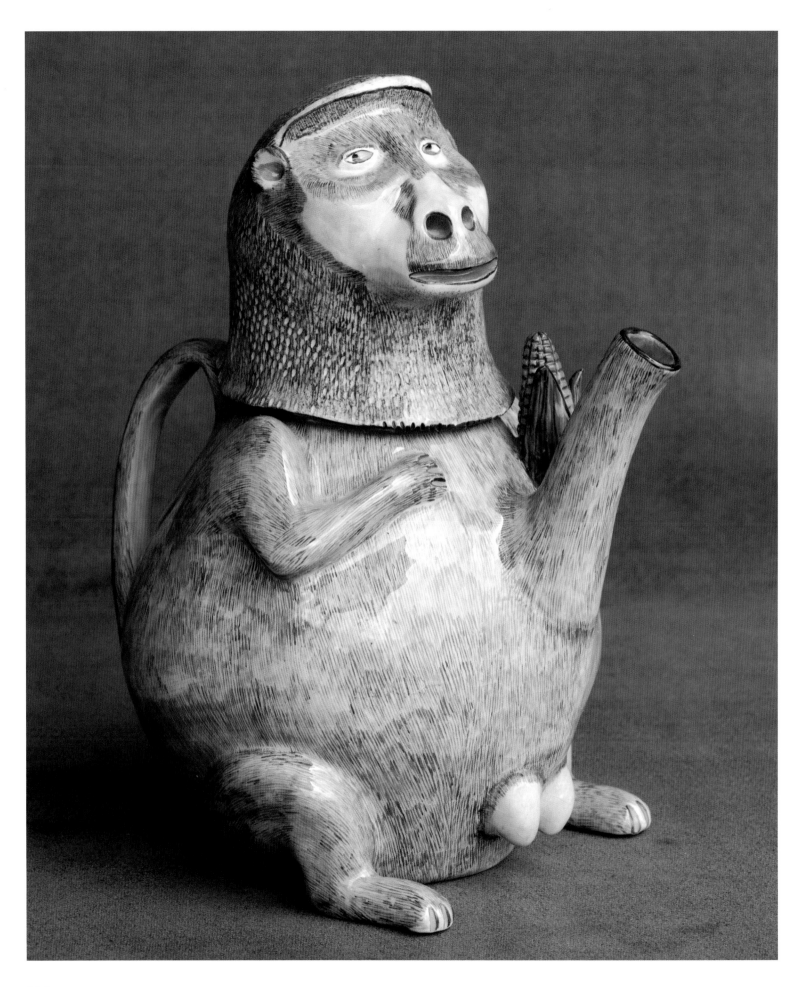

Two other sculptors, Bennet Zondo and Mthandeni Mkhize, fall somewhere between the free spirits whose sculptures are expressive of their own imagination and the naturalists whose works are inspired by the physical world around them. Bennet was born in Lesotho. Like most of the young men there, he tended the family's cattle, relieving his boredom by moulding clay found on the river banks. At the age of twenty, he left Lesotho for South Africa in search of better opportunities. Through Sfiso, he found an outlet for his talent at Ardmore and quickly developed into one of Ardmore's top artists.

Like his cousin Bennet, Thabo Mbhele grew up in Lesotho but left the country to find work in South Africa. He discovered Ardmore while visiting Bennet, and it kindled in him a deep desire to work with clay. He found an excellent mentor and teacher in his cousin, who took him under his wing and taught him the fundamentals of ceramic sculpting. Thabo is a master of invention and a highly original sculptor, and it is little wonder that he has become one of Ardmore's most successful artists.

The works produced by all these artists are exceptional and are usually sold to art collectors through auction houses and art galleries. Christie's, Sotheby's and Bonhams in the United Kingdom, the Amaridian Gallery in New York, and the Everard Read Gallery and Gallery on the Square in Johannesburg have all sold their works.

Opposite: Monkey teapot, inspired by Egyptian funeral urns, sculpted by Nhlanhla Nsundwane and painted by Virginia Xaba, 2000.

Above right: Thabo Mbhele's artworks can be found in some of the finest international collections.

Below: Leopard bowl sculpted by Somandla Ntshalintshali and painted by Jabu Nene, 2009.

Right: Frog pot made by Slulamile Mlambo and painted by Jabu Nene, 2008.

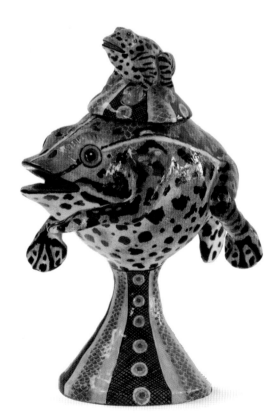

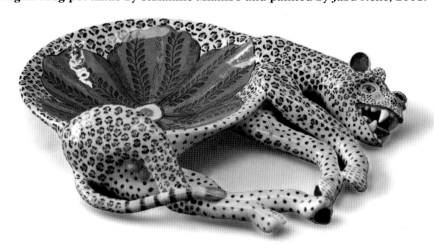

a

Ardmore Ceramic Art

A celebration of
"The Wonderful
World of Ardmore"

Groote Schuur Estate
9, 11, 12 February
2008

n July 2007, Eleanor Kasrils asked if we would like to hold an exhibition at Groote Schuur Estate, the historic home of Cecil John Rhodes, premier of the Cape at the end of the nineteenth century. The exhibition was to coincide with the opening of parliament in February 2008. Thanks to Eleanor, we were given a wonderful opportunity to celebrate the nation's uniquely African artistic talent and to do so in a spectacular setting.

I was most excited about the event, and pleased that our travelling and venue hiring costs would be kept to a minimum. We would travel by road and had no need of passports, visas and the confusion of currency changes that marked our international shows. I also thought that, after the complex exhibitions we had held all over the world, setting up this show would be simple. But, with one crisis after another, I soon discovered that there was more to learn.

Planning for the Groote Schuur show could start only once we had completed the work for the *Great Cats of the World* exhibition, scheduled for the end of July 2007 at Charles Greig Jewellers in Hyde Park Corner, Johannesburg. The realistic style of the pieces created for that collection was highly successful and served as an inspiration in conceptualising the works for the forthcoming show at Groote Schuur. Taking the lead were sculptors Sondelani Ntshalintshali, Petros Gumbi, Bennet Zondo, Sabelo Khoza and Nkosinathi Mabaso, as well as two young painters, Wiseman Ndlovu and Mickey Chonco, who had proved their worth on the *Great Cats* exhibition. Another youngster, Siyabonga Mabaso, who hailed from the Caversham area, was showing potential as a painter and I had no doubt that his work would be on display at Groote Schuur. We also had the expressionists to add spice to the collection. The result was that the style and quality of our work rose significantly, which was later reflected in the value the art world placed on our ceramics.

We had barely seven months in which to prepare for the exhibition, and I had many ideas for the 400 pieces we planned to display. I wanted big pieces that would fill the ample space of the manor house, where they would be placed on the grand piano and the massive dinner table, around the huge fireplaces and in the enormous entrance hall. I also wanted lots of small pieces that visitors could carry home with them. The Western Cape's natural wonders would serve as our subject matter: proteas, whales, baboons, penguins, herons, guineafowl, sunbirds and cranes. In addition, we would feature lions, which had once roamed the slopes of Table Mountain, and rhinoceros, elephants, springbok and monkeys.

Despite having no trouble assembling the collection of ceramics that would make Groote Schuur the best exhibition we had ever had, it was

Opposite: The poster advertising Ardmore's exhibition at Groote Schuur Estate in 2008.

Above: Groote Schuur, designed by Sir Herbert Baker, was the home of Cecil John Rhodes. On his death, Rhodes bequeathed it to the nation.

Below: Lion candlestick sculpted by Sabelo Khoza and painted by Wiseman Ndlovu, 2007.

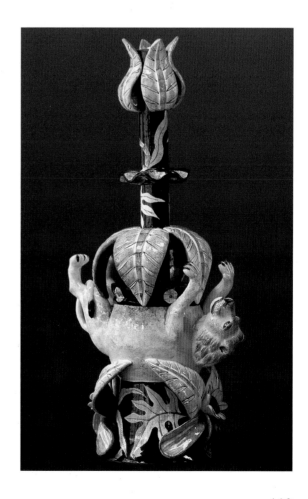

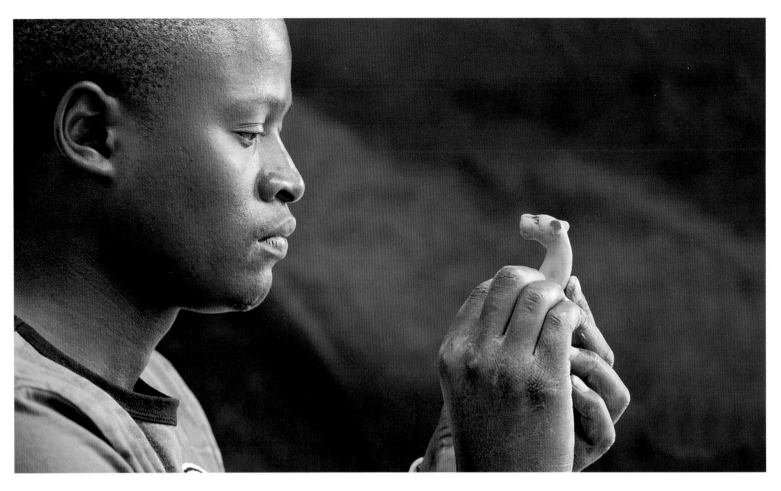

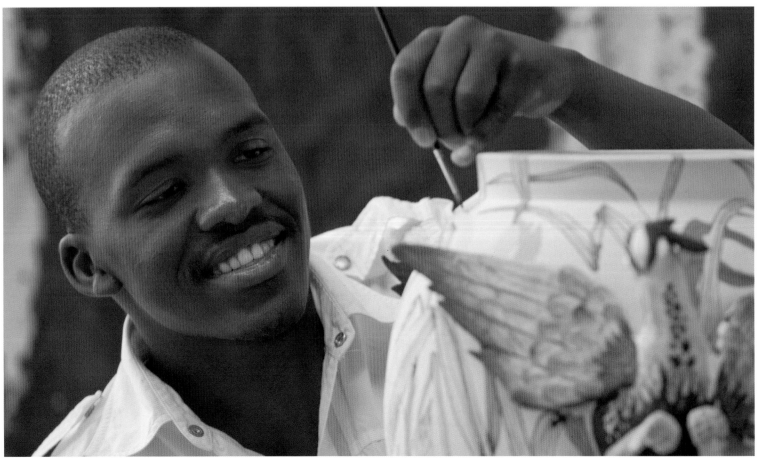

clear from the beginning that it was not going to be an easy ride. A friend, Anthony Record MBE, told me, 'There's no money in Cape Town. We had an exhibition at Groote Schuur and never sold a thing. Don't get too excited.' The Groote Schuur curator at the time, Alta Kriel, said much the same thing. Several artists had exhibited paintings there and had sold nothing. It was almost as though Rhodes's ghost was making sure that his magnificent home with its beautiful furniture was not to be used for commercial purposes. For me it was a historic occasion. I thought that perhaps Ardmore, with all its energy and colour, would break the spell and bring the house to life. But I was not holding my breath.

Two outstanding teams made some of the spectacular large pieces for display at Groote Schuur: the duo of Sondelani and Wiseman, and a team consisting of Nkosinathi, Mickey and Sabelo. Over this period, Nkosinathi matured into one of Ardmore's finest sculptors.

By November the collection was coming together beautifully. The publicity material had already been designed, and there was plenty of time for printing and distribution before our opening on 9 February 2008. However, when we showed Eleanor the brochure, she very sensibly suggested that we should include a message from Zanele Mbeki, the wife of President Thabo Mbeki, and one from Lindiwe Mabuza, who had agreed to be our guest of honour. This was easier said than done. Jacob Zuma had just taken over as head of the ANC and communicating with senior members of the government was near impossible. The weeks ticked by, the year ended and we still had nothing. Then, early in the new year, I managed to reach Lindiwe in London and a few days later we had her message. A week later Zanele Mbeki's message arrived. But we were not out of the woods yet – the printer had not yet reopened after the year-end holidays. Fortunately, ten days before the opening, we had our publicity material. Everything looked marvellous and we were off at breakneck speed, posting invitations and delivering posters to hotels, art shops, galleries, interior decorators, restaurants and golf clubs – in fact, anywhere we could find people who had an interest in art and ceramics.

We packed up the 400 pieces, including some works from the museum collection, and loaded the six berths of our Ardmore horse truck from floor to ceiling. Right on time, the party of artists, headed by Christopher Ntshalintshali and Lovemore Sithole, set off on their 1600-kilometre journey, with Gordon Mbanjwa driving the truck. Four artists travelled in the cab of the truck, while seven squeezed into the Citroën that Angela Gill, our accountant, kindly lent us.

Angela and I flew to Cape Town, scheduling our arrival to coincide with that of the artists. My mum, who was celebrating her eighty-fourth birthday during the exhibition, arrived a few days later together with

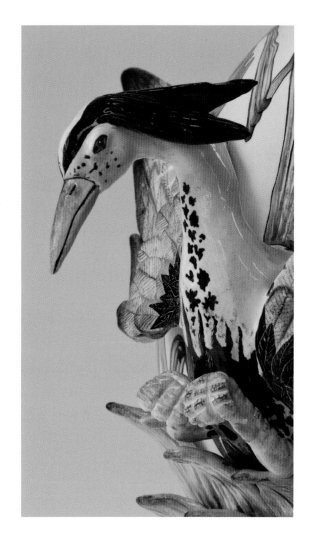

Opposite: Sondelani Ntshalintshali (top), one of Ardmore's finest sculptors, teamed up with painter Wiseman Ndlovu (bottom) on the production of the superb heron urns that were photographed for the cover of the 2008 Groote Schuur exhibition brochure.

Above: Detail of a heron urn sculpted by Sondelani Ntshalintshali and painted by Wiseman Ndlovu, 2007.

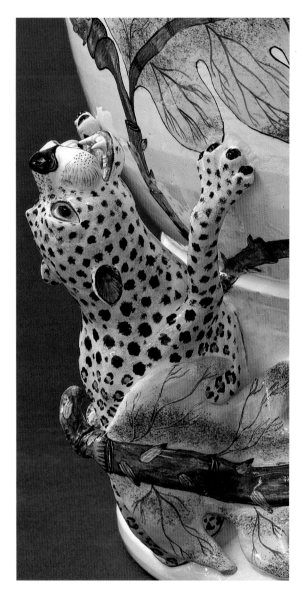

Nkosinathi Mabaso (top) and Mickey Chonco (above) developed a great partnership while preparing for the 2008 Groote Schuur exhibition. In the skilful hands of Nkosinathi, the delightful monkey planter, created in 2007, took shape. Once it was out of the kiln, Mickey began on the painting – soon the monkeys appeared as if alive, seemingly taunting the leopard below them. The result was a piece that everyone wanted.

Mickey's smiling face and charming manner reflect a cherished and joyous childhood during which he excelled both at school and on the sports field. After he matriculated, he first worked at a garage and then at a retail store before his sister, Kate, who managed the Springvale Gallery, introduced him to Ardmore in 2000. Although he played with clay from the age of eight, his passion is drawing and painting. He is diligent and has endless patience, blending his paints until he finds the exact colour he wants. The results are always harmonious and elegant, with the colours closely matching those found in nature.

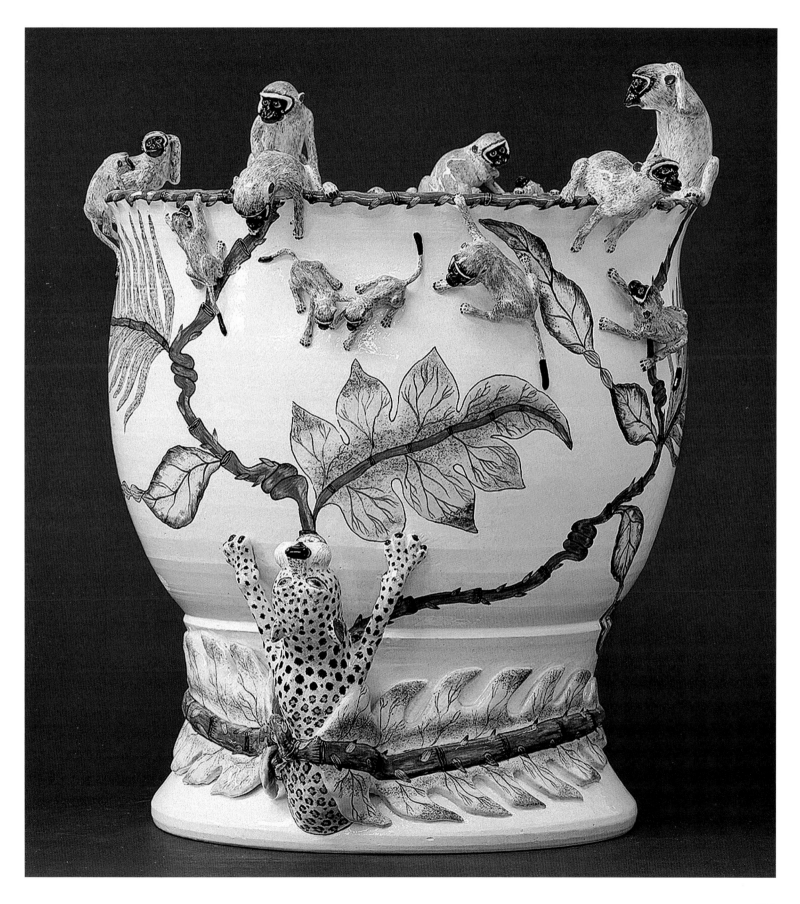

Above: Wonderboy Nxumalo's plates, 2007, contain commentary on pertinent social issues, as these extracts, copied verbatim, indicate: (top and shown on p. 53) 'Each history has to be told so that our children can understand what theire forefathers went though for them. It does not matter whether you are black, Indian or white people. Everyone's history is very important.'; and (bottom) 'I am Wonderboy, I love my country South Africa and God. Please let our leaders not be greedy and take everything for themselves.'

Opposite: Baboon and leopard candlesticks sculpted by Bennet Zondo and painted by Jabu Nene, 2007.

Cathrin Ogram and my elder daughter, Catherine, who was at university in Pietermaritzburg. My son, Jonathan, who was studying at Stellenbosch University, was there too. Prior to the opening, he had helped us distribute publicity material all over the place to promote the exhibition.

With only three days to go we started to learn that what can go wrong will go wrong. Just before reaching Cape Town, Lovemore hurt his back badly when he accidentally fell into a ditch after stopping at the side of the road to stretch his legs. Although terribly bruised, he managed to limp to the opening. The ceramics were unpacked and, despite my fears, hardly a piece was damaged. Then, on the morning of the opening, we could not find the champagne. Ten phone calls later, friends Anthony and Carol Record arrived loaded with cases of champagne, beating the first guests to the door with fifteen minutes to spare.

But our problems were not yet over. At the last minute, Eleanor had added another hundred names to our invitation list. The result was that, instead of having too few guests, we had too many – far too many. We were delighted of course, but the head of security, Inspector Kaye, was not. He told us that we should have had only 150 guests. Instead, we had over 400. What fun! We ran for cover and let Eleanor sort it all out. The logistics of getting so many people into Groote Schuur caused havoc. Guests had to show their identity documents or passports at the gate and be checked off against our lists. The procedure caused cars to be backed up over a distance of nearly a kilometre from the entrance gate.

Still, the guests poured in, the champagne flowed and before long we were in business. There was a tremendous crowd on the opening night and such a queue at the sales desk that it was difficult for people to see or buy all they wanted. Many people returned the next morning, some with their friends in tow, to make their purchases.

The exhibition was a great adventure. The artists and I stood in the entrance hall, welcoming the guests as they arrived. I was so proud of them, especially Wonderboy, who seized every opportunity to talk about Ardmore to guests and, particularly, government officials. After Lindiwe had formally opened the exhibition, I invited Christopher to introduce the artists one by one. When we returned home, he asked if he could take a course in public speaking. He said he had found it difficult to find something different to say other than 'talented' when he got to the tenth and eleventh artists!

One other person stood out that week. Happiness Sibisi was tireless in her handling of the sales, from collecting purchases from the sales desk as the invoices were completed to packing and checking invoices. The Groote Schuur exhibition was a turning point in her life and she was really excited about her future, which heralded the promise of learning computer skills and handling the sales at Caversham.

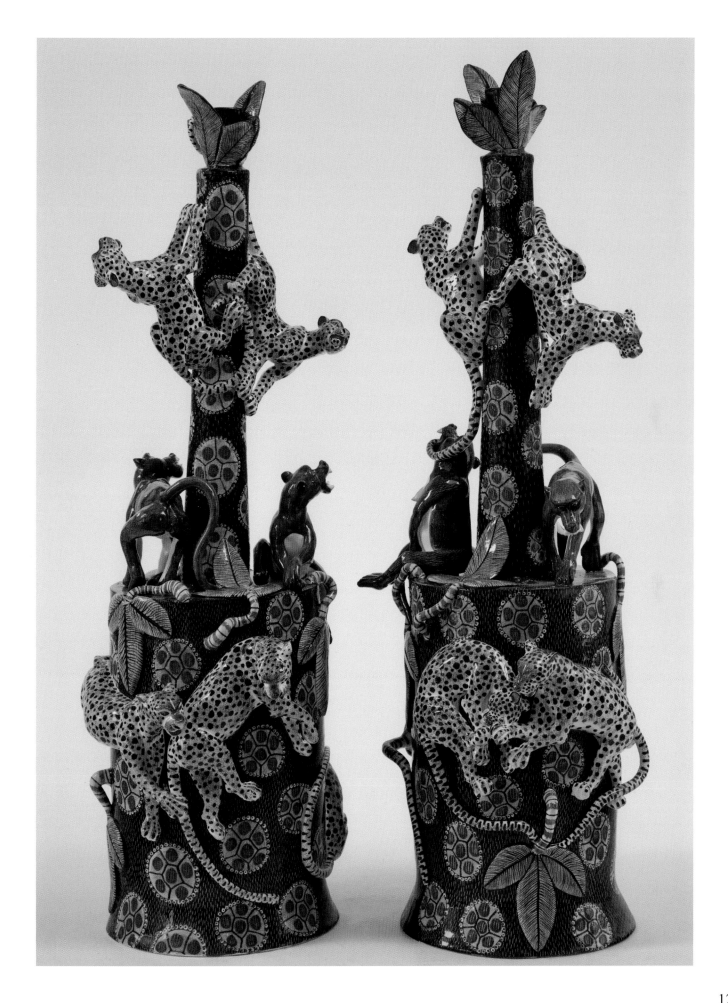

**Top: Insect bowl hand-coiled and painted by
Zeblon Msele, 2007.**

**Above: Sunbird and flower plate sculpted by
Slulamile Mlambo and painted by Rosemary
Mazibuko, 2007.**

Donald Greig also played a major part in the success of the show. He invited Charles Greig's Cape Town friends to a cocktail party on the Sunday evening, to which he brought nearly all the Ardmore pieces he had in his showroom at the V&A Waterfront. It was a spectacular success; the guests loved the pieces and happily emptied their pockets.

On the Monday we were inundated again. A review of Ardmore had been splashed across a full page of the *Cape Times* and everyone who read it wanted to see the exhibition. Our phones kept ringing and visitors flowed in. On Tuesday evening I told everyone to take the following day off. With the exhibition over, I was quite sure I could manage on my own.

Yet again I was proved wrong. As people came to collect their purchases on Wednesday morning, they, and the friends they brought with them, looked to see if there was anything more they could buy. By the end of the day there was almost nothing left, and I looked and felt as though I had done a cross-country marathon. I even had blisters on my feet.

Eleanor was once again a true friend and a huge support, seeing where she was needed and offering much-needed assistance. Another friend, Vivien Cohen, pulled out all the stops to show the artists around Cape Town after the exhibition had closed. A highlight for them was a visit to Robben Island, which they particularly wanted to see. Vivien is an intuitive collector who early on recognised something very special in the art of Wonderboy. Ever since, she has been collecting his work and is a very special and generous friend to Ardmore.

There are many advantages in taking the artists with me to our shows. Travelling to exhibitions provides a wonderful opportunity for all of us to get to know one another. This is what creates Ardmore's unique team spirit, which, in turn, helps to develop the business. The artists also get to learn about the myriad aspects of managing the business, from the logistics of setting up an exhibition to gaining firsthand experience of what the sales function entails and developing a deeper understanding of the skills that are required to present the works and negotiate the best price for each one. Most important, though, is the affirmation they get from the public of their worth as artists and the value of their work. It increases their self-confidence and pride and inspires them to reach for even greater heights.

In retrospect, I believe we were successful at Groote Schuur because we arrived with such a positive attitude in the midst of a lot of negativity in South Africa. The president of the country had just lost the leadership of the ANC. The Zimbabwe election was looming and, to all appearances, it seemed unlikely that it would be free and fair. Some wondered whether civil war would break out on our border. Many were despondent about South Africa's future. Yet we were saying, 'Look at us. It's good to be alive in South Africa. Yes, we can!' We were buoyed by the life force that comes

**Above: Photographed on the steps of the Groote Schuur manor house,
the Ardmore team at the exhibition in 2008 comprised (standing, from
left) Happiness Sibisi, Jabu Nene, Wiseman Ndlovu, Nomali Mnculwane,
Siyabonga Mabaso, Christopher Ntshalintshali, Petros Gumbi and (seated,
from left) Lovemore Sithole, Wonderboy Nxumalo, me, Fiko Mfuphi and,
the centre of attention, Moppet, the Groote Schuur cat.**

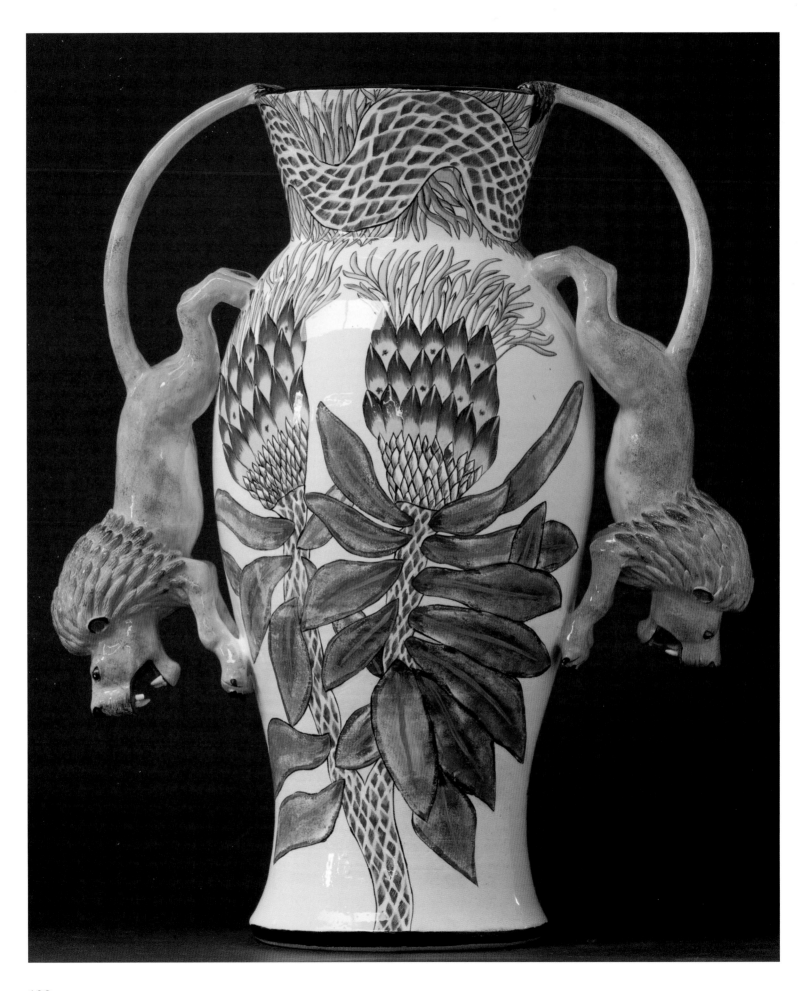

from creating beauty out of a lump of clay and from making things that keep us happy and make other people smile. Groote Schuur was a celebration; it affirmed our belief in our country and the spirit of democracy.

There was one more twist in the tale. Just as the truck got to Bloemfontein, our driver, Gordon, was stopped by the police. On discovering that he had only one eye, they took him off to a nearby police station. When Lovemore called to tell me, my automatic reaction was to send another driver. Then I remembered my experiences of travelling with horses – there were always problems, but there were also always people who were willing to assist. With this positive attitude, I called one of my brothers, Charles, who has a business in Bloemfontein, and in no time had he sent people to help. The police allowed the truck to continue with a new driver. Later that day, they all arrived safely home.

And so, our spectacular ten days of ups and downs came to an end, but not without a grand finale. A week after we arrived home, I handed out bonuses, certificates of excellence and diplomas of recognition. Recipients included our team of back-room packers, without whose sterling efforts we could not have mounted the exhibition. Some cried with excitement and I knew that everyone was ready to meet the next challenge. More than that, they wanted to do better. And it was going to be tough. We had elevated our standards and market expectations were now so high that we dared not create anything less than superb. I was not perturbed. We had climbed another twenty rungs up the ladder and were now beyond a shadow of a doubt seen as creators of excellence.

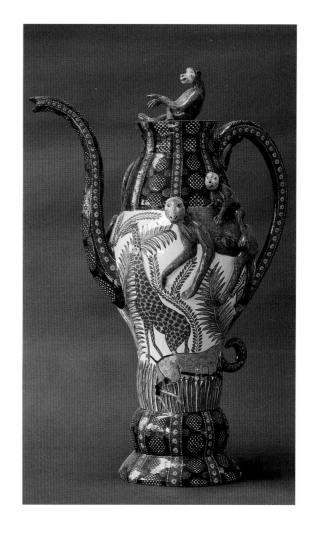

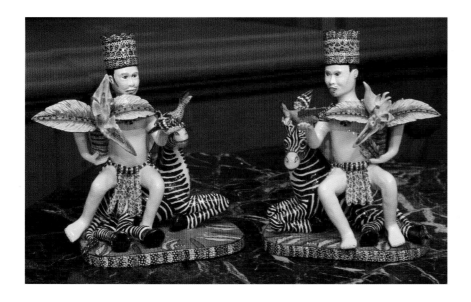

Opposite: Lion vase sculpted by Petros Gumbi and painted by Nonhlanhla Khanyeza, 2007.

Left: Two figures sitting on zebras sculpted by Petros Gumbi and painted by Punch Shabalala, 2008. These were inspired by Royal Doulton figurines of balloon sellers.

Above: Monkey and giraffe coffee pot sculpted by Sfiso Mvelase and painted by Jabu Nene, 2008.

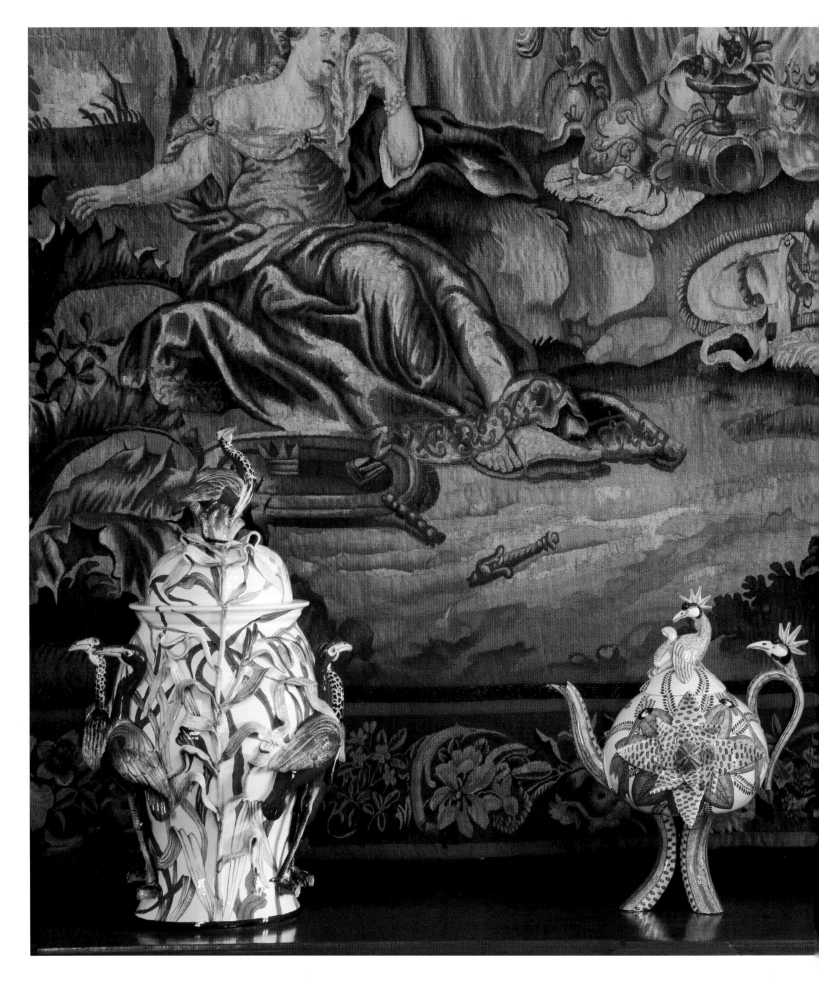

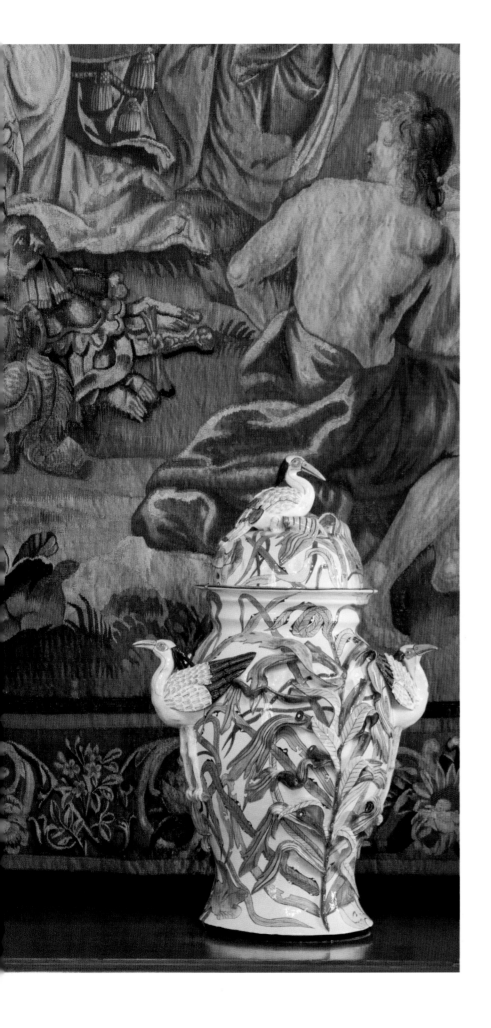

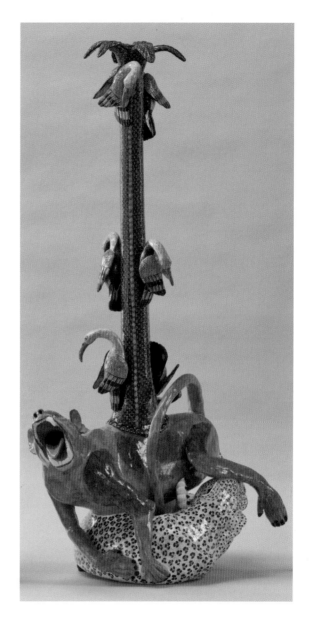

Left: Heron urns thrown by Lovemore Sithole, sculpted by Sondelani Ntshalintshali and painted by Roux Gwala, 2007, and crested crane teapot sculpted by Slulamile Mlambo and painted by Jabu Nene, 2007. The wall hanging forming the backdrop to the artworks is one of four seventeenth-century hand-woven Flemish tapestries displayed in the Groote Schuur manor house. They are considered to be some of the house's greatest treasures in terms of craftsmanship, historical interest and grandeur.

Above: One of a pair of leopard and baboon candlesticks sculpted by Bennet Zondo and painted by Jabu Nene, 2007.

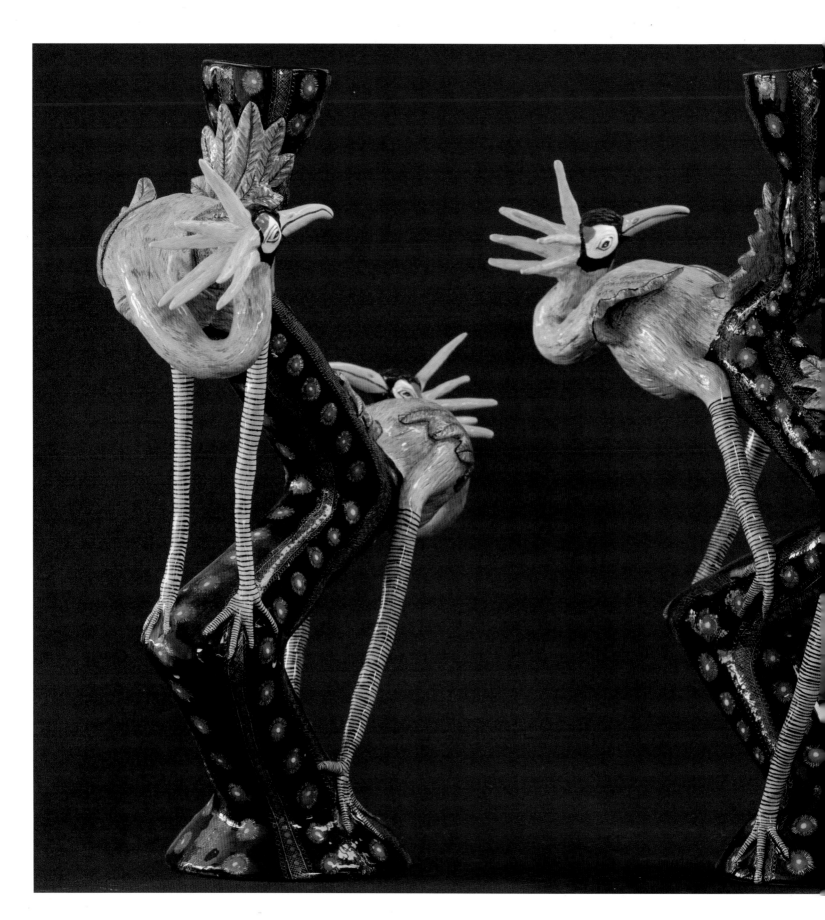

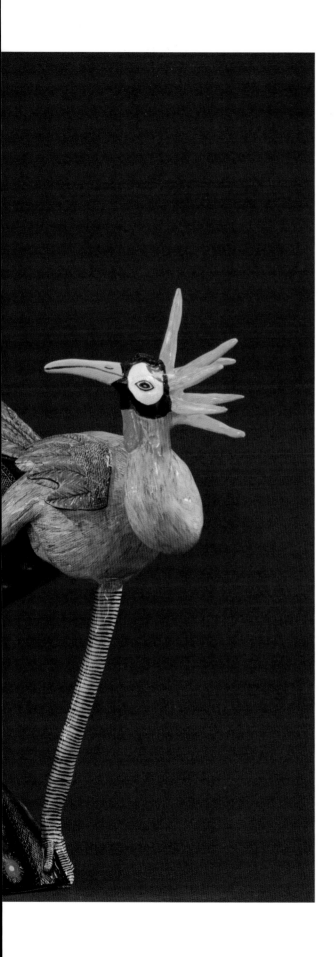

ormer South African first lady Zanele Mbeki wrote the foreword to our first book, *Ardmore – An African Discovery*, which was published in 1998. In her contribution, there are a few lines that I believe reflect the spirit of Ardmore: 'In true South African rural tradition, most of the pieces are a social enterprise where the end product cannot truly be claimed as the work of one individual. One artist throws, another paints, and yet another glazes – each contributing his or her artistic talent to the work.' Very little has changed since Zanele wrote those words. The ceramics produced under the Ardmore emblem are still the result of teamwork. However, since the market for Ardmore products has expanded internationally and our work now increasingly includes pure art forms, changes in the structure of the team have become inevitable. With some fifty artists in the mix, more people are needed to perform marketing, training and management functions.

My job is to teach and inspire the artists to discover their own creativity and to mentor them. I never try to tell them what to do; like a conductor, I prefer to suggest themes for them to interpret in their own way. When we are preparing for a major exhibition, the artists can sense my excitement and enthusiasm. It is contagious, inspiring them to create works that far exceed my expectations. The common denominator is teamwork, with all team members giving their very best. The excellence of each sculpture, its form, painting and glazing, is the direct result of cooperation and absolute trust between painter and sculptor. The magic of each ceramic lies in its originality, beauty and life force. These qualities make each piece unique and almost impossible to replicate.

All over Africa many people with creative potential get locked into a repetitive style. The same wooden hippos are carved, the same beaded guineafowl are created, and the same long-legged giraffes are sculpted. This is not art; it is simply about creating a piece for the sole purpose of making money. Buyers in this market are easily bored, and even the crafters suffer from a lack of stimulation – and it is all because the artists are not given the freedom to explore their own creativity. Art is about change, and at Ardmore this philosophy forms the foundation of all our work. Our success lies in our ability continually to steer a new course and to give our artists the time and space to develop their own ideas.

In my meetings with the artists I often use the analogy of a soccer team; you need a manager, a coach, a link, backs and forwards, and even someone to wash the jerseys. At Ardmore, the backs – the sculptors – are responsible for sending the ball up the field, and the forwards – the painters – have to complete the movement and score the goal. This has led to the development of a winning team.

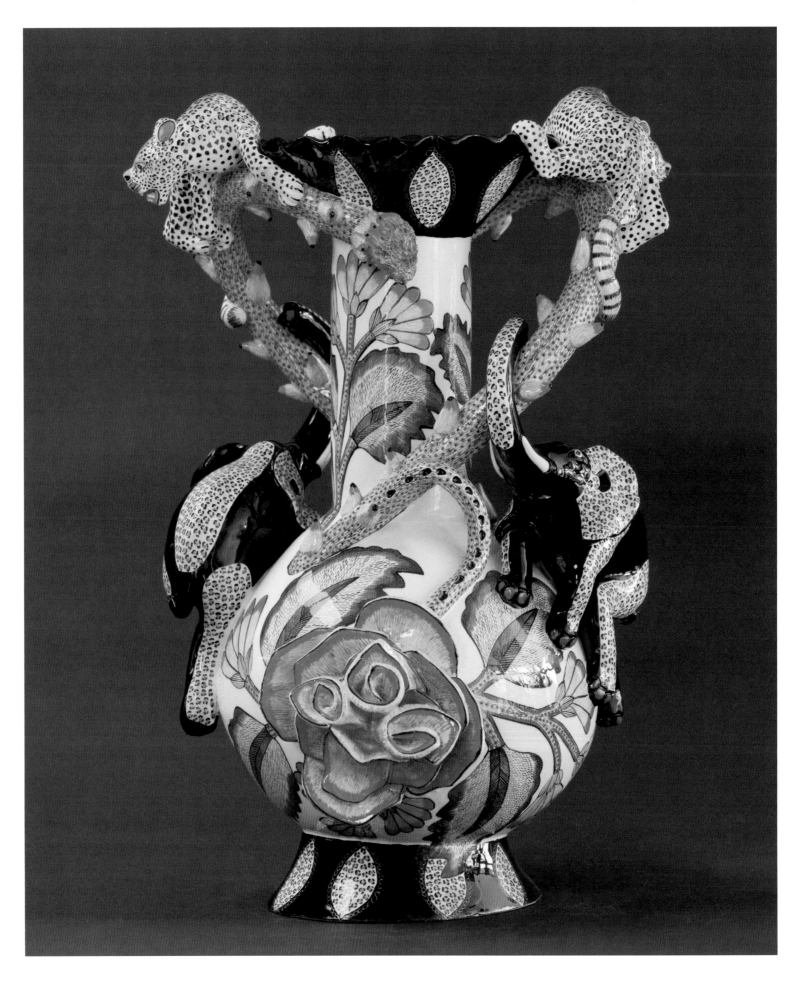

134

I have also used the soccer team analogy to communicate other issues. What happens to the top eleven players when they do not come to practice? The answer is that they lag behind. I always show the newcomers the artworks created by some of our great artists, to demonstrate how much they improved by working consistently over time.

There is always new talent knocking on my door. Everyone wants to play for the best team. Ardmore has become so well recognised that I get applications from all over Africa, many of them from people with experience in ceramics. One of the skilled 'players' who called me was Lovemore Sithole, a highly experienced thrower who trained at the Mzilikazi Pottery Studio in Bulawayo. Another was Elias Lulanga, who contacted me from Malawi. I try not to turn people away – even if some of them have a less than fair idea of what we do.

Although I have never had to go out and search for new talent, my 'system' has resulted in some unusual situations. The case of James Dlamini is one such example. James was down on his luck. He had been injured in a mining accident and the small business he had started in Lesotho had failed. When he arrived at Ardmore asking for a job as a painter, it did not immediately dawn on me that he was wanting to paint walls and ceilings. I told him to join the ceramic painters, which he did. He surprised me and himself. In 2006 his work was shown at the Amaridian Gallery in New York, the High Commissioner's residence in London and the Everard Read Gallery in Johannesburg. In 2007 he participated in the Christie's auction in London and the *Great Cats of the World* exhibition at Charles Greig Jewellers in Johannesburg. Sadly, the last display of his work was at the Groote Schuur exhibition in Cape Town in 2008. He died just before the show opened.

Prices for the artists' works are established during a 'crit session', or 'postmortem of the game', after each firing. Cracks can occur and the glaze firing can alter the colours, sometimes causing great disappointment. These faults have to be taken into account when assessing the works, and the artists are taught to look for both the good and the bad when determining prices. The contributions of the sculptor and the painter to a piece also have to be taken into account. Sometimes the work is the result of greater input on the part of the sculptor, at other times the painter is the more dominant partner, and they have to be rewarded accordingly. This process helps to develop an understanding of what creates excellence and how fairness in the earnings of painters and sculptors is determined.

Over the years I have come to believe that artists need the support of a patron, just as the Medici family supported artists by commissioning works from them all those centuries ago. For artists to focus wholly on their creativity, they need the security of a regular income and of knowing that they will be able to feed their families. They also need the support of a solid

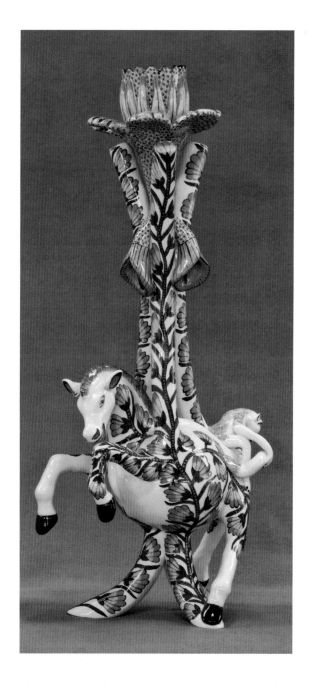

Opposite: Elephant and leopard vase sculpted by Slulamile Mlambo and painted by Jabu Nene, 2008. It is in the collection of Lindiwe Mabuza.

Above: One of a pair of horse and monkey candlesticks sculpted by Slulamile Mlambo and painted by Jabu Nene, 2008.

Previous spread: Grey crowned crane candlesticks made by Victor Shabalala and painted by Jabu Nene, 2006. They were shown at the Amaridian Gallery in New York in 2008.

infrastructure: space in which to work and availability of clay, paint, kilns and electricity. Financial support for the artists takes the form of monthly earnings and benefits such as leave pay and contributions towards funeral policies for them and their families. Since the artists are paid before their works are actually sold, the business takes a huge gamble because stock on the shelf does not equate to money in the bank. However, it is a risk I am more than prepared to take. I have total belief in the beauty and charm of the creations and am never in doubt that I will find willing buyers who will love the artworks as much as I do.

The making of ceramics starts with clay. We have worked with outstanding throwers and turners, among them Phineas Mweli and Elias Lulanga, who took over Ardmore's production lines after Phineas died. When Elias left in 2005, I was desperate to find a replacement. Out of the blue, I received a phone call from Lovemore Sithole, enquiring about working at Ardmore. When he told me what he could do, I suggested that I meet him in Johannesburg, where he was living. His reply was, 'I'll drive down tomorrow.' We met at Caversham the next day; it was only a month later that he returned home to collect his belongings. He saw what was needed and without any hesitation got started at the wheel. Subsequently, Christopher Ntshalintshali and Sabelo Khoza have also become expert throwers.

Above: Lovemore Sithole, about to turn a ball of clay into a large vessel.

Right: Bird bowl thrown by Lovemore Sithole, sculpted by Octavia Mazibuko and painted by Ottilia Nxumalo, 2008.

Opposite left: Espresso cup and saucer thrown by Lovemore Sithole, sculpted by Sondelani Ntshalintshali and painted by Rosemary Mazibuko, 2009.

Opposite right: Shown from top to bottom, zebra egg cup sculpted by Sondelani Ntshalintshali and painted by Mpume Mchunu, 2009; giraffe egg cup sculpted by Thabo Mbhele and painted by Sharon Tlou, 2009; and elephant egg cups sculpted by Thabo Mbhele and painted by Langa Sithole, 2009. The egg cups were thrown by Lovemore Sithole.

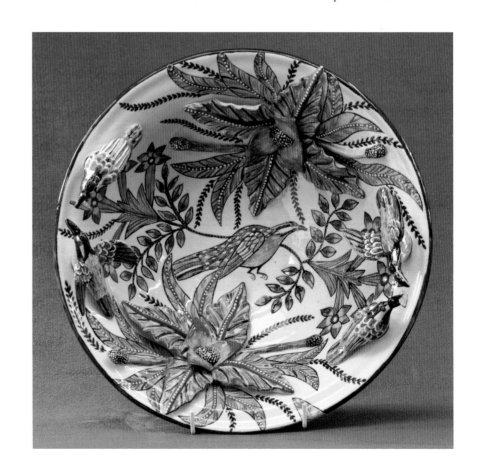

Lovemore and Petros Gumbi were originally responsible for glazing and firing the kiln. The two men have made a real impact at Caversham and have now also taught others to fire the kiln. Lovemore bridges the divide between different cultures by communicating with understanding and empathy and, where necessary, a firm hand. He also speaks up for those who are too reserved or shy to express themselves. He is respected by all the artists and will always make time to discuss with them any personal problems they may have. He is well known for his self-discipline and sets an example for the younger men. He is a leader among men and I am grateful that he is on our team.

The following pages tell of the special associations some of Ardmore's outstanding artists have built with each other over the years: Sabelo Khoza with Mickey Chonco and Punch Shabalala; Sondelani Ntshalintshali with Siyabonga Mabaso, Punch Shabalala and Wiseman Ndlovu; Roux Gwala with Victor Shabalala, Nkosinathi Mabaso and Sfiso Mvelase; Jabu Nene with Somandla Ntshalintshali and Alex Sibanda; Virginia Xaba with Victor Shabalala, Somandla Ntshalintshali, Sondelani Ntshalintshali and Slulamile Mlambo; Betty Ntshingila with Siyabonga Mabaso, Sthabiso Hadebe, Zinhle Nene and Virginia Xaba; Siyabonga Mabaso with Sondelani Ntshalintshali and Betty Ntshingila; and Alex Sibanda with Jabu Nene and Roux Gwala.

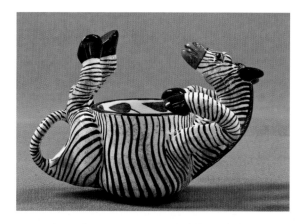

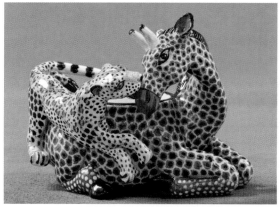

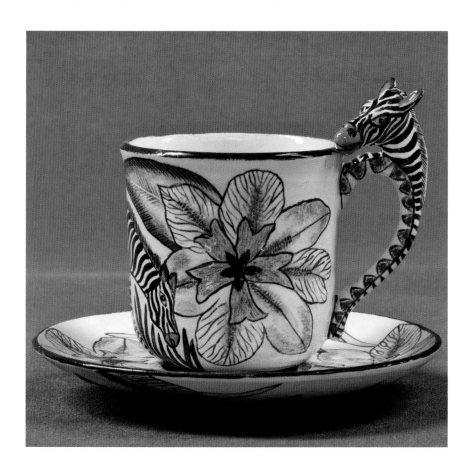

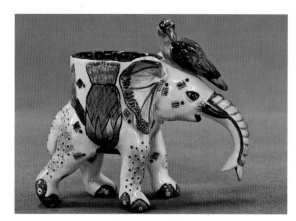

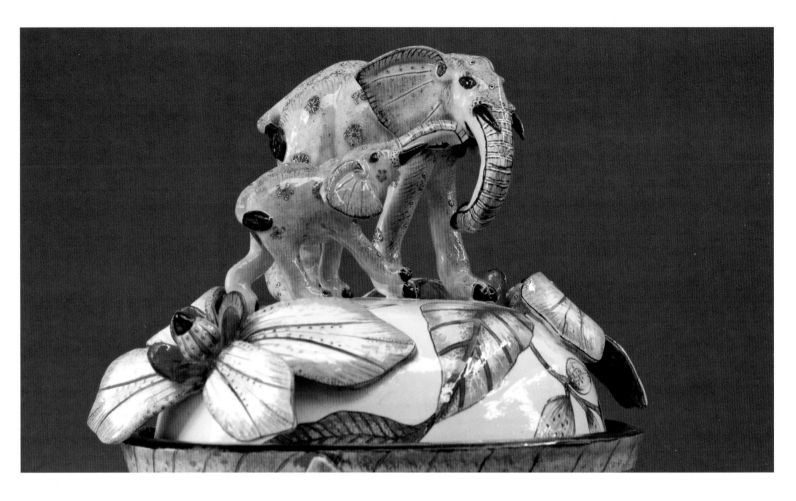

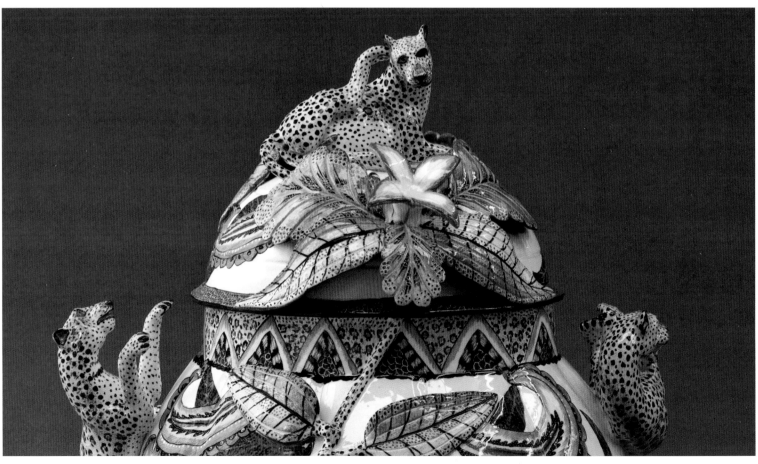

138

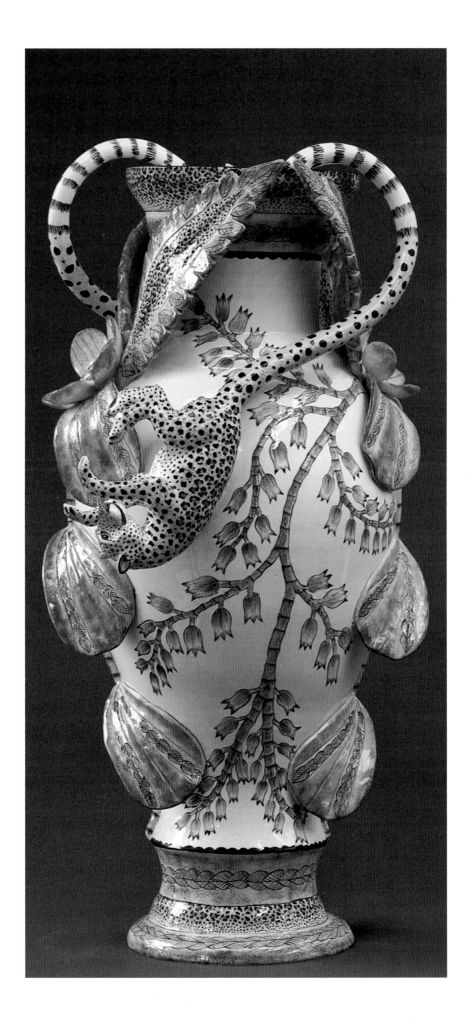

Sabelo Khoza is a thrower and a brilliant sculptor. After finishing school in Estcourt in 2000, he went to Johannesburg to work for his uncle who was in the building trade. Two years later he returned home, again finding work with a relative, this time as a truck driver for his mother's sister. Over weekends he would meet up with his cousins Petros Gumbi and Sondelani Ntshalintshali, listening to their stories about their work at Ardmore. Reasoning that he had built things with clay as a young boy, he asked whether he could join the studio. Petros became his first teacher. He was also encouraged to observe master thrower Elias Lulanga and to try his own hand at throwing when the wheel was free. When Elias left in 2005, Sabelo was ready to take over the production of Ardmore's functional ware.

However, it is as a sculptor that he has flourished. Today this prolific artist throws his own work and embellishes his forms with his own sculpted figures. He teams up with a number of top painters, including Mickey Chonco and Punch Shabalala.

Opposite and left: Works sculpted by Sabelo Khoza and painted by Mickey Chonco, 2009 (elephant tureen), and Punch Shabalala, 2009 and 2008 (leopard tureen and leopard and flower vase, respectively).

Introduced by Nhlanhla Nsundwane, Sondelani Ntshalintshali arrived at Ardmore at the age of nineteen, having survived the childhood trauma of his family home burning down and the immense difficulties that followed. With Petros Gumbi as guide, he learnt the techniques of ceramic sculpture and revelled in the exploration of his own creative talent. Sondelani works with speed, skill and dedication, and his sculptures are beautifully finished. In addition to his exquisite platters, tureens and candlesticks, he has begun to create fine art forms – just like his mentor, Nhlanhla. His work has been successfully exhibited internationally and in South Africa, and he has become one of Ardmore's most successful artists.

Sondelani partners with painters Siyabonga Mabaso, Punch Shabalala and Wiseman Ndlovu.

Right and opposite: Dog and rabbit sculpture, 2009, and hunting urn, 2011, sculpted by Sondelani Ntshalintshali and painted by Wiseman Ndlovu. The urn is in the collection of the Tatham Art Gallery in Pietermaritzburg.

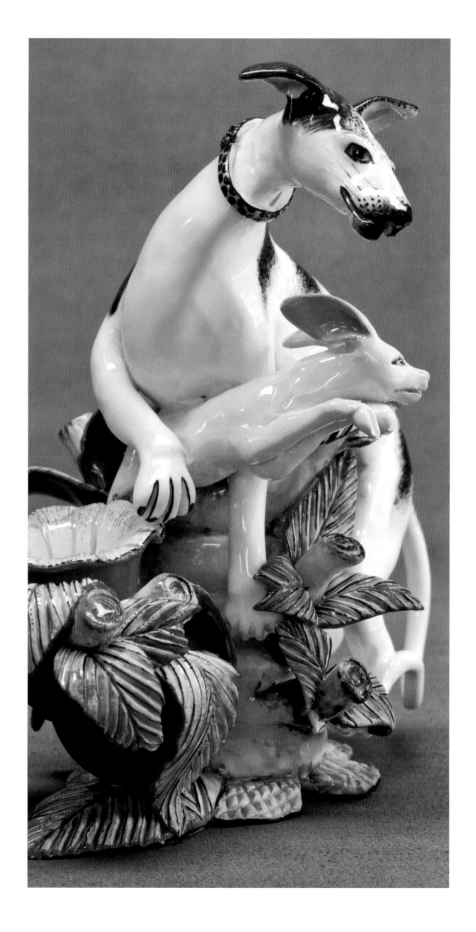

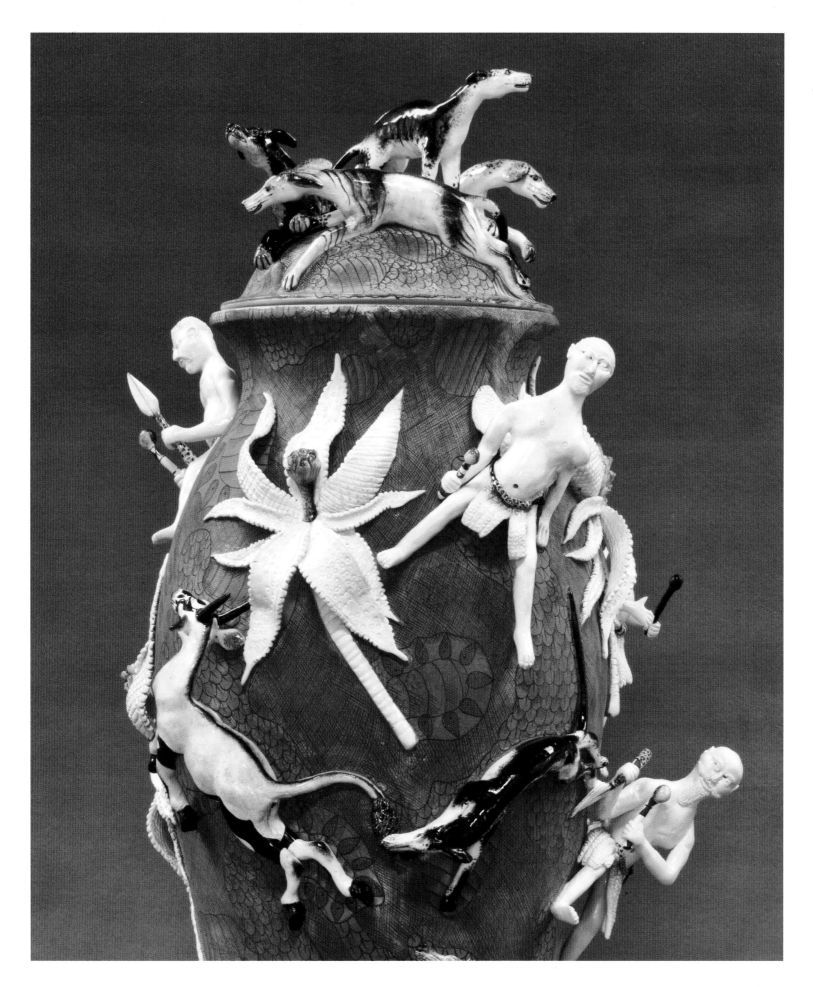

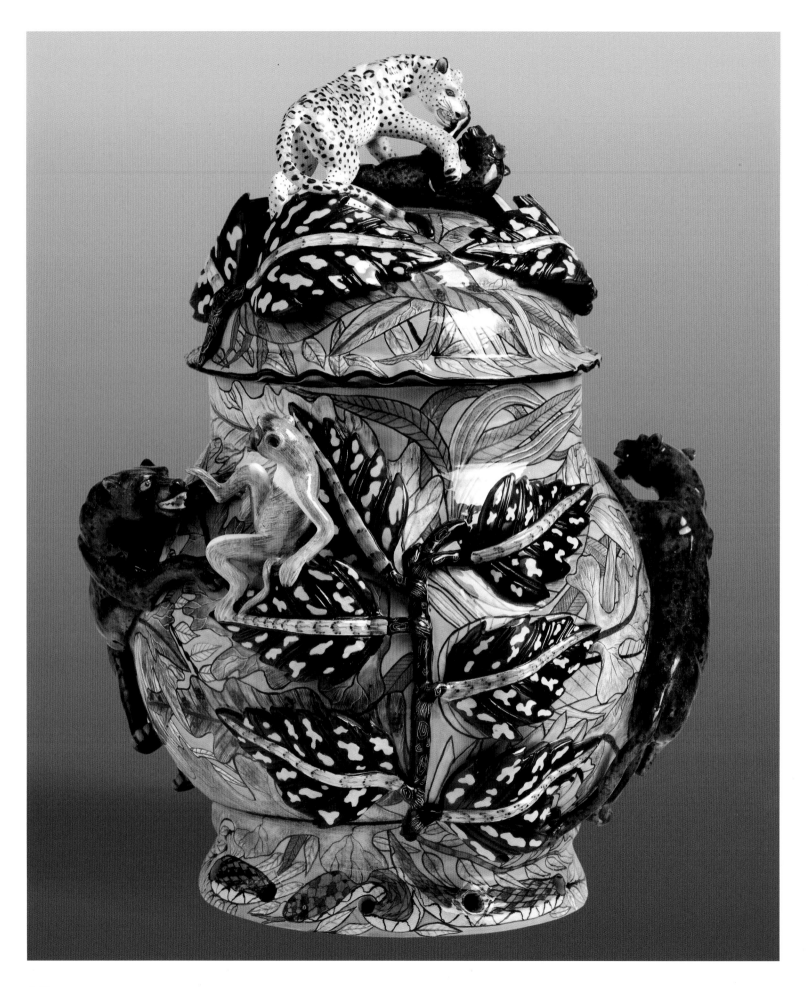

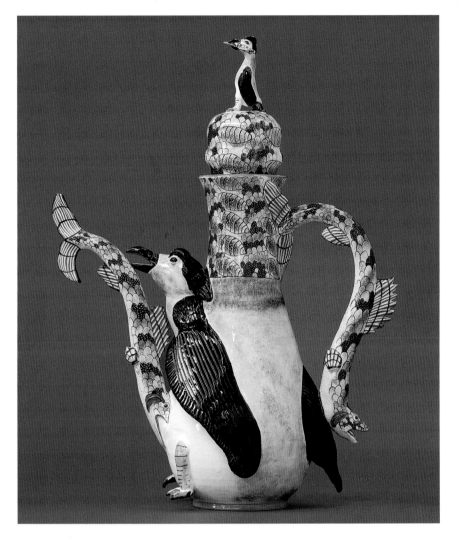

Roux Gwala was born in 1974 and grew up near Ardmore farm in the Champagne Valley. He was still a teenager when he first heard about the studio and that the women who worked there earned a living by painting and sculpting clay. Although Roux painted at school, art was not his first love; with his powerful singing voice he dreamt of a career in music. When he left school he headed straight for the recording studios of Johannesburg, but success escaped him and he returned home. He later married Virginia Xaba, one of Ardmore's top painters. In 2005 he joined the studio and began his painting career, working under the watchful eye of his wife. He soon found his own way, painting with great attention to detail. One of his techniques is to 'scratch' into the paint with a sharp needle to create fine swirls that have an energy all of their own without detracting from the form. He has participated in exhibitions in New York, London, Johannesburg and Cape Town.

Roux prefers partnering with Victor Shabalala, Sfiso Mvelase and Nkosinathi Mabaso.

Opposite, left and below: Artworks painted by Roux Gwala and sculpted by Sondelani Ntshalintshali, 2007 (leopard urn); Sfiso Mvelase, 2007 (penguin coffee pot); and Victor Shabalala, 2009 (detail, fish candlestick).

Jabu Nene's artistry took an exciting turn with the creation of new, sophisticated sculptural art forms by a younger generation of Ardmore artists. Her painting style is intensely decorative and adds a wonderful energy and rhythm to a sculpture. She covers petals, leaves, feathers, animals and insects with geometrics, zigzags, chevrons, squares and circles, making her work reminiscent of ancient Aztec art. She paints in kaleidoscopic colours across the entire piece, using everything from pinks to oranges.

Jabu is outgoing and a natural leader and gifted teacher. Beneath her charm is a strong, dynamic personality, which makes her the team player most in demand at Ardmore. Jabu likes to work with the best, preferring to team up with Somandla Ntshalintshali and Alex Sibanda.

Opposite: Chameleon urn painted by Jabu Nene and sculpted by Somandla Ntshalintshali, 2007.

Above: Flying leopard tureen painted by Jabu Nene and sculpted by Bennet Zondo, 2008.

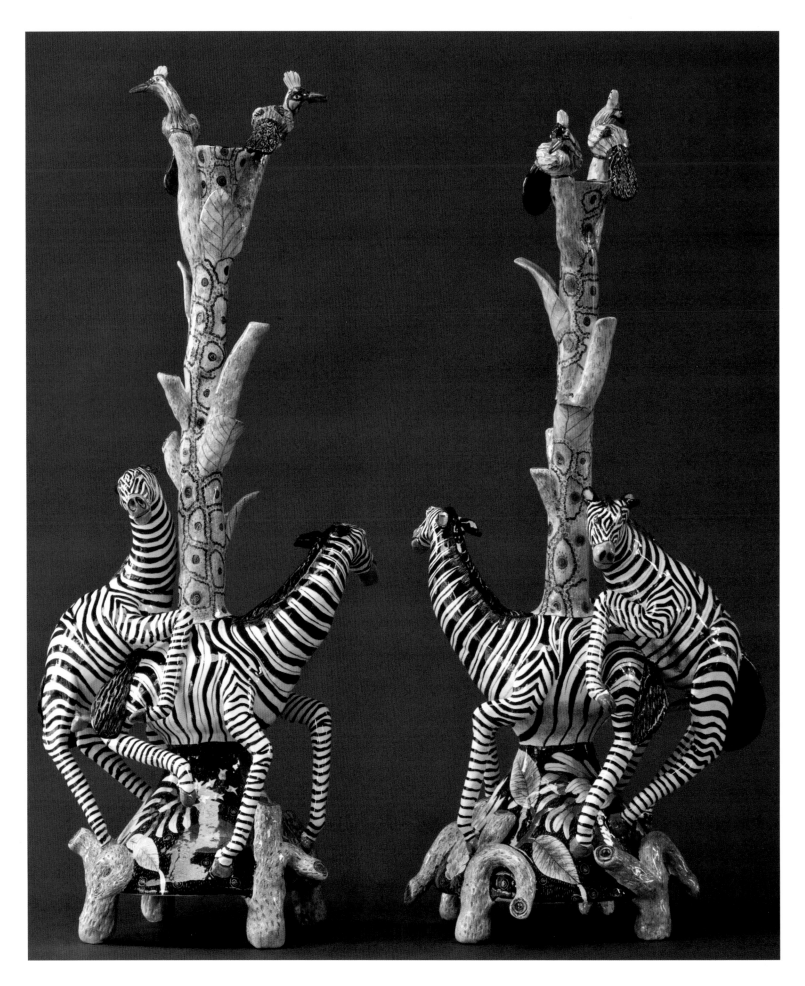

Virginia (Lindiwe) Xaba was born in Winterton, KwaZulu-Natal, in 1975. A chance meeting with Virginia as she was walking home from school one day led me to show her the studio. Soon thereafter, Bonnie Ntshalintshali and Sindi Ntshalintshali began to teach the seventeen-year-old painting and sculpture. It did not take long before Virginia chose to focus on painting.

Her exceptional drawing skills are evident in her art: the colours are subtly and painstakingly worked, with every detail, whether a feather, scale or animal skin, patiently created. Her delicate shading gives the ceramic surface a three-dimensional effect. Her excellent eye and fine brush strokes make her one of Ardmore's leading painters. She is also a great teacher and is often seen helping younger painters. In 2008 she won the prestigious Nivea Art Award for her self-portrait.

She favours working with Victor Shabalala, but also collaborates with Slulamile Mlambo, Somandla Ntshalintshali and Sondelani Ntshalintshali.

Opposite and below: Artworks painted by Virginia Xaba and sculpted by Victor Shabalala, 2007 ('bonking zebras' candlesticks); Slulamile Mlambo, 2008 (zebra teapot); and Sondelani Ntshalintshali, 2008 (owl and leopard urn).

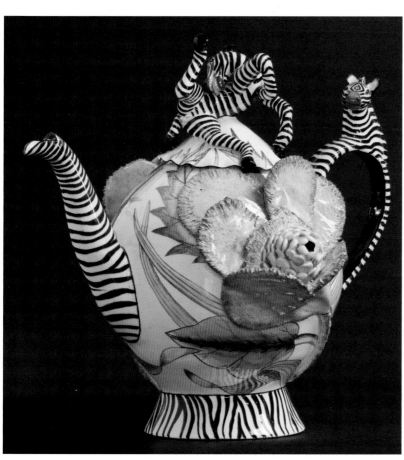

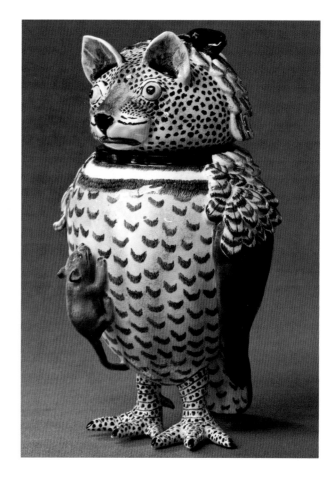

Betty Ntshingila is fondly referred to as both a 'mother hen' and a 'busy bee'. Like these creatures, she is extremely hardworking. She provides for her family through her art but also earns additional income from her chicken-keeping business – hence her familiarity with the dominant subject of her sculptures, the domestic fowl. She also sculpts bees, which she observes closely when they collect nectar. Another of her subjects is little birds building their nests and feeding their chicks. Sculptures of these she places on miniature jugs and pots. Her detailed works are greatly sought after and are eagerly snapped up by keen collectors around the world.

Betty has formed a special partnership with painters Zinhle Nene, Virginia Xaba, Siyabonga Mabaso and Sthabiso Hadebe.

Below: Hen and hatching chicks butter dish sculpted by Betty Ntshingila and painted by Zinhle Nene, 2008.

Right: Cockerel candlesticks sculpted by Betty Ntshingila and painted by Virginia Xaba, 2008. The pair of candlesticks was exhibited at the Ardmore exhibition at South Africa House in London in 2009.

Opposite: Cockerel vase sculpted by Betty Ntshingila and painted by Goodness Mpinga, 2008.

Shortly after completing his schooling in 2006, Siyabonga Mabaso, who had heard about the work being done at Ardmore, paid the studio a visit. Wonderboy Nxumalo, who was in the gallery that weekend, suggested that he show the Ardmore team his portfolio of drawings and paintings. His drawings were exceptional and we did not hesitate to ask him to join us. Within a short space of time his work was included in two significant shows, the *Great Cats of the World* exhibition in Johannesburg in 2007 and, a year later, the Groote Schuur exhibition in Cape Town, where his realistic style of painting caught the attention of a number of collectors.

Siya is known for using his initiative to explore his subjects in greater detail; he will listen to ideas and then search libraries for reference material on the birds, animals, flowers and plants he wants to paint. He also observes nature closely and aims for perfection in his art. Watching 'Speedy Siya' at work is fascinating. He is a superb draughtsman and his hand–eye coordination is excellent. He has heaps of potential, as well as the tenacity to achieve his ambition of being a first-class artist.

Siya has also turned his hand to sculpture and is not afraid to work with clay. In fact, he is not afraid of anything, and is keen to learn more – from teaching to packing to selling. Like so many of the artists at Ardmore, his entire family relies on him financially. Through his efforts, he is able to support the people who depend on him.

Besides painting his own sculptures, Siya mostly teams up with Sondelani Ntshalintshali, although the other sculptors are always delighted when he chooses to paint their work.

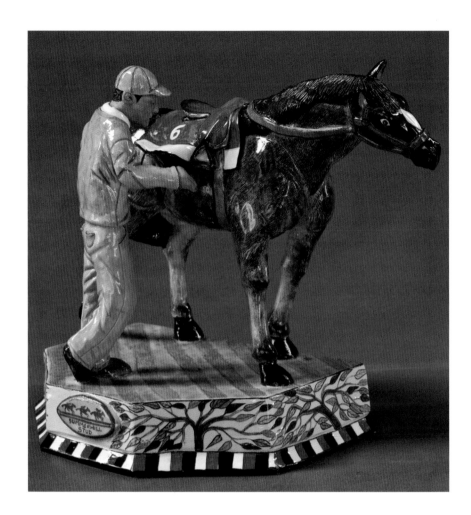

Above: In 2009 we made a collection that paid tribute to Zulu horsemen – among the finest in Africa – for the Summerhill Stallion Day. This horse and groom sculpture was created and painted by Siyabonga Mabaso, 2009.

Right and opposite: Leopard teapot and leopard and toucan tureen painted by Siyabonga Mabaso and sculpted by Sfiso Mvelase, 2007. The tureen, which was created for the Groote Schuur exhibition held in Cape Town in 2008, is in the collection of Zanele Mbeki.

One of eight children, Alex Sibanda was born in Gweru, Zimbabwe, in 1963. In 1978 he joined the Mzilikazi Pottery Studio in Bulawayo where he was involved in drawing, sculpture and mural painting. Then, in 2004, like so many other Zimbabweans, he moved to South Africa to escape the strife back home. In 2009 Alex's friend and fellow countryman, Lovemore Sithole, persuaded him to leave his job at a commercial pottery studio in Johannesburg to join Ardmore, where he would have ample opportunity for self-expression. Since joining the studio in January 2010, he has grown into an exceptional sculptor: courageous, open-minded and unafraid of exploring his own creativity. His famous sculptures of travellers being transported on the backs of hippos have won him international praise, and one of these works is now in the permanent collection of the Museum der Kulturen in Basel, Switzerland.

Alex regularly works with painters Jabu Nene and Roux Gwala.

Opposite: Hippo riders vase sculpted by Alex Sibanda and painted by Jabu Nene, 2011. The vase was inspired by the plight of countless Zimbabweans who have crossed the Limpopo River into South Africa to escape the turmoil in their homeland.

Left: Elephant and riders sculpted by Alex Sibanda and painted by Roux Gwala, 2012.

Below: Frog and snail vase sculpted by Alex Sibanda and painted by Zinhle Nene, 2011.

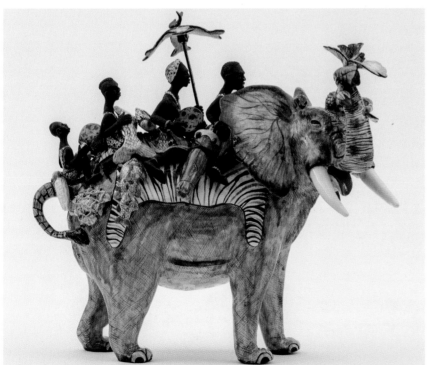

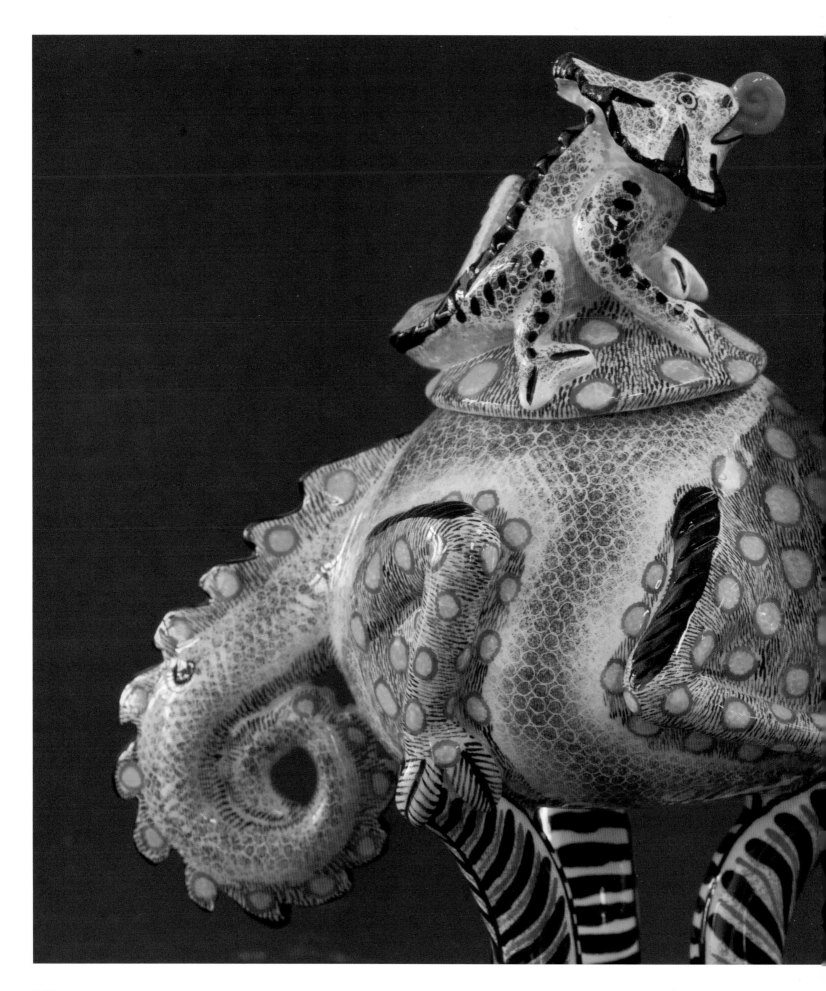

One of my friends, Creina Alcock, who has devoted her life to working with Zulu farmers in rural KwaZulu-Natal and is well known for her beadwork and welfare projects, commented that development is like a tree that grows imperceptibly. I think it can also be likened to the slow, tentative movement of a chameleon, or *nwabo*. Each step a chameleon takes is charged with uncertainty. It pushes one leg forward, then pauses and withdraws it. Hesitantly, it extends its leg again, pauses once more and, at last, cautiously lowers it.

Since first opening the Ardmore studio nearly thirty years ago, I have seen the artists, and the business, undergo phenomenal changes, even if slow. The young artists who joined Ardmore in the early days learnt relatively quickly how to paint, coil and sculpt, but, for most, their progress towards the superb quality we see today was gradual.

As Ardmore grew in size and stature, it became a priority to nurture leadership and business administration skills among the artists, not only for their own professional development, but also to ensure the sustainability of the studio. I did not expect to run into any problems but, as with most initiatives that involve change, unforeseen stumbling blocks did threaten to scupper the process. I also had a lesson to learn from the chameleon: take one step at a time. Unlike the chameleon, all too often my enthusiasm and impatience would carry me close to the 'heat of a fire'.

The first opportunity for sharing responsibility for the day-to-day management of the studio arose in 1996, when, with my family, I left the Drakensberg for Springvale farm near Rosetta. Thrown in at the deep end, Moses Nqubuka became the first manager at Ardmore Champagne. I trained him how to run a studio and handle sales, which he did for ten years.

In 2006, soon after our return from another exhibition at Highveld, the residence of the South African ambassador to the United Kingdom, Christopher Ntshalintshali, who was based at Ardmore Champagne, asked if I would teach him the running of the business. I was thrilled; he had developed a passion for this kind of work and would be of much-needed support to Moses, whose time was increasingly taken up by AIDS education in the local community. Christopher spent six months at Caversham, where I worked closely with him, training him in all aspects of running a studio. Managing Ardmore Champagne was not easy for him. He was young, possibly too young to lead an elder brother, aunts and uncles and even grannies. Many found it difficult to accept his promotion. He also had to contend with instances of substance abuse, drunkenness, violence and, occasionally, a poor work ethic among some of the artists. As a consequence of poor discipline and lack of control, the quality of the work dropped. Eventually, Christopher found it impossible to manage the situation.

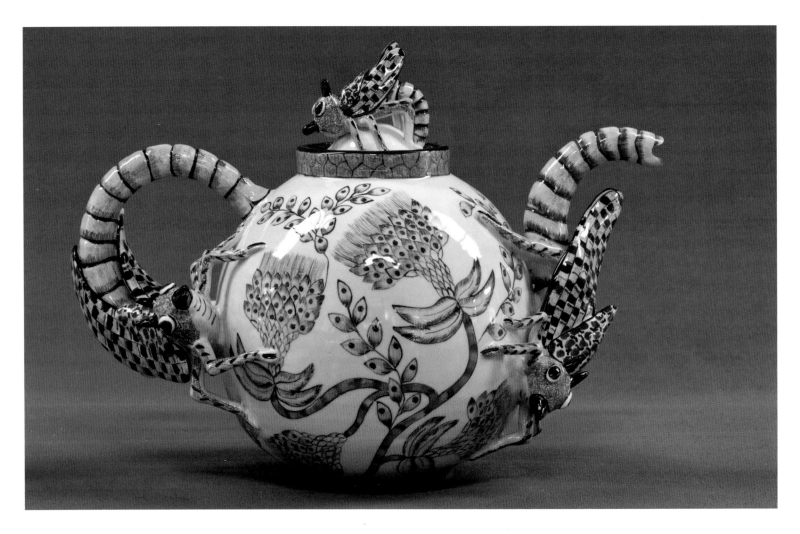

Above: Insect teapot sculpted by Sfiso Mvelase and painted by Zinhle Nene, 2010.

Opposite top: Insect teapot sculpted by Sfiso Mvelase and painted by Sthabiso Hadebe, 2010.

Opposite bottom: Insect sculpture created by Nhlanhla Nsundwane and painted by Roux Gwala, 2007.

Previous spread: Chameleon tureen sculpted by Slulamile Mlambo and painted by Jabu Nene, 2007.

The crisis at Ardmore Champagne intensified when some of the artists wanted to be employed permanently, which, they argued, would enable them to join a trade union; others wanted higher pay. They did not recognise the benefits for artists that are inherent in the business model we employ at Ardmore. For almost thirty years the studio has provided its artists with materials, equipment and infrastructure, allowing them the freedom to come and go as they please – a set-up, I believe, that is a fundamental requirement for creativity. Ardmore's current system of remuneration, whereby the artists are paid for their works even before they are sold, ensures a steady flow of income for them. Throwers, sculptors and painters share a percentage of the price set for each work after it has been fired, and the amount each artist is paid at month-end will depend on how many works he or she sent to the kilns during the month. It is a system that works, and the model has even been the subject of academic research.

Although my focus was on resolving the issues at Ardmore, there were other factors at play that were beyond our control. Throughout 2007 and 2008 the artists' earnings escalated as we held one successful exhibition

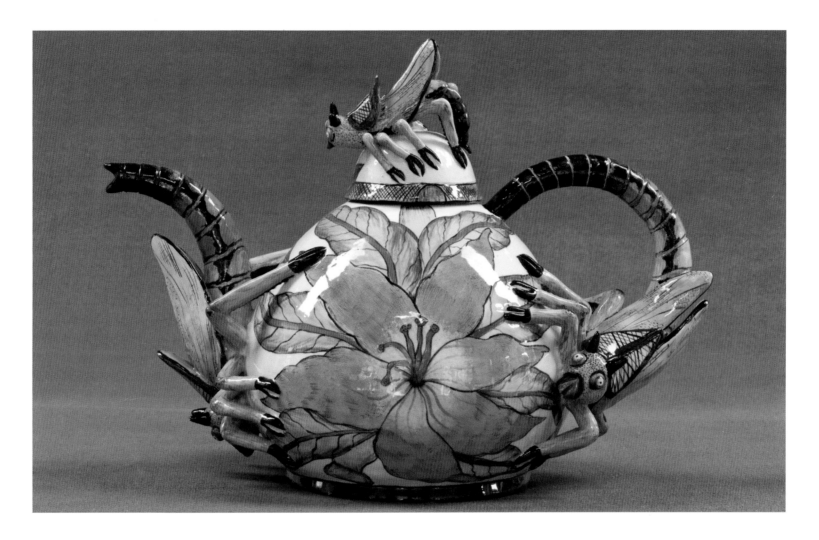

after another. They fared better than they had ever dreamt possible. Then, in 2009, as the global recession deepened, we had to face reality. On the one hand, the artists relied on their work at Ardmore for their livelihood; on the other, as a seller of goods in the luxury market, the studio was facing a massive reduction in turnover as people worldwide tightened their belts. Our production costs also escalated: the electricity bill tripled, the price of fuel increased, and food costs shot up. At the same time, we were plagued by frequent power blackouts, which affected the firing of the works in the kiln. These were no small quandaries. For a while, the entire structure I had built threatened to come tumbling down.

We had come this far without financial support from the government or any other agency. The business simply could not finance trade union demands, especially if they came without a corresponding increase in productivity. By mid-2009 trade union activity in South Africa was at an all-time high. Strikes were taking place across all sectors, including the construction industry, where workers involved in building massive soccer stadiums for the 2010 World Cup downed tools and demanded a thirteen

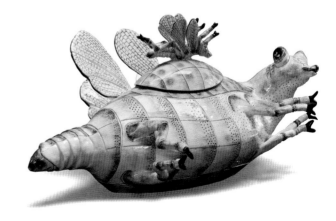

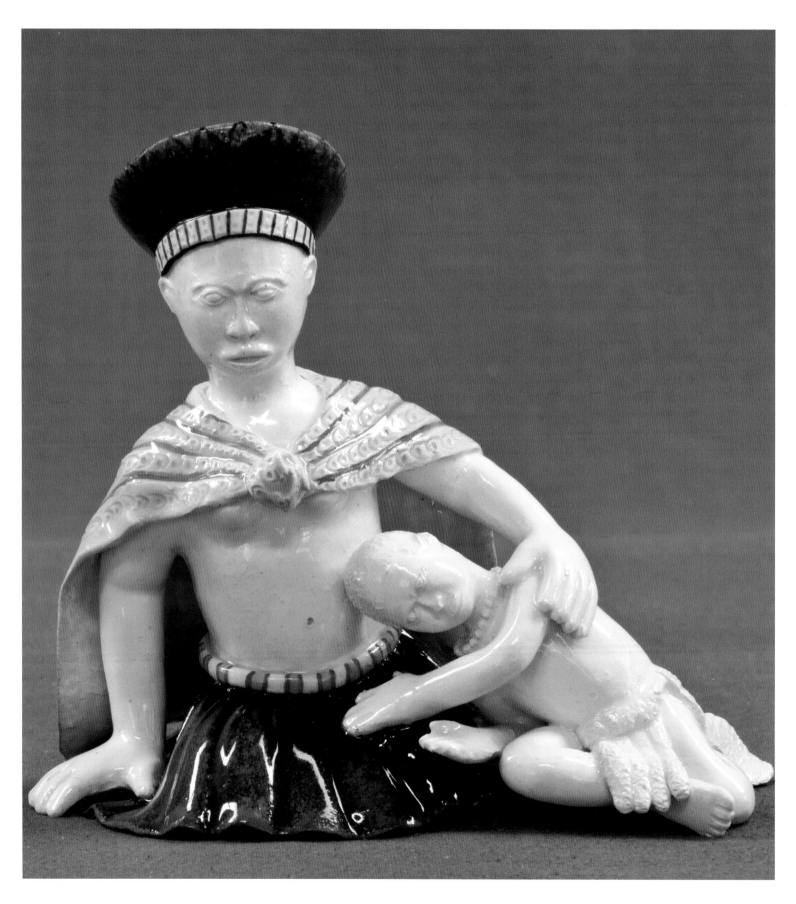

per cent wage increase. Closer to home, striking municipal workers cut off the water supply to a town in KwaZulu-Natal.

I realised that I could not cope with the problems I was up against and that the team, not the individual, was what counted. I had no alternative but to close the studio in the Drakensberg. It was a huge disappointment to me, but, looking back, I can see that it was the right decision. I called it an act of creative destruction. Most of the artists from Ardmore Champagne came to Caversham, where they quickly matured during that stressful year. Christopher, in particular, rapidly adapted to the change and has become one of our key people and a member of the management team. In addition to his many responsibilities, he still finds time to put his hand to the wheel. He is confident, is never shy to voice his opinion, and understands the importance of being accountable and of accepting responsibility.

During that challenging year I was fortunate to have had the sound advice of a special friend and neighbour, Malcolm Christian. I first met Malcolm when I was at university in Pietermaritzburg. He and David Walters worked as lecturers in the fine arts department. In 1985 Malcolm founded Caversham Press, a professional printmaking studio housed in an old chapel next to the Caversham Mill in the KwaZulu-Natal Midlands. Today the press is one of several programmes that are run by the Caversham Centre to foster leadership, creativity and innovation in the arts. Malcolm, like me, gave up his own artistic development to teach others, and his centre has become a haven for artists and writers. He encouraged me to find a way of sharing Ardmore's problems and the challenges it faced with the artists. 'Find solutions together as a team,' he told me.

At his suggestion, I asked the more experienced artists to start taking on the tasks of teaching and guiding the newcomers. The senior men and women were doing outstanding work and were more than capable of training a new generation of artists. This helped to free up my time so that I could concentrate on building leadership and achieve my goal of making sure that Ardmore could always sustain itself, even without me. By developing leaders I would also be giving back to a community that had helped me grow in so many ways. Malcolm taught me that it was important for the artists to learn that they, too, have a responsibility to teach others in their communities and, in that way, give back some of their good fortune. To this end, two young artists, Octavia Buthelezi and Alex Shabalala, volunteered to attend a leadership training course at the Caversham Centre and have used the opportunity to empower themselves and others.

Ardmore has also been fortunate to have the support of Lovemore Sithole, a Zimbabwean who fled to South Africa to escape the turmoil at home. He has an impressive talent for throwing and turning clay, but his real strengths lie in his ability to communicate and his organisational and

Opposite: Sculpture of a Zulu mother and child created by Petros Gumbi and painted by Alex Shabalala, 2010.

Above: Alex Shabalala joined Ardmore in 2007. He learnt from the late Gabi Nkosi, an outstanding printmaker and former programme manager at Caversham Centre.

Below: With three friends who have greatly influenced my life, (from left) David Walters, Professor Juliet Armstrong and Malcolm Christian, at the *Remembering Artists Past* exhibition at the Bonnie Ntshalintshali Museum in 2009.

**Above: Octavia Buthelezi joined Ardmore
Champagne in the late 1990s as a painter. I
discovered that she spoke good English and
would thus be able to help Moses Nqubuka with
sales. She soon became proficient at handling
sales transactions and was good at interacting
with customers. She left Ardmore for a while to
have a child but rejoined the studio a few years
later. Octavia has always shown great fortitude
and enthusiasm, and is not afraid of speaking
her mind. Her strength of character is evident
in her bold painting style and use of strong
colours. On her own initiative, she underwent
training at Malcolm Christian's Caversham
Centre, where she found her vocation in
teaching children in communities. She loves to
share her knowledge with others, giving from
the heart without ever asking for reward.**

**Right: Crocodile jug sculpted by Victor
Shabalala and painted by Jabu Nene, 2006.**

**Opposite: Fish and heron vase sculpted by
Victor Shabalala and painted by Octavia
Buthelezi, 2010.**

leadership skills. He has became the father figure at Caversham and has gained the respect of all the artists. Lovemore's wife, Sharon Tlou, also joined Ardmore. Although she started out working as a painter, it soon became clear that, with her personality and dedication, she would be a great asset in the gallery. She has gone on to acquire computer and administrative skills and is now responsible for handling online and general sales.

At the same time that I was training Christopher, a young woman, Happiness Sibisi, joined Ardmore. Motivated to learn about all facets of the business, she has gone from cleaning and packing to mastering every aspect of sales. She has a special aptitude for assessing the quality and market value of each piece. Happiness has become my personal assistant in the gallery, replacing Cathrin Ogram, who emigrated in 2008.

At the start of 2009, I told Ardmore's artists that, to protect ourselves against the global recession, we would have to create exceptional products. We would have to make ten smaller pieces that sold quickly instead of one large one. We would also have to cut waste to a minimum. Everyone recognised that they were being challenged to do their best. In no time, instead of finding only five or six Triple A quality pieces, we were having to hunt for those that did not make our highest grade. It was thrilling and took us another step forward.

I hope that in the next decade Ardmore will see more leaders and entrepreneurs emerge who are keen to ensure the long-term sustainability of the business for the benefit of all the artists. The artists have all developed outstanding technical skills that far surpass my own. Now they must learn to plan for the future and to solve problems without me.

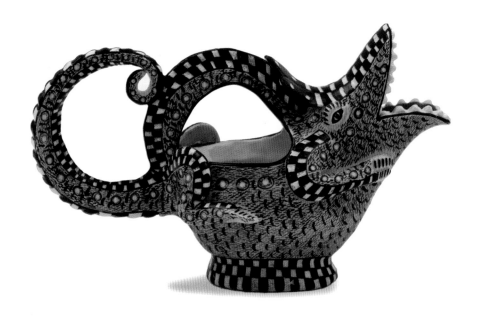

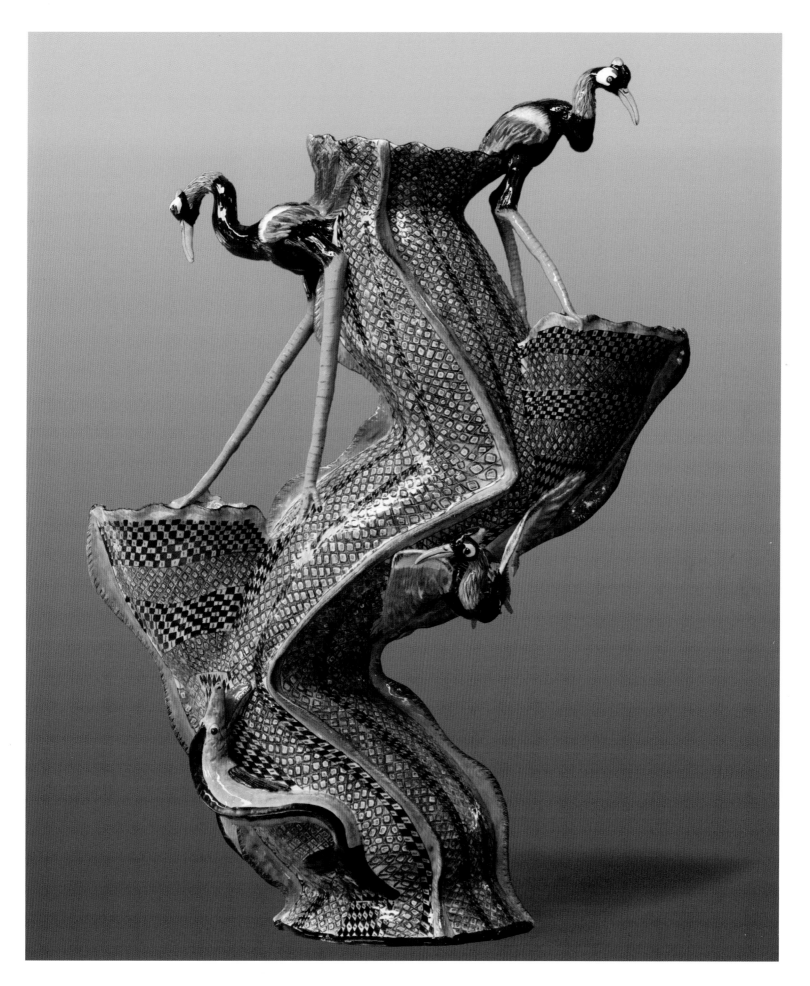

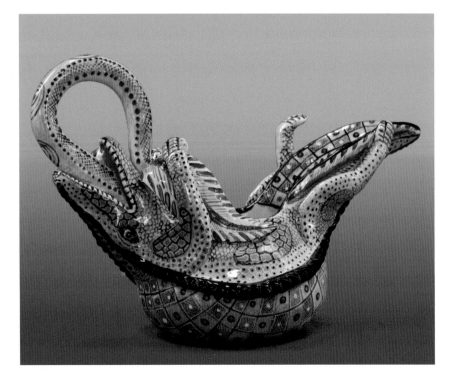

In the last few years four people have developed management and administrative skills and have taken on additional roles and responsibilities in the running of Ardmore.

A skilled thrower, Lovemore Sithole (above left) is responsible for running the studio and is a member of the management team. He is a superb communicator, and adept at helping me and the artists communicate with each other.

Sharon Tlou (above right) and Happiness Sibisi (opposite left) both work in the gallery, where their charming manners and efficient service are a breath of fresh air. They have completed computer courses and are involved in the administration of the business. Sharon is an excellent salesperson and manages general and Internet sales. She is responsible for maintaining the online gallery, including photographing all new pieces and uploading the images for our customers worldwide to view.

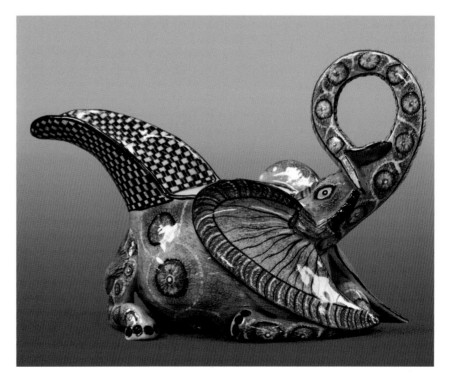

Happiness is the office manager and helps with bookkeeping and sales. She also works as my personal assistant.

A member of the management team, thrower and sculptor Christopher Ntshalintshali (above right) manages the operation and maintenance of the kilns and is the resident restorer. He is a good teacher and an excellent people person. He has the confidence and ability to address any audience and effortlessly rises to any challenge that comes his way.

Opposite bottom: Crocodile jug sculpted by Somandla Ntshalintshali and painted by Mbusi Mfuphi, 2008.

Right: Elephant jug sculpted by Somandla Ntshalintshali and painted by Winnie Nene, 2008.

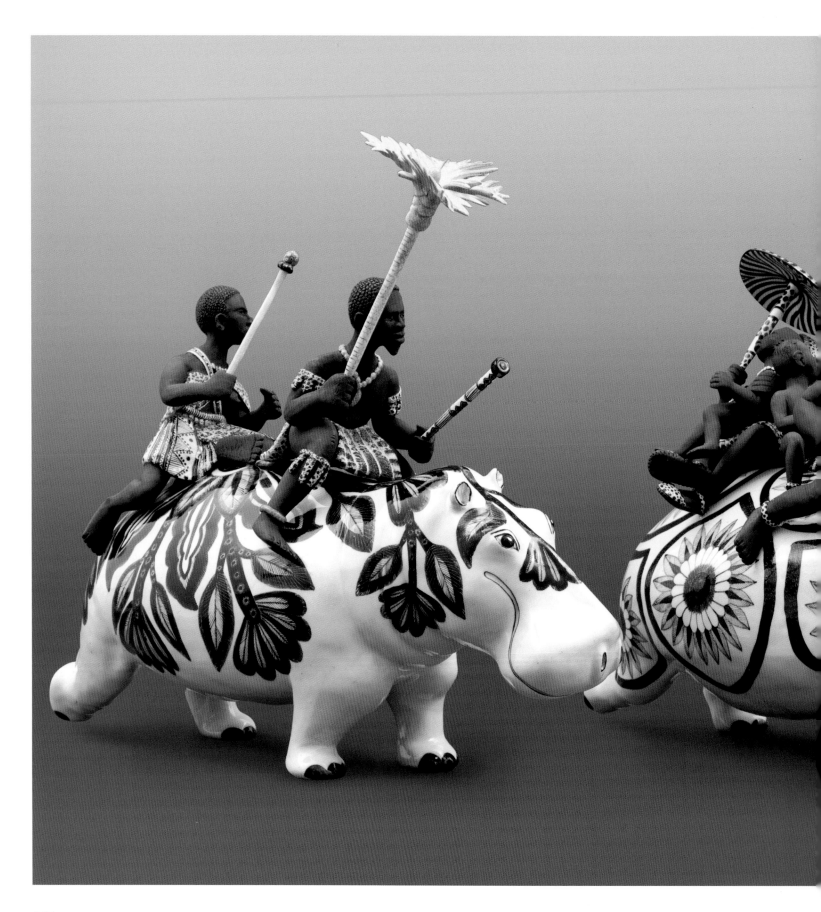

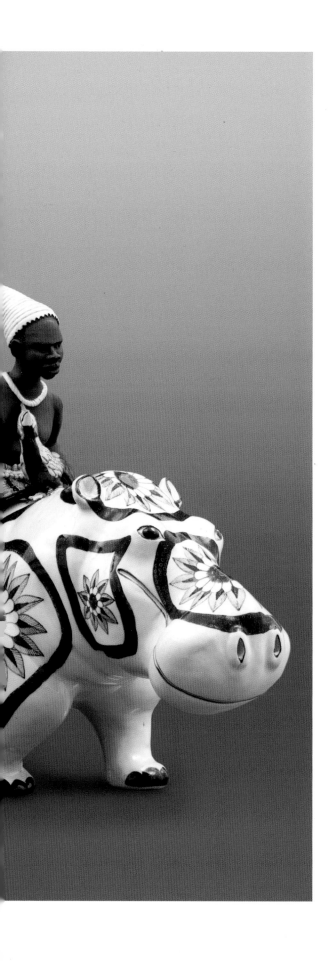

ver the years James's aunt Rilda has become one of my dearest friends. She has always been a great supporter of Ardmore, hosting shows at her home in New Jersey and introducing me to many wonderful people. On one of my visits I met her neighbour, Mari Watts, already in her eighties, but full of *joie de vivre*. After a visit to Egypt, Mari covered the walls of her home with murals. In the heart of New Jersey I discovered a procession of leopards, cheetahs and zebras led by parasol-carrying figures walking under swaying palms along the banks of the Nile. Her home was also decorated with *papier mâché* leopards ridden by turbaned Egyptians. After she died, her house was sold, but her daughter, Mai, kept some of the figures. When I visited America in early 2010 with Catherine, I was able to show them to her. We photographed them, hoping that one day we would be able to honour Mari's wonderful creativity.

In keeping with the excitement of South Africa hosting the 2010 FIFA World Cup™, soccer and vuvuzelas, not ceramics, were the talk of the year. Even so, Christopher Greig, after two tough years of recession, started to discuss a new show with me. When he suggested something along the lines of travellers in Africa, I immediately pulled out the photographs of Mari Watts's figures. 'That's exactly what I want,' he said.

It was a hugely ambitious project. We were breaking away from our usual motifs of flora and fauna and moving boldly into figurative sculpture. Out came reference books on past travellers in Africa: Thomas Baines, a remarkably prolific artist who died in Durban in the 1870s; the Frenchman, François le Vaillant, who arrived in South Africa in 1781; William Cornwallis Harris, who spent two years in southern Africa from 1836; Abu Abdullah Ibn Battuta, a fourteenth-century explorer from North Africa; and Mzilikazi, who trekked northwards after quarrelling with King Shaka and eventually founded the Matabele kingdom in Zimbabwe. I also told the artists the story of Operation Noah, which was launched to rescue wildlife trapped by the rising waters of Lake Kariba, a reservoir created when the hydroelectric Kariba Dam situated at its northeastern end was completed in the late 1950s.

Three sculptors surpassed all expectations with their extraordinary ceramic creations: Petros Gumbi, Bennet Zondo and Alex Sibanda stretched the boundaries of their imaginations and transcended the limitations of the medium. Mickey Chonco, Jabu Nene, Virginia Xaba and Wiseman Ndlovu excelled in the painting of the works. Initially we glazed the black figures, but the finish was harsh and we lost significant detail. I experimented with boot polish, which gave a lovely velvety texture to the figures. We used a local paint, Claybright, on some of the pieces and left them unglazed. We found the paint to be every bit as good as the imported brand that we had used for so many years.

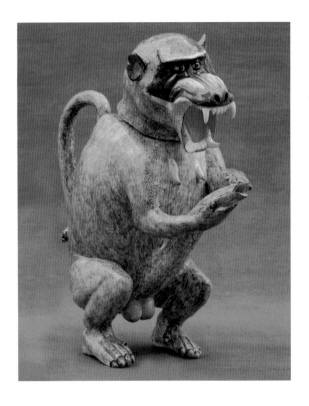

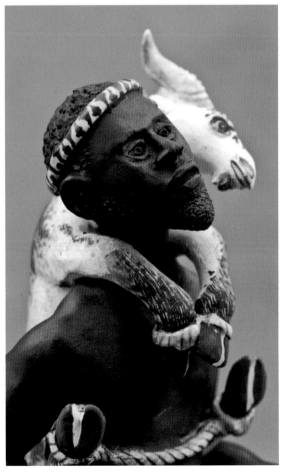

Christopher flew in every few weeks over a period of five months to work with me on developing the collection. He was thrilled when he saw the way the artists had interpreted his brief. The sculptures were full of fun and charm, the subjects were a delight, and the finishes represented a significant departure from our earlier work.

The World Cup was still on when the first pieces arrived in Johannesburg. Some lucky visitors to Charles Greig, among them people from China, Alaska and Turkey, got a sneak preview of the sculptures and were so captivated by them that they coaxed Christopher into selling them a couple of the artworks before the launch. Christopher remembers, 'It made me realise that Fée had created a style that has universal appeal and great charm.'

When the collection was launched at Charles Greig Jewellers in Johannesburg in September 2010, its success was assured. The advertising was superb, the invitation and brochure were stunning, the guest list was extensive and the sculptures were beautifully arranged. The event was co-hosted by The Collection by Liz McGrath. The owner of boutique hotels in Cape Town, Hermanus and Plettenberg Bay, Liz McGrath has long been a staunch supporter of Ardmore and stocks our pieces at all her establishments. Together with Christopher, Liz and I share a great love of Africa and a desire to see its people reach their full potential.

Above left: Baboon *amapipi* teapot sculpted by Bennet Zondo and painted by Wiseman Ndlovu, 2010. When Christopher Greig first saw the *amapipi* teapots, he ordered a dozen. They flew off the shelves.

Left: Sculpture of a traveller with his goat created by Alex Sibanda and painted by Wiseman Ndlovu, 2010.

Opposite top: A group of zebras ridden by Zulu women figures, sculpted by Alex Sibanda and Petros Gumbi (sculpture second from left) and painted by Wiseman Ndlovu, 2010.

Opposite bottom: Sculpture of a female traveller riding a sable antelope created by Sabelo Khoza and Petros Gumbi and painted by Wiseman Ndlovu, 2010.

Previous spread: Sculptures of hippopotamuses and their riders created by Alex Sibanda and painted by Jabu Nene, 2010.

Overleaf: Sculptures created in 2010 for the *Travellers of Africa* exhibition included Arab riders sculpted by Alex Sibanda and painted by Siyabonga Mabaso (p. 168 top); mokoro laden with baboons sculpted by Bennet Zondo and painted by Mickey Chonco (p. 168 bottom); miniature leopards and riders sculpted by Petros Gumbi and painted by Virginia Xaba (p. 169 top); and mokoro loaded with zebras sculpted by Bennet Zondo and painted by Virginia Xaba (p. 169 bottom).

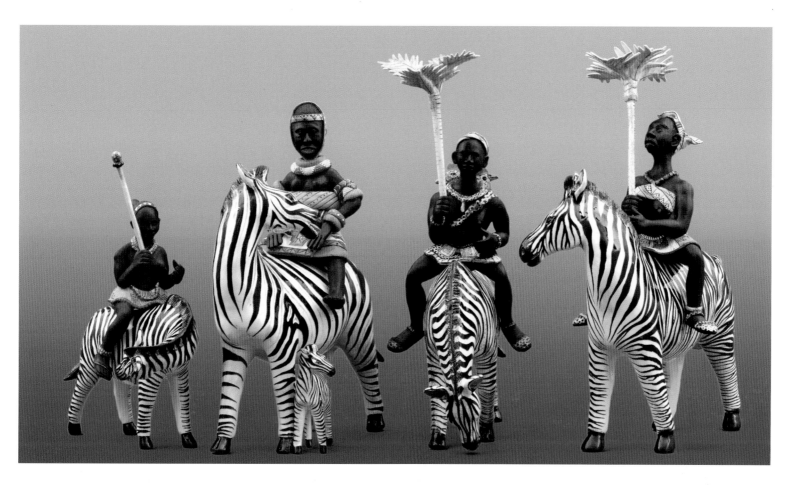

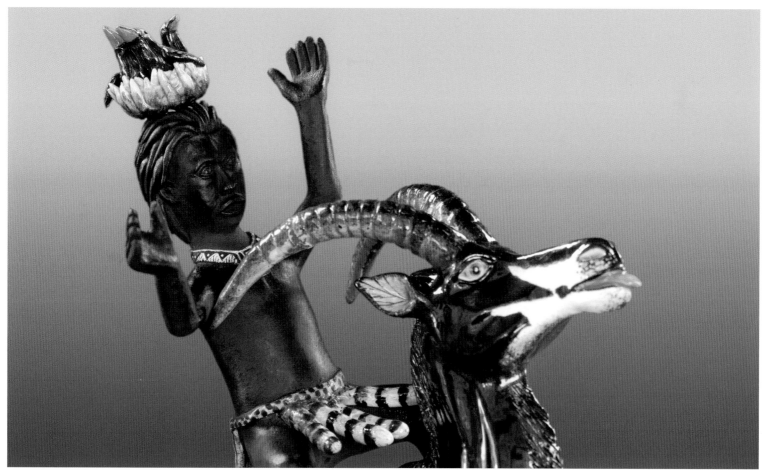

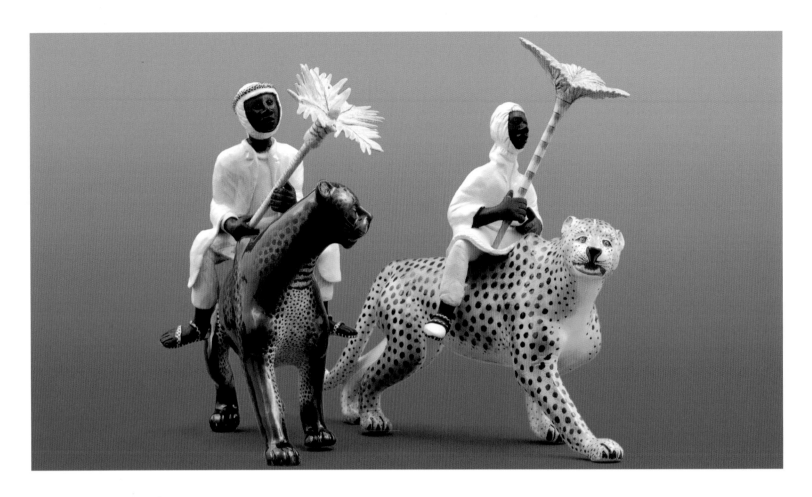

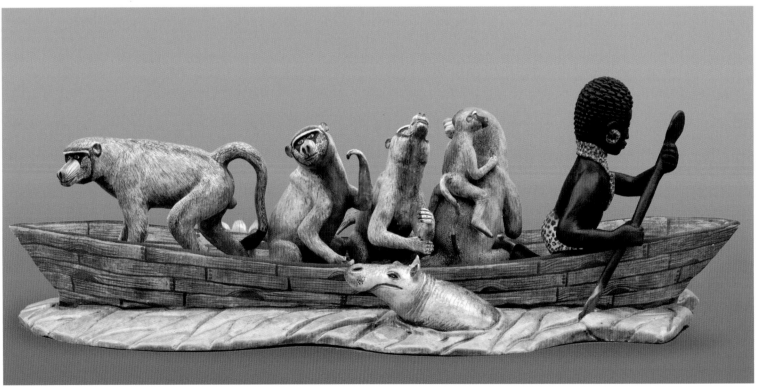

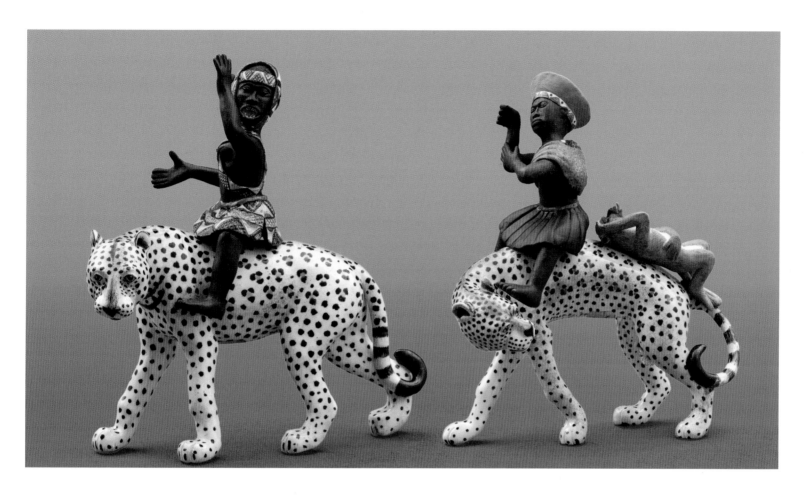

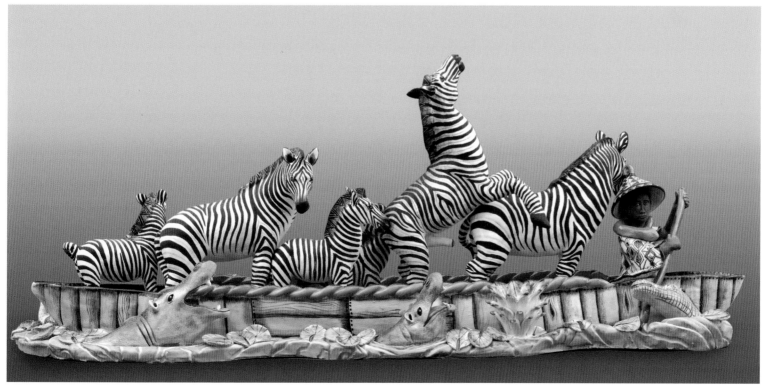

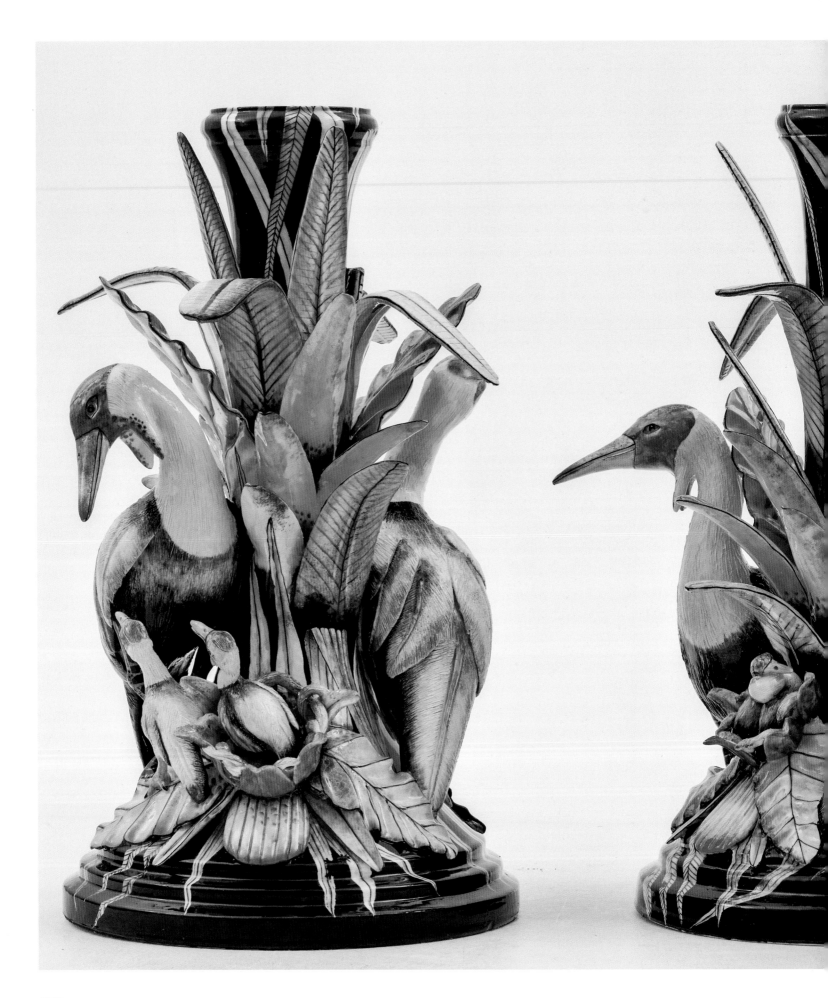

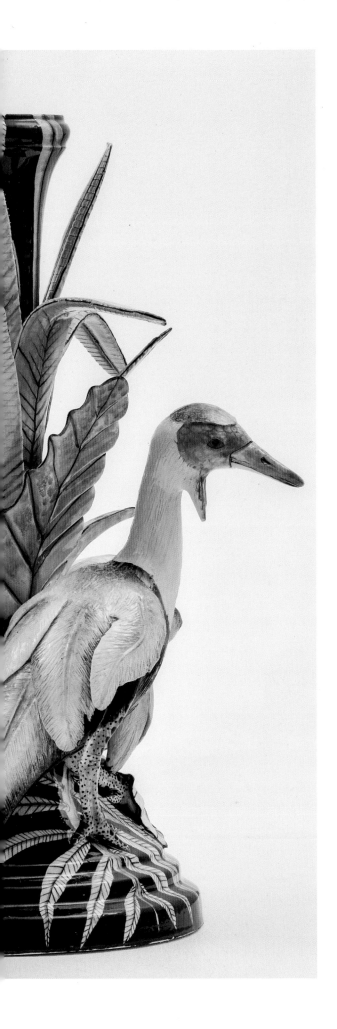

On a business trip to Cape Town in 2009 I took some time out to see my son, Jonathan, who was completing a postgraduate course in finance and investment at Stellenbosch University. Over breakfast in Claremont, I felt compelled to share an idea with him that had been percolating in my mind for a while. I had turned fifty and was beginning to reflect on my 'legacy'. Concerned about Ardmore's future, I had been giving a great deal of thought to the sustainability of the business. I told him that Ardmore's most valuable asset is its fabulous designs – thousands of different ones from over the years – and that it would be a pity if these did not live on in a different form. Furthermore, I said that I would love to start a business with him that would explore the feasibility of creating a different line of Ardmore design products. Most of all, I wanted him to experience the magic of an idea becoming reality. Jonathan had gone to boarding school when he was young and I had not been able to spend as much time with him as with the girls. I felt that creating a new business venture would give us a chance to work closely together, to experiment, and to get to know each other again. Additionally, the recession was in full force and jobs for youngsters leaving university were not easy to come by.

After graduating at the end of 2009, Jonathan began his training under the expert eye of then marketing manager Jennifer Fair at Ardmore's Cape Town office. Together they laid the foundation for a new enterprise that would mark the next phase in our pursuit of innovation: Ardmore Design Collection. Its mission was to translate Ardmore imagery, colour and wit into quality, functional ceramic and non-ceramic products. Jennifer and Jonathan established the necessary legal and accounting frameworks, drew up budgets and hired graphic designer Diana Chavarro. From time to time they reported back to me, and I thoroughly enjoyed their enthusiasm.

In the meanwhile, my daughter Catherine initiated the idea of creating scarves as well as textiles featuring Ardmore designs. Catherine and I spent hours poring over concepts and designs, debating what would be popular and what would be saleable. As neither of us had any experience in textile design, Catherine spent a great deal of time with Home Fabrics designer Hayley Stevenson learning the ropes. At Ardmore, Catherine was put in charge of a team of design artists as well as an experimental lab to test sample products, mainly fabrics for cushions, placemats and other soft furnishings. Catherine, Zinhle Nene, Goodness Mpinga and Octavia Buthelezi worked together to transform some of Ardmore's earlier works into shapes and patterns that could be used in tapestry and textile designs. Jonathan and Jennifer chased the markets, while Catherine, her team and I did our best to flounder along in the lab.

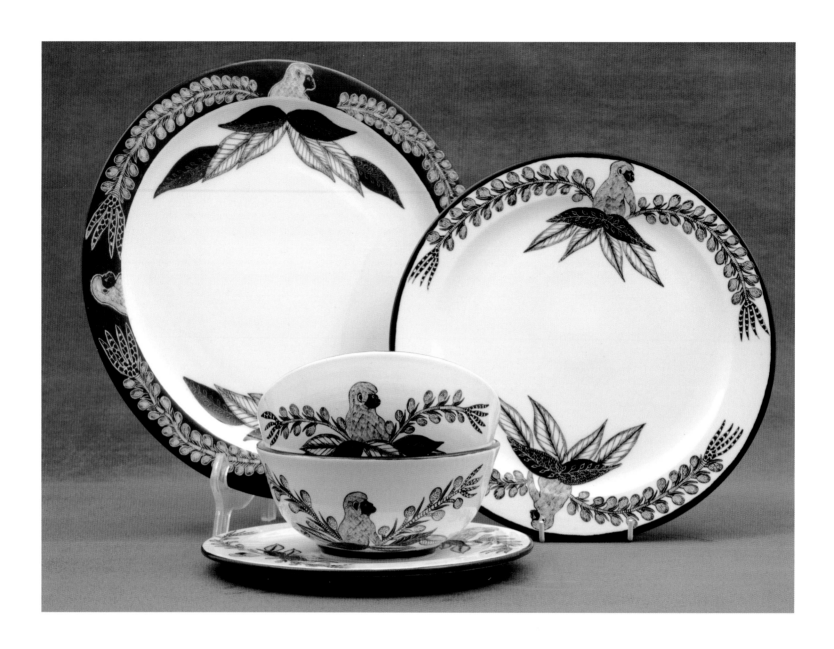

Above and opposite: Ardmore Design Collection's first two ranges of tableware were launched in 2010. The Ebony range (above) was designed by Alex Shabalala and Octavia Buthelezi and the Zinhle range (opposite) was created by Zinhle Nene. The development of this product range was made possible by a grant from the Business Trust's Shared Growth Challenge Fund.

Previous spread: Wattled crane lamp bases thrown by Lovemore Sithole, sculpted by Betty Ntshingila and painted by Wiseman Ndlovu, 2012.

Work in the studio was also continuing apace. Liz McGrath had asked Ardmore to produce commemorative plates to give to 400 delegates from around the globe who would be visiting Cape Town for the 2010 Relais & Châteaux international conference. Our answer was 'Of course'. Talented Ardmore artist Alex Shabalala did the design. The plates were so successful that, before we knew it, we were busy planning our first dinnerware sets under the Ardmore Design Collection label. We started with two limited-edition ranges: Zinhle ('it is beautiful' in Zulu), named after Zinhle Nene, the artist who designed it, and Ebony, created by Octavia Buthelezi and Alex Shabalala. Delicate in colour, the Zinhle range features three iconic Ardmore animals, the leopard, the giraffe and the zebra, while the Ebony range comprises black-and-white designs inspired by printmaking techniques. The monochrome palette of the Ebony range, we thought, would work well with silver cutlery. The tableware series was first shown at the *Travellers of Africa* exhibition at Charles Greig Jewellers in Johannesburg in 2010.

None of this would have been possible had it not been for a generous grant from the Business Trust's Shared Growth Challenge Fund (SGCF). The fund was established by South African business leaders and uses private sector and government resources to support initiatives that are innovative, commercially viable and contribute to poverty reduction. In terms of the grant, we had to have a product ready to deliver to the market by the end of 2010. Although we had made significant progress with the creation of several new products, such as the tableware ranges, the deadline was looming and we were fast running out of time.

There were just too many ideas, designs and products; we needed help to consolidate them and to determine the best way forward. I called in an old friend, Neville Trickett, who runs his own advertising and design company, Wisdom and Youth, in Durban. Neville, like me, had grown up in Zimbabwe, and his wife, Sharon, had been in the same class as me at school in Bulawayo. Neville and I had collaborated on several Ardmore projects and international ventures over the years. With the clarity of vision that only an outsider can offer, Neville identified key design elements of our ceramic art that could be transferred to the fledgling Ardmore Design Collection. He reminded us that Ardmore's success was derived from the organic shapes, animal patterns, wit, humour, naivety and eclectic cultural representations that characterise its designs.

With renewed focus, we set about developing a small range of lifestyle objects that, in addition to the tableware, would officially be launched as the Ardmore Design Collection at the Food Wine Design Fair at Hyde Park Corner in Johannesburg in November 2010. Neville lent me one of his graphic designers, Kevin Perry, and he and I immediately set about planning the Ardmore Design Collection stand for the fair. We had decided on the theme of 'A well-laid table', and everything was carefully measured and made to specification to fit the space: a table, upholstered benches, a sofa, an Ottoman, an old batonka stool with a gorgeous tapestry seat, a sideboard, scatter cushions, framed wall designs, table linen and a dinner service. Diana and Jonathan travelled from Cape Town to oversee the installation. Jonathan and two assistants had to carry the table from the car park to the exhibition venue on the rooftop as it would not fit in the lift! I joined them on the last day of the fair and gloried in the whole vision and the positive response from the public.

The highlight of the show was the Qalakabusha ('new beginnings' in Zulu) sofa, upholstered in Ardmore textiles printed especially for the fair. As the flagship object of Ardmore Design Collection, it continues to create a stir wherever it goes. Our first milestone was when it was selected as a finalist for the Most Beautiful Object in South Africa Award at the prestigious Design Indaba in Cape Town in February 2011. We did not win but we

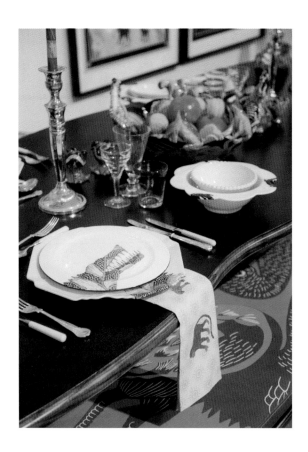

came a close second. Soon thereafter, international style guru Lidewij ('Li') Edelkoort invited us to send the sofa to the Talking Textiles show at the 2011 Milan Furniture Fair. Jennifer was apprehensive but I said we should give it a go. My decision was vetoed. Li felt so strongly about it being showcased at the fair that she offered to help with the shipping costs, so off it went! After the Milan fair, the couch was displayed at the high-profile Spazio Rossana Orlandi store in Milan. Next, in June, 2011, it travelled to Vienna, Austria, as part of the South Africa in Colours Festival, an initiative by a South African-based non-profit organisation, Makhaya Art & Cultural Development, to promote South African arts and culture. Its last stop of the year was at the Museum of African Art in Belgrade, Serbia, where some of South Africa's best arts and crafts were showcased as part of the *Meeting Point* art exhibition, which opened in September.

Because it continued to cause waves, we decided to release a limited edition of forty sofas, labelled and numbered in the fine-art manner of printmaking. I am a great believer in the power of families, so it was inevitable that we would join forces with leading fabric design company Mavromac, which is co-owned by my sister-in-law Marguerite Mavros Macdonald, to manufacture the sofa. Partnering with Marguerite and Mavromac made perfect sense: they are experts at what they do and we could trust them wholeheartedly. In addition, distribution of the sofa would be managed by The Gatehouse at Mavromac, also specialists in their field. By the beginning of 2012 we had sold our first twelve sofas to buyers across the world.

Following the successful launch of the sofa, we focused our attention on developing a textile range – for soft furnishings, curtaining and upholstery – that would be as vibrant as our ceramics. Marguerite led the project, and Catherine, Diana and I were put to work searching for iconic Ardmore designs that could be transferred to fabric. Once we had made a reasonable selection, Marguerite skilfully guided us through a process of integrating the shapes and patterns into contemporary textile designs. One of the patterns that she proposed involved a monkey perched on the branch of a palm tree (the monkey symbolises the wit and humour associated with Ardmore). Although I gave the drawing of a palm tree my best shot, Jonathan is responsible for the one that was eventually chosen. He said that my illustration was awful, so he drew the tree himself. Diana cleverly added the monkey that is such a prominent feature of the Qalakabusha sofa. Another suggestion was to do curtaining, and Marguerite envisioned a simple but elegant design of wavy stripes. This turned out to be the biggest challenge of all because at Ardmore nothing is ever plain and simple. Eventually I found a stripe I liked: an organic plant stem that features in several Ardmore designs. We embellished it a little by superimposing zebra-like white 'stripes' across the stem. Other fabric designs include a crocodile

Above: Ardmore Design Collection launched its first range of luxury lifestyle items at the annual Food Wine Design Fair at Hyde Park Corner in Johannesburg in 2010. In keeping with our chosen theme, 'A well-laid table', our stand featured exquisite dinnerware, table linen, soft furnishings, tapestry designs and the iconic Qalakabusha sofa upholstered in vibrant Ardmore textiles.

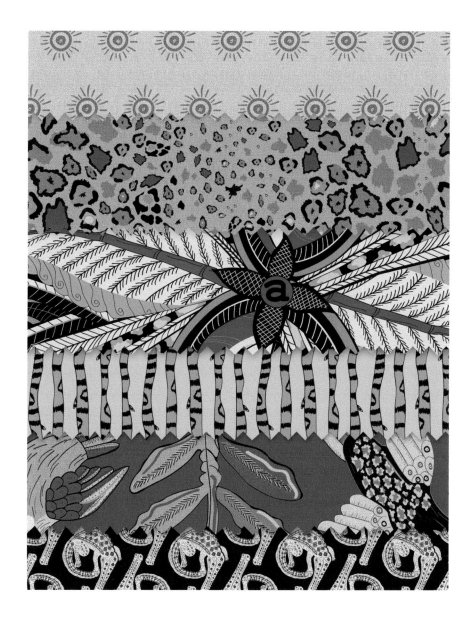

copied from the handle of an Ardmore planter, a striking flower pattern redrawn from a ceramic tray, and a colourful rendition of four birds that appear on a small ceramic dish that I designed many years ago. Launched in May 2012, the textile range has proved to be more successful than we could ever have hoped for.

The business side of Ardmore Design Collection and Ardmore Ceramic Art also underwent change. On the advice of Fleur Heyns, a dynamic young businesswoman and business mentor, an advisory board was set up in 2010. It is chaired by Deirdre Simpson and includes Ted Adlard, Anthony Record MBE and Fleur. At its first meeting, in December 2010, the board recommended that Jonathan take up the position of operations manager to support me in overseeing the running of the two entities. Jonathan moved

Above: The bold colours, floral patterns and sculptural forms that characterise Ardmore's ceramic art, such as these artworks painted by Virginia Xaba (top) and Punch Shabalala (bottom), 2010, inspired Ardmore Design Collection's first textile range launched in 2012 (above left).

back to Caversham at the end of 2010, found digs in Nottingham Road with old school friends, and began his new job working alongside me in January of the following year. Neither of us knew if the new arrangement would work but we have surprised each other with how well it has turned out.

Jonathan and the board continue to run the show, with the support of a great team of accounting, human resource and marketing experts. I am finding myself less worried and less involved with issues about which I am not knowledgeable, and more and more able to work creatively alongside the artists, with Catherine as my right-hand woman.

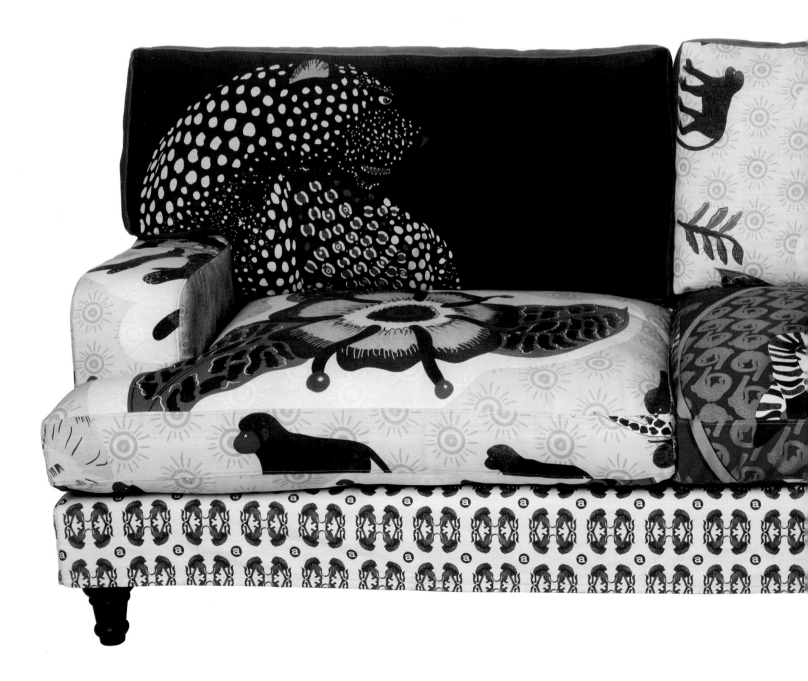

I cannot predict with accuracy what the future holds for Ardmore Design Collection. Like Ardmore Ceramic Art, it is destined to unfold organically, at its own pace. All I know is that it will take my children and a new generation of artists on an enthralling journey and, as in all good stories, it is the journey that is most important. I feel the same way I did almost thirty years ago when Ardmore was in its early stages – excited, nervous, and full of anticipation and curiosity.

I am sure that somewhere in heaven my dad and my ancestors are looking down, with joy, on the boundless creativity of the next generation.

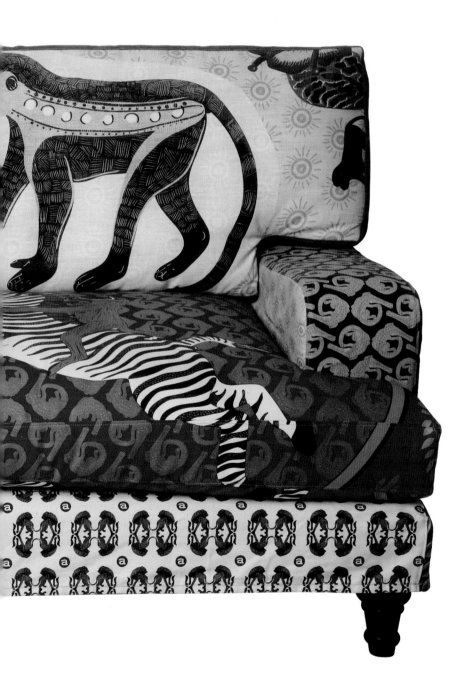

Left: What started out as an idea turned into a most desirable and celebrated item: the Qalakabusha ('new beginnings' in Zulu) sofa. Vibrant and quirky, the showstopping upholstery fabric symbolises the style, spirit and humour that is synonymous with Ardmore. The sofa is the flagship object in the Ardmore Design Collection, and a limited edition of forty sofas was released globally in 2011. The couch is distributed by The Gatehouse at Mavromac, a leading South African fabric house.

Above: Punch Shabalala's plate designs from the early 1990s were the inspiration for a series of stylish decorative tapestries. One of these was used to cover the seat of a batonka stool, which was displayed at the 2010 Food Wine Design Fair in Johannesburg.

y children have enjoyed a healthy and happy lifestyle, including having access to good schools and a university education. They recognise the privileges they have had and appreciate the advantages of having grown up surrounded by people from whom they could learn about creativity, art and the richness of cultural differences. Their lives have been enhanced by their extended family – aunts, uncles and cousins – and the many people who have visited Ardmore, as well as friends and acquaintances they have met while travelling with the artists and me to local and international exhibitions.

From early on, Jonathan, Catherine and Megan understood that working at Ardmore would be a part of their lives, and they have never hesitated to lend a helping hand when necessary. If we are packing a big order, they roll up their shirtsleeves. If we are entertaining buyers, they cook the dinner. Catherine provided us with hot soup on many a cold winter's night when we had to work around the clock. Jonathan willingly ran around doing deliveries for me in Cape Town and the surrounding areas during the four years that he was a student at Stellenbosch University. Megan never hesitates to interrupt whatever she is doing to send emails for me. They have learnt that being involved in Ardmore requires teamwork.

Jonathan completed a degree in economics in 2008 and a postgraduate course in finance and investment the following year. Now, with his studies behind him, he works full-time at Ardmore, managing the business and developing opportunities in the design arena. In his role as operations manager he has brought improvements to almost every part of the business, from operational systems and financial management to human resources. Under his leadership, Ardmore has become an efficient and well-run operation. We love the discipline and routine he has introduced, and appreciate his ability to manage us all. He commands great respect from his co-workers and the artists, and the fact that he is fluent in Zulu is an asset. Jonathan is a born leader and I am proud to have him at my side.

My elder daughter, Catherine, studied fine art at the University of KwaZulu-Natal and works at Ardmore, focusing on graphic design, ceramics and textile design. Catherine plays an important role in the development of Ardmore's new textile range, requiring close collaboration with a team of artists, Ardmore's graphic designer, Diana Chavarro, and Marguerite Mavros Macdonald of Mavromac. She contributes to Ardmore in other ways too: she runs the blog, is a great salesperson and a charming hostess, and assists me whenever necessary. She has a great eye for detail, is full of ideas and does everything with passion and determination.

Megan, my younger daughter, matriculated with seven distinctions and was dux of her school in 2011. After completing school, she enrolled

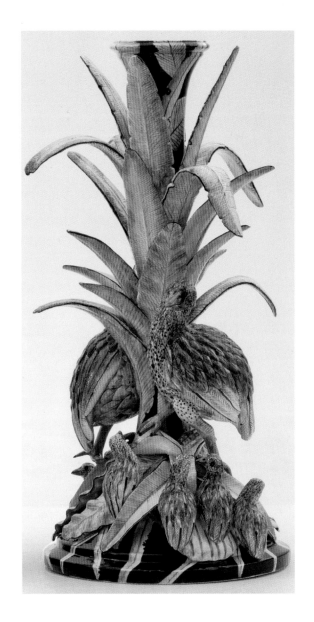

Opposite: My best friend, Mistral. Horses take me away from my everyday problems into another world.

Above: Spurfowl mother and chicks lamp base thrown by Lovemore Sithole, sculpted by Betty Ntshingila and painted by Siyabonga Mabaso, 2011.

Above: Catherine Berning has been working with a team of artists preparing designs for tableware, tapestries and printed fabric. With Catherine are Goodness Mpinga (centre) and Zinhle Nene (right), two of Ardmore's outstanding painters.

Right: Elephant bowl thrown by Sabelo Khoza, sculpted by Sondelani Ntshalintshali and painted by Punch Shabalala, 2010.

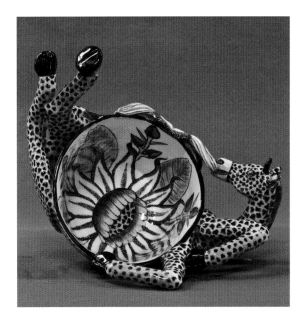

for a degree in fine art at the University of KwaZulu-Natal. She has a wide range of interests and demonstrates all-round excellence in whatever she does. She is full of energy and loves sketching, covering the back of the office wastepaper with a variety of designs, from dresses, shoes and hats to scarves and handbags.

Both Catherine and Megan are accomplished horsewomen and are passionate about their chosen sport. They are dressage enthusiasts and have won several South African equestrian titles. Megan has also become a fearless show jumper. It seems that it is only her mother who has her heart in her mouth when she flies over the jumps.

I am impatient to see their future. But it is up to them to shape their own destinies. I can only watch with love.

Above left: My younger daughter, Megan Berning, sees a future for herself in fashion and accessory design. This could change over the next few years while she is studying at university.

Top: Giraffe bowl sculpted by Sfiso Mvelase and painted by Mbusi Mfuphi, 2010.

Above: Detail of a tureen sculpted by Somandla Ntshalintshali and painted by Jabu Nene, 2010.

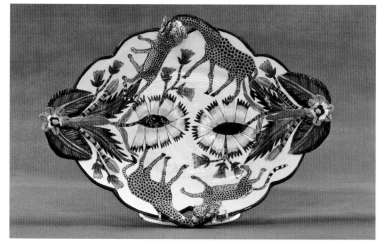

Above: My son, Jonathan Berning, handles the business side of Ardmore. He works closely with Sharon Tlou (right), who is responsible for Internet sales.

Right: Flower and giraffe platter made by Sondelani Ntshalintshali and painted by Sharon Tlou, 2010.

From time to time, projects come along that make me truly appreciate the creativity and artistic talent that is the lifeblood of my extended family. It has brought me great delight to work with my nephew Forbes Mavros, a truly talented jewellery designer and the son of my sister, Catja, and her husband, renowned sculptor and jeweller Patrick Mavros.

Based in Harare, Zimbabwe, Patrick designs and makes exquisite sculptures and men's and women's jewellery, and has outlets in London, Harare and Mauritius. The flagship store – in London's Fulham Road – is run by Patrick and Catja's eldest son, Alexander. Their second son, Forbes, completed a degree in jewellery design at the Edinburgh College of Art in Scotland and attended the Royal College of Art in London. The younger boys, Patrick Jr. and Benjamin, are designers as well.

Forbes lives and works in Mauritius, where he also heads the Patrick Mavros Atelier in Terre Rouge, north of Port Louis. His Mauritius Collection, inspired by the tropical and marine surroundings of his island home, was launched in London in 2011.

Forbes's long-standing desire to work with Ardmore became a reality in 2011. On an earlier visit to Caversham he showed me a drawing of a decorative hanging light that he wanted to have installed in the Patrick Mavros Atelier, which was still under construction at the time. He wanted it to hang in the double-volume space of the design studio and shop, next to the staircase, where it could be admired as one ascends the stairs. Forbes envisaged a large ceramic work that would be in the shape of a banana flower, covered with beetles, chameleons, lizards and other creatures that represent the studio's island setting. 'And it must definitely have a monkey,' he said.

No challenge is ever too big for the Ardmore team, and the enormous light fixture was sculpted, fired and painted over a period of four months. The artists – sculptors Bennet Zondo and Sfiso Mvelase and painters Wiseman Ndlovu and Sthabiso Hadebe – revelled in the excitement of having a new creative person working alongside them, and thrower Lovemore Sithole enjoyed the engineering aspects of working to a specification.

Shipping the completed fitting to Mauritius proved to be a daunting challenge. In the end it was decided that Forbes would have to collect it at Caversham. He duly arrived, declared it was everything he had dared to hope for, and lovingly wrapped and packed the individual segments in boxes to carry back home. After delicate negotiation with his airline carrier, he was allowed to stow his boxes, covered with 'Fragile' stickers, in the hold. We all hoped and prayed that the contents would arrive undamaged at the other end. Miraculously, they did! The 'chandelier' was installed just in time for the opening of the studio and shop at the end of 2011 and was an immediate hit. Since then, we have received numerous inquiries through Forbes's studio and are exploring the possibility of launching Ardmore in Mauritius.

I thoroughly enjoyed collaborating with my talented nephew. More important, it gave me great pleasure to see my children and their cousin get on so well and have fun together. The cousins have so much in common: creativity, courage, commitment to innovation, an entrepreneurial spirit and a deep love of Africa.

Above: Photographed in Zimbabwe, the Mavros family are (from left) Patrick Jr., Forbes, Catja, Patrick, Benjamin and Alexander.

Below: A large ceramic light fixture was created by Ardmore sculptors and painters for the Patrick Mavros Atelier in Mauritius.

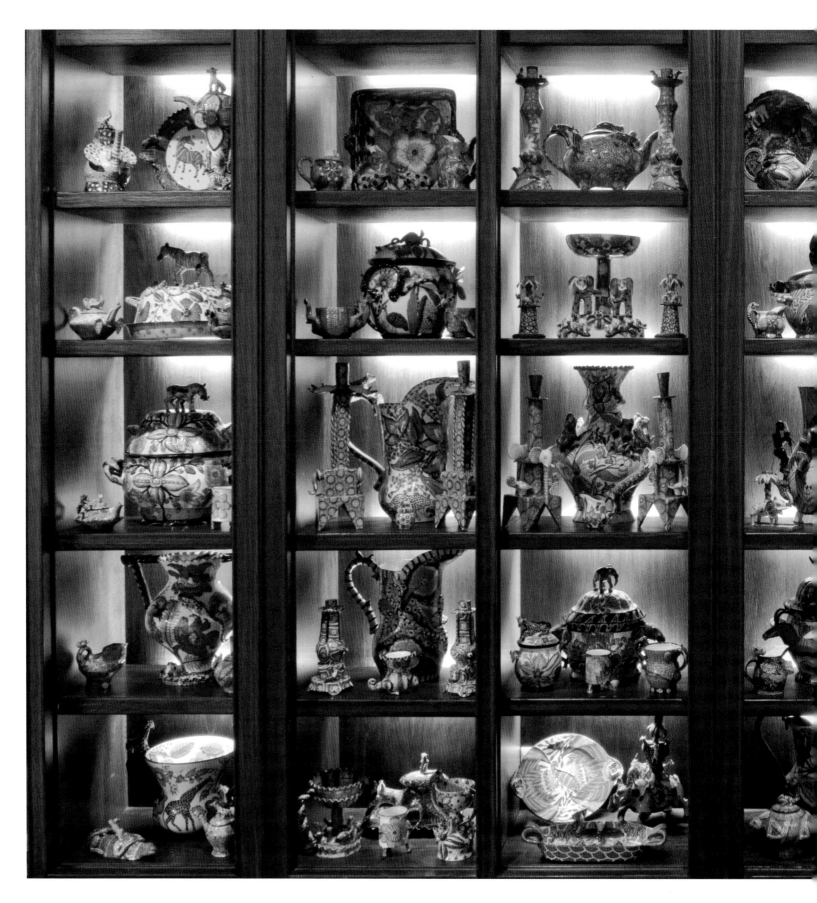

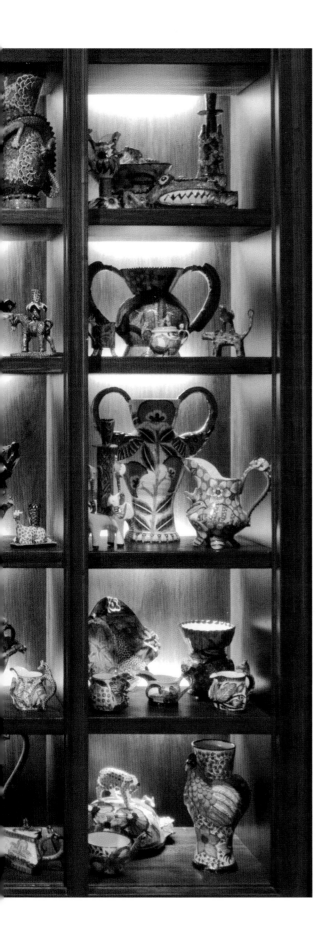

Lindiwe Mabuza has often described herself as an 'Ardmore addict'. She loves our ceramics as well as the story behind Ardmore and its famous artists. Whenever she makes a speech at an Ardmore exhibition she warns guests to beware, because once they start buying they will not know when to stop. Another devotee, Brian Greis, who hails from Florida in the United States, told us that some of his friends have become concerned about his 'addiction'. He loves the fun and humour in the artworks and treasures the friendships he has made through sharing his discovery of Ardmore's ceramics. Besides Lindiwe and Brian, Ardmore has many other compulsive collectors. They include Susan Mathis, Leslie Hollander Eichner, Mark Rutt, Ellie and Dan Bump, Ted and Dorothea Adlard, Vivien Cohen, Deirdre and Mark Simpson, Peter St George, Jane Bedford, Ken and Blair Beall, Neal Baer and Gerrie Smith, Cathe and John Kobacker and Maysie Starr.

After the publication of our first book in 1998, we found that Ardmore ceramics were increasingly being given as state gifts to visiting foreign dignitaries as well as leaders of countries visited by the South African president. One of the first recipients of an Ardmore work was ex-US president Bill Clinton. Other recipients included former French president Jacques Chirac, Empress Michiko of Japan and the Queen of Malaysia. In 2010 President Jacob Zuma gave a platter created by Somandla Ntshalintshali to Queen Elizabeth II during his state visit to Britain. This has opened the door for Ardmore to be recognised as a premier but quintessentially South African brand, akin to how the classic German and French porcelain brands of Meissen and Limoges, respectively, are perceived.

I have often wondered why people buy our pieces. Although I have been given many different explanations, the answer seems to lie in the fact that our ceramics have universal appeal. Some love the humility of Wonderboy Nxumalo's designs and messages. Others admire the creative energy evident in Victor Shabalala's sculptures. Many people are drawn to the complex painted patterns created by Jabu Nene or the natural realism in the works painted by Mickey Chonco and Wiseman Ndlovu. There is something for everyone. The only common denominator is an irresistible urge to own an Ardmore work.

Towards the end of 2008 we arranged for a private collection to be sold through Stephan Welz & Co. in Johannesburg. The collection featured works by Bonnie Ntshalintshali, Josephine Ghesa and several other artists. Technology played a huge part in the success of the auction. We were able to email collectors across the globe, inviting them to put in bids. I was left speechless as bidding for a Wonderboy vase reached R60 000, after which things really heated up. At R100 000, calls were still coming in.

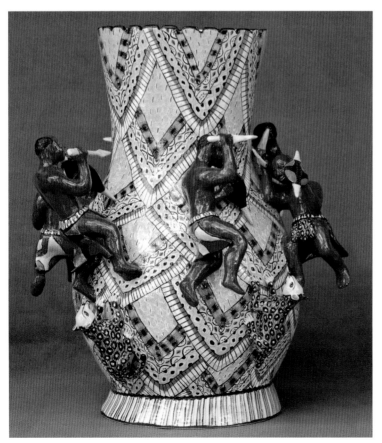

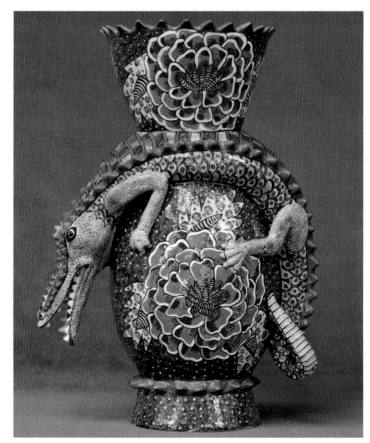

Eventually the auctioneer's hammer came down on a bid of over R200 000 – the highest price ever achieved for a single Ardmore artwork. There was a standing ovation and lots of tears were shed in memory of Wonderboy, who had died earlier that year. We knew how much he would have enjoyed the occasion. What this auction showed us was that there is no limit to the price that top pieces can command.

While Ardmore is synonymous with quality, we firmly believe that the brand also stands for heart, soul, caring, integrity and community. One of our aims is to bring people together to enjoy the beauty of objects that not only offer great pleasure, but also touch the heart. Artworks created for exhibitions such as the 2007 *Great Cats of the World* and the 2008 Groote Schuur shows achieved that objective. So did the pieces we submitted for the *South African Invertebrate Art* exhibition, held at the Brenthurst Library in Johannesburg in 2008. The exhibition, commissioned by Strilli Oppenheimer, aimed at drawing attention to the decline in insect populations as a result of habitat loss, pollution and other factors. The events were happy celebrations that created a buzz among a growing community of supporters.

The notion of community extends to our large network of friends, collectors and dealers with whom we are in regular contact thanks to Alan

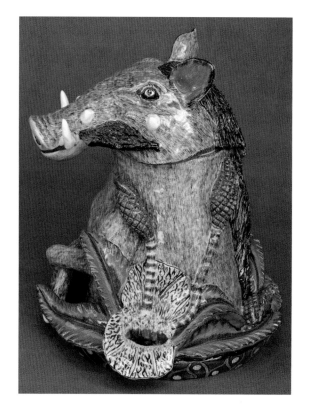

Opposite top: A hoopoe urn sculpted by Sondelani Ntshalintshali and painted by Angeline Mathebula, 2009, is displayed in the home of collectors Ken and Blair Beall.

Opposite bottom and above: Works in the collection of long-time Ardmore friend Susan Mathis include a Zulu warriors vase sculpted by Nhlanhla Nsundwane and painted by Jabu Nene, 2006 (bottom left), a crocodile vase sculpted by Victor Shabalala and painted by Zinhle Nene, 2006 (bottom right), and a warthog container sculpted by Sfiso Mvelase and painted by Rosemary Mazibuko, 2006 (above).

Left: Ardmore collector Brian Greis, seen here with artist Sfiso Mvelase, lives in Florida in the United States. For Brian, Ardmore epitomises African creativity. He is especially attracted to the whimsy and wit of Sfiso's sculptures.

Previous spread: Susan Mathis is the dynamic owner of a luxury safari lodge in South Africa's North West province. Her private Ardmore collection comprises more than 750 works.

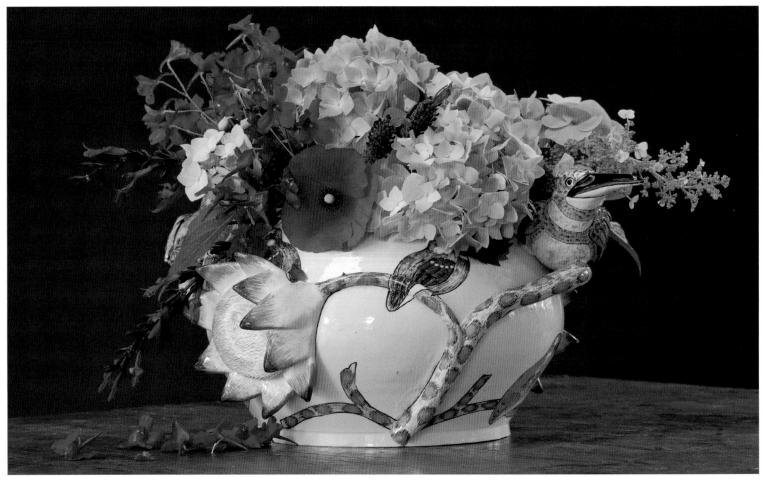

McGregor who, some years ago, updated our communications systems and enhanced our online capabilities. Since then, Jennifer Fair has expanded Ardmore's profile through a variety of marketing and communication strategies, including distributing a bi-monthly electronic newsletter and sending advance notices and photographs of new artworks to customers around the world. They can order on sight of the images or commission individual pieces from the studio. Today we talk to the world by sending pictures instead of ceramics, thus saving costs and avoiding breakages.

Another of Alan's great ideas was to introduce an evaluation system to certify the best Ardmore works, based on the quality of the sculpting, painting and glazing of the pieces. Known as the Triple A Award for Excellence, it has a dual purpose: artists whose works are recognised for their excellence receive a bonus, and buyers of such works are assured of quality. A description of Ardmore's ceramics as 'modern collectibles' by Christie's in London represented a further stamp of approval, one that was later endorsed by Bonhams, Sotheby's and, locally, Charles Greig Jewellers and Stephan Welz & Co. This validation has given Ardmore works a recognised investment value and has provided buyers with a guarantee that they are spending their money wisely.

Ted Adlard is both a collector and, like so many other people who are fascinated by the story of Ardmore and the creativity of its artists, one of our special friends. For years now, whenever he visits Ardmore, he brings his toolbox and checks our electrical equipment, repairing anything that is out of order. In addition, he organised a much-needed kiln for the studio. Fortunately for us, Ted agreed to be a member of the Ardmore Board of Advisors, which was established in 2010.

A more recent Ardmore admirer is Rohan Vos, owner of Rovos Rail, Africa's answer to the Orient Express. As well as long journeys to places like the Victoria Falls and Dar es Salaam, his company also offers shorter rail safaris around South Africa, one of which takes passengers through the KwaZulu-Natal Midlands, with a scheduled stop at the Lions River Station near Caversham. When Rohan asked us to consider entertaining his guests at Ardmore, we were more than happy to oblige. We provide refreshments and take them around to meet the artists and visit the gallery and museum. Those who are interested are treated to an equestrian display.

In the United States we have established significant outlets for Ardmore's fine art ceramics through three American art dealers: Pascoe & Company in Miami, Malena Ruth in Los Angeles, and the Amaridian Gallery in New York.

Pascoe & Company traces its roots back to 1969 when, at the age of sixteen, Ed Pascoe discovered Wedgwood Jasperware in London's antique shops and markets and sold them back home in Philadelphia. From then

Opposite: Dylan, the son of collectors Dorothea and Ted Adlard, admires a sculpture of a group of Ardmore artists created by Nkosinathi Mabaso and painted by Nomali Mnculwane, 2008 (top). Also in the collection of the Adlards is a kingfisher bowl made by Slulamile Mlambo and painted by Angeline Mathebula, 2007 (bottom).

Below: Wild dog urn thrown by Vusi Ntshalintshali, sculpted by Bennet Zondo and painted by Zinhle Nene, 2007. It was shown at the *Global Africa Project* exhibition held at the Museum of Arts and Design in New York in 2010.

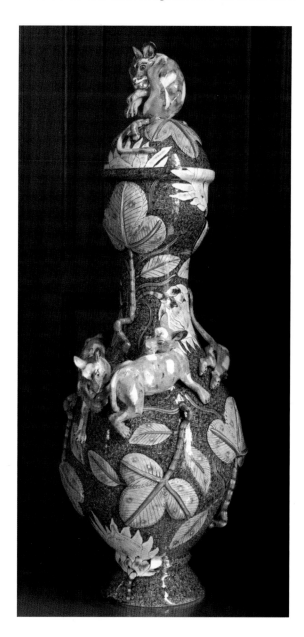

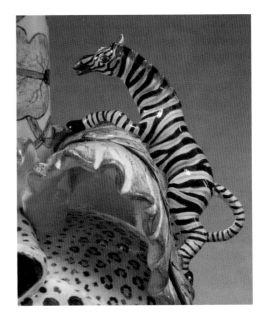
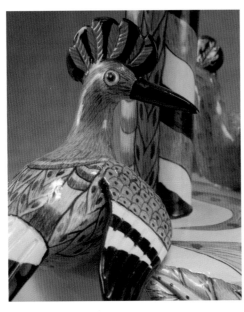

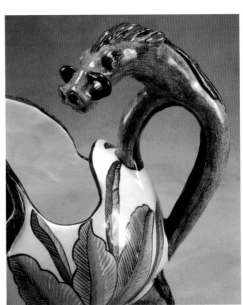
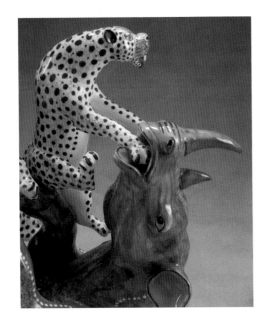

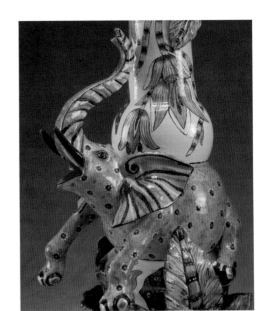

on he was hooked on ceramics. By the time he opened his first antiques shop, after graduating from college, he had already made contact with Royal Doulton, Moorcroft Pottery, Wedgwood and other British art pottery makers. I got to know Ed through Christiaan Scholtz, a former Springbok rugby player turned antiques dealer. Ed and Christiaan first met at a Johannesburg arts and antiques fair. After hearing Chris sing Ardmore's praises, Ed felt compelled to visit the studio. He has become an ardent fan of our art and is supplying our works to a new generation of aficionados who love the originality, verve and energy inherent in our creations.

Another of Ardmore's friends is Malena Ruth, one of the most interesting women I have ever met. Malena grew up in the aftermath of the Mozambique civil war and has firsthand experience of poverty and lack of opportunity, especially for women. After studying economics at the Eduardo Mondlane University in Maputo, Malena joined the United Nations Fund for Women as a researcher, focusing on women's issues and women's rights in Africa. She later became president of the African Millennium Foundation, a strategic non-profit, non-governmental organisation committed to the social and economic empowerment of the people of Africa, which she co-founded with her husband, Joe Sive. Malena learnt about Ardmore and the work we do in the Midlands following a chance meeting with an early Ardmore collector, Louise Nykamp. Malena takes a keen interest in Ardmore's artists, and provides an outlet for our ceramics in California. She has found that Americans love the fun and energy of the ceramics and the colour they bring into their lives.

Malena counts actresses – and avid Ardmore collectors – Helen Mirren and CCH Pounder among her many friends. It was Dame Helen who took Ardmore to the silver screen when she asked Malena to provide a few pieces to be displayed on the set of her 2009 political thriller *State of Play*, in which she starred as a newspaper editor.

Also among Malena's large circle of friends is Dr Neal Baer and his wife, Gerrie Smith, who have an extensive collection of Ardmore ceramics. Neal is a paediatrician, former executive producer of the NBC television series *Law & Order: Special Victims Unit* and executive producer of the CBS television series *A Gifted Man*. Malena describes Neal, whose interests, qualifications and experience span the arts, health-care, education and humanitarian disciplines, as 'rather like three men rolled into one'. One of his passions is storytelling for social change, and he considers the Ardmore pieces that he and his wife have collected as visual representations of the lives and experiences of their creators.

The Amaridian Gallery in New York, which was founded by South Africans Mary Slack and Fraser Conlon, sets out to introduce the immense richness of contemporary African arts and crafts to an American

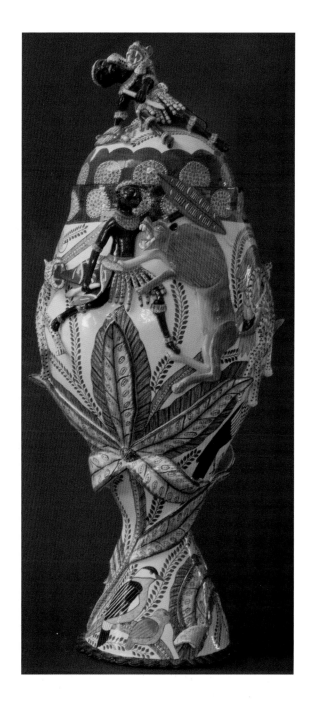

Opposite: Dr Neal Baer and his wife, Gerrie Smith, have been collecting outstanding Ardmore ceramics for several years. These photographs show details from some of the works in their collection.

Above: Hunting urn sculpted by Sondelani Ntshalintshali and painted by Jabu Nene, 2007. The urn is in the collection of Neal Baer and Gerrie Smith.

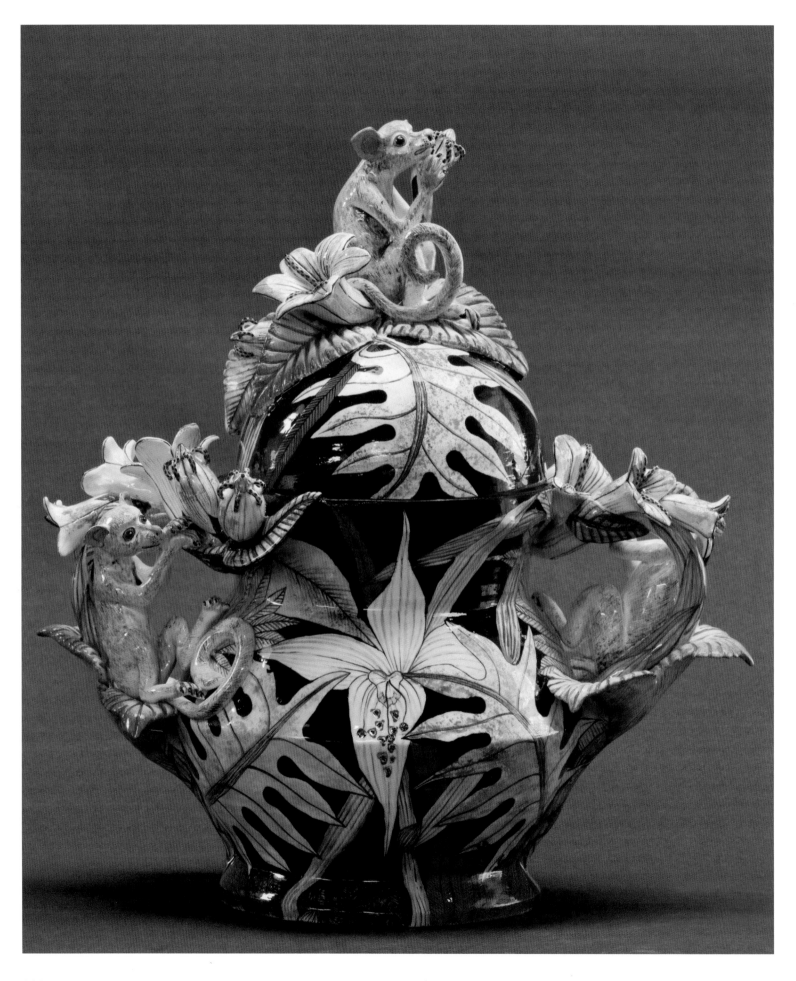

**Opposite and above: Ardmore sculptures in
the collection of Americans Cathe and John
Kobacker include a bushbaby tureen made by
Sfiso Mvelase and painted by Wiseman Ndlovu,
2008 (opposite), two unpainted sculptures,
Spider Giraffe (top left) and *Before the Wedding*
(top right), created by Petros Gumbi, 2008, and
a flowers and flying dragons tureen sculpted
by Slulamile Mlambo and painted by Bennet
Zondo, 2008 (above).**

audience. In 2010 Amaridian exhibited a collection of Ardmore works as
part of the Sculpture Objects & Functional Art (SOFA) fair held in New
York and Chicago, respectively. In the same year, two exceptional Ardmore
works, selected at the SOFA fair, were included in the *Global Africa Project*
exhibition held at the Museum of Arts and Design in New York.

Cathe and John Kobacker of Ohio in the United States are
two special people who were introduced to Ardmore by Fraser. They
were immediately attracted to the lively colours and bold designs of our
artworks, as well as the sense of community and depth of culture that form
the invisible foundation of each piece. Cathe and John have developed
a particular passion for our white, glazed sculptures, created in the style
of blanc-de-chine porcelain. Whether it is a piece showing the custom of
lobolo or another with a warrior riding atop a mythological beast, these
pieces, while devoid of colour, evoke emotional responses that are anything
but monochromatic.

The reverence that collectors have for Ardmore ceramics is best
explained by Cathe Kobacker: 'Through the use of human figures, insects,
animals and mythological creatures, the pieces tell us of tribal culture and
traditions, both real and legendary. What makes Ardmore pieces so amazing
is the way in which the artists work in a communal way, while allowing for
tremendous respect for the individual artist. The quality, uniqueness and
beauty of the work done at Ardmore is in a class of its own.'

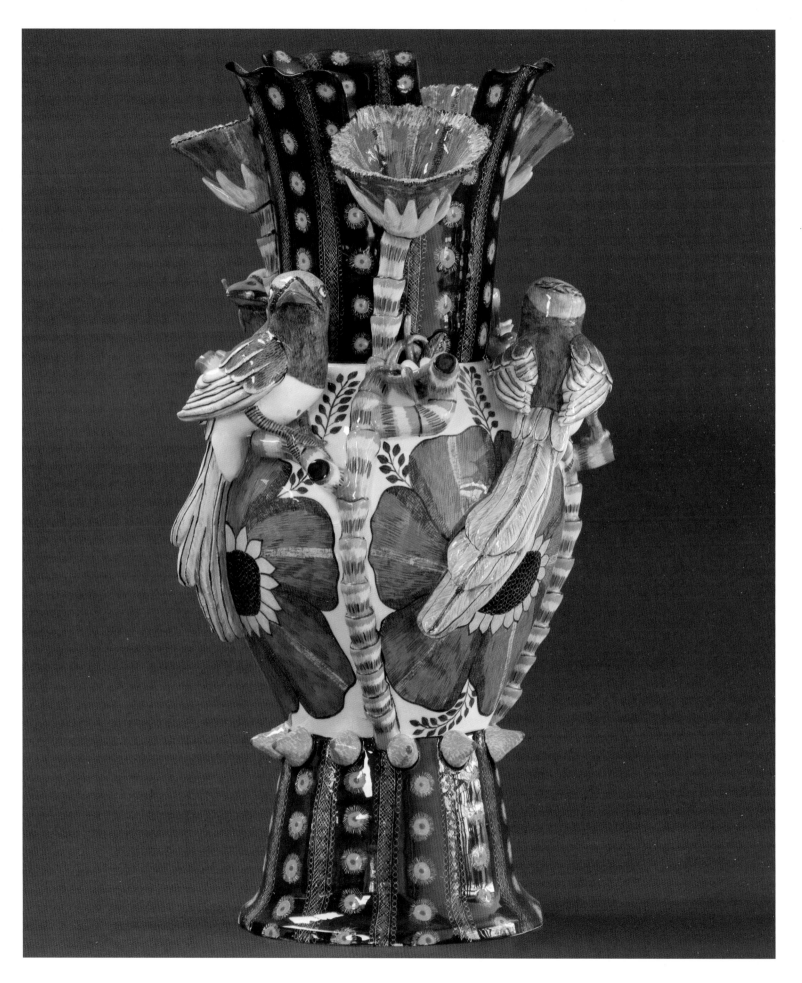

194

here is no doubt that, despite difficult conditions at times, Ardmore has gone from strength to strength. The artists have become more mature and we have found ourselves working as a family, sharing responsibilities and understanding that we are reliant on each other for our survival. Our craftsmanship has vastly improved and our creativity has taken us in new, unexpected directions, from ceramics to textiles. We have gained international recognition, not just for our beautiful objects and fabrics, but also for our commitment to the socio-economic development of people in one of the poorest areas in Africa.

Our development work caught the attention of Steven Dubin, Professor of Arts Administration at Teachers College, Columbia University, who is now a regular visitor to Ardmore. He encouraged one of his students, Sarah Schramm, to do her research thesis on Ardmore's approach to social responsibility. She spent a productive three months with us doing research and assisting with strategic planning.

In November 2010 I was honoured by the Philadelphia-based Women's Campaign International for the difference Ardmore's work has made in the lives of rural women in the KwaZulu-Natal Midlands. Following in the footsteps of previous recipients, such as US Secretary of State Hillary Clinton, I was humbled by the recognition. In the speech that I delivered at the gala event in New York, I said, 'I accept this honour on behalf of the artists who have worked with me at Ardmore, from 1985, when Bonnie Ntshalintshali became my first student, to the present day, with artists such as Punch Shabalala, Jabu Nene, Virginia Xaba, Betty Ntshingila and Sharon Tlou continuing the tradition of making a difference in the lives of people in their communities.' It was one of the most exciting days of my life.

The next day my heart leapt again as we drove around Columbus Circle towards the Museum of Arts and Design, where some of Ardmore's sculptures were being displayed as part of the *Global Africa Project* exhibition. Hanging from the lampposts were exhibition banners showing a monkey vase sculpted by Sfiso Mvelase. It was spectacular. Many more such events lie in Ardmore's future, supported by long-time friends and collectors in South Africa, the United States and parts of Europe, and new ones in countries such as Finland, Sweden, France and Australia.

I am filled with hope for Ardmore's future. When I started Ardmore, I leapt onto a merry-go-round that has been revolving at higher and higher speeds. I cannot slow it down or jump off. Years ago, I gave up my own art and chose to become a creator of artists. I love teaching and consider myself the luckiest person in the world. When dawn breaks, I cannot wait to share a new idea, watch the magic evolve, and see the excitement of self-discovery. I thrive on the energy and beauty that fills my life.

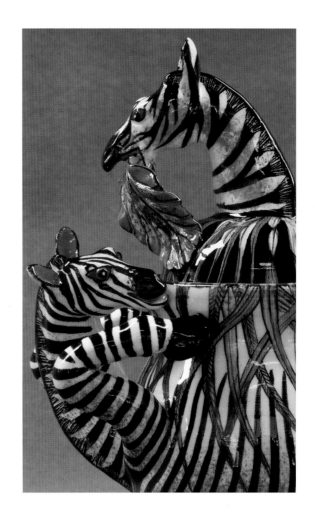

Opposite: Flycatcher vase sculpted by Slulamile Mlambo and painted by Jabu Nene, 2009. The sculpture depicts the life cycle of a flycatcher – from eggs in a nest to fledglings to adult birds. The vase was sold through Amaridian Gallery in New York and is now in the collection of Cathe and John Kobacker.

Above: Detail of a zebra sugar pot thrown by Sabelo Khoza, sculpted by Sondelani Ntshalintshali and painted by Wiseman Ndlovu, 2009.

COLLECTOR'S EDITION

Amanda Ackerman
Rosemary Beggs
Louise Glenton
Mr and Mrs Kenneth Beall
E Rubens
Kelly Foster
Jon Brian Greis
Linda Miller
John and Cathe Kobacker
Mark Rutt
Jürgen Kögl
Louise Nykamp
Pierre F Haesler
Angela Dick
Christopher Seabrooke
Dorothea and Ted Adlard
Arnold and Rebecca Gain
AP Rubens
Miriam, Gill and Joachim Zahn
Mark and Deirdre Simpson
Mikael Celvin
Joy Adams
Maysie Starr
Leslie Hollander Eichner
Yanni Vosloo
Stephen Johnson

SPECIAL EDITION

Mr and Mrs Kenneth Beall
Christopher Seabrooke
Andre Ahlers
Luanne Adams
Miriam and Joachim Zahn
Don Barrell
Cheryl and David Smith
Bridget Searle
Nicky Leitch
Glenn Goldblum
Gill and Joachim Zahn
Jill Derderian

John Broadhead
Stuart Conway
Andrea Lapsey
Richard and Julie Braby
Sharon Schachter
Amanda Webb
Genevieve Robert
Juliet Knight
Caryn Crosbie
Gavin Tollman
Toni Tollman
Amanda Kate Fitschen
Beatrice Poussin
Maite and Joachim Zahn
Beatrice Poussin
Sally Moore
Terry-Anne Pryke
Anne P McDowell
Merle King
Gail Dorje
Lexie Armstong
Kelly Foster
Plumbago
Gerald Weft
Hilton Kuck
Inger Palm Andersen
Janine Deleflie
Steve Connolly
The Oyster Box
Roelien Theron

STANDARD EDITION

Werner and Heide Bothner
Dawn Ginori
Kim Smith
Judy Lea Cox
Suzanne Armstong
Moira MacMurray
GM Cook
Susan Mathis
Shirley Norval

RD van Niekerk
Jo Neser
John Ray
Pam Stegman
Leo van Straten
Glenn Goldblum
Camilla Keating
Salome Meyer
Jane Rowse
Ingrid Weiersbye-Porter
Jim Graham
Janetjie van der Merwe
Barbara Kinghorn

Mabel Tyne
Sarah Palmer
Alkis J Macropulos
Dana Wakefield
Annelie Wada
Jennifer Diamond
Erica Smythe
Maggie Tyler
Nancy Davis
Mrs Hancock
Marsja Hall-Green
Sue Gibson
Sharon Schachter

Opposite: Leopard and protea vase sculpted by Sabelo Khoza and Sondelani Ntshalintshali and painted by Punch Shabalala, 2010.

Above: *Monkey Boss* sculpted by Sondelani Ntshalintshali and painted by Wiseman Ndlovu, 2010.

Every effort has been made to trace copyright holders. The publisher apologises for any inadvertent omissions and would be grateful if notified of any corrections, which shall be included in future reprints and editions of the book.

All photographs were taken by Roger de la Harpe (©Ardmore Ceramic Art), except for the following:
17 Prestige Photography; 23 Anne Marie Sconberg; 26 (left), 27 (top), 29 (top), 31 (top), 35, 40 (bottom), 75 (top), 76 Anthony Bannister; 28 (top), 29 (bottom), 30 (top), 31 (bottom left), 40 (top), 41, 46 (bottom), 47 (top, bottom right), 48 (bottom) Doreen Hemp; 34, 75 Kathleen Comfort; 52, 80, 81 (top), 94 Hetty Zantman; 70–71 Franco Esposito; 77 Spencer McMillian (©Ardmore Ceramic Art); 174, 176, 177 David Ross (©Ardmore Ceramic Art); 183 (top) Sean Lee Davies (©Patrick Mavros); 183 (bottom) Kunal Patel (©Patrick Mavros Mauritius); 186 (top) John J. Lopinot; 188 Ted Adlard; 190 Ed Glendinning; 193 (top right) Robert Selby (©Amaridian Gallery).

Photographs on the following pages were supplied courtesy of:
12, 13 (top), 16, 24, 25, 45 (top), 56, 60 (bottom right), 61 (top), 64 (bottom left and right), 159 (bottom) Fée Halsted; 14, 15 Joy (Treasure) Foster; 22 David Middlebrook; 26 (right) David Walters; 66, 67 (top), 68, 69, 71, 78, 79, 83 Christopher Greig; 82–83 Caversham Mill Hotel; 112 (top) Stephan Welz & Co.; 175 (left) Mavromac.

Left: Zebra angels and jackal tureen sculpted by Sondelani Ntshalintshali and painted by Virginia Xaba, 2009.

199

Page numbers in *italics* indicate photographs.

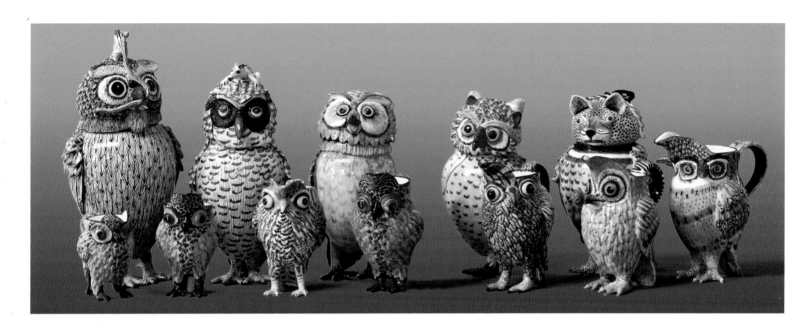

Above: The tureens and jugs of owls and a leopard were thrown by Lovemore Sithole. The tureens in the back row were sculpted by Sondelani Ntshalintshali and painted by (from left) Punch Shabalala, Sharon Tlou, Siyabonga Mabaso, Fiko Mfuphi and Virginia Xaba, 2010. The jugs in the front row were sculpted and painted by the following teams: (from left) Kenneth Msomi and Wiseman Ndlovu; Kenneth Msomi and Virginia Xaba; Kenneth Msomi and Wiseman Ndlovu; Kenneth Msomi and Punch Shabalala; Thabo Mbhele and Sthabiso Hadebe; and Thabo Mbhele and Nonhlanhla Nxumalo, 2010.